Trauma-Informed Practices for 9–12 Theatre Education

This resource bridges the worlds of education, mental health, and the performing arts to offer a comprehensive roadmap for 9–12 theatre educators looking to promote safe, supportive, and creative spaces for their students. Written by a seasoned theatre educator and a licensed mental health clinician, this book explores trauma-informed teaching techniques tailored specifically for theatre classrooms, encompassing both acting and production processes. Chapters cover a broad range of topics, from fostering resilience in students to collaborating with caregivers, administrators, and communities across the educational journey. The authors introduce essential concepts such as intimacy direction and consent, ensuring ethical and inclusive practices. They also provide strategies for teachers to prioritize their own self-care. Core themes and objectives include: trauma-informed teaching, holistic theatre production, community engagement, ethical theatre practices, and educator wellness. Packed with practical exercises for exploration, discussion questions for book studies, and meticulously researched insights, this resource strikes a balance between therapeutic guidance and professional development. Ideal for 9–12 theatre educators in drama classrooms, after-school programs, and more, this guide equips you with the tools to support students who may have experienced trauma, empowering them in performing arts environments while maintaining healthy boundaries.

Jimmy Chrismon is Associate Professor of Theatre Teacher Education at Illinois State University, USA.

Adam W. Carter is the CEO of PATH Inc., a nonprofit dedicated to providing access to help services in Illinois, USA.

Also Available from Routledge
Eye on Education
(www.routledge.com/eyeoneducation)

Stage It: Making Shakespeare Come Alive in Schools
Floyd Rumohr

**Implementing Reflective Practice in the K–12 Classroom:
How to Easily Structure Teaching and Learning Reflections into Your Day**
Joanna C. Weaver and Cynthia D. Bertelsen

**Implementing Creative Movement and
Theater Across the K–6 Curriculum: Moving Through the School Day**
Kelly Mancini Becker

**Immersive Arts Integration:
A Step-by-Step Guide to Transitioning Your K–8 School**
Jenna Masone and Jennifer Katona

**Drama for the Inclusive Classroom:
Activities to Support Curriculum and Social-Emotional Learning**
Sally Bailey

**Trauma-Informed Teaching in Your Elementary Classroom:
Simple Strategies to Create Inclusive, Safe Spaces
as the First Step to Learning**
Lori Brown and Alison Bartlett

**Trauma-Responsive Practices for Early Childhood Leaders:
Creating and Sustaining Healing Engaged Organizations**
Julie Nicholson, Jen Leland, Julie Kurtz, LaWanda Wesley, and Sarah Nadiv

**Supporting Young Children to Cope, Build Resilience,
and Heal from Trauma Through Play:
A Practical Guide for Early Childhood Educators**
Julie Nicholson and Julie Kurtz, with La Feshia Edwards, Jonathan Iris-Wilbanks, Samantha Watson-Alvarado, Maja Jevgjovikj, and Valentine Torres

**Supporting the Wounded Educator:
A Trauma-Sensitive Approach to Self-Care**
Dardi Henershott and Joe Hendershott

**Teaching Resilience and Mental Health Across the Curriculum:
A Guide for High School and College Teachers**
Linda Yaron Weston

**Cultivating Behavioral Change in K–12 Students:
Team-Based Intervention and Support Strategies**
Marty Huitt with Gail Tolbert

Trauma-Informed Practices for 9–12 Theatre Education

Jimmy Chrismon and Adam W. Carter

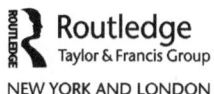

Routledge
Taylor & Francis Group
NEW YORK AND LONDON

Designed cover image: © Brad Floden. See more of his work on Instagram: @photosbycobalt. www.cobaltphotography.com

First published 2025
by Routledge
605 Third Avenue, New York, NY 10158

and by Routledge
4 Park Square, Milton Park, Abingdon, Oxon, OX14 4RN

Routledge is an imprint of the Taylor & Francis Group, an informa business

© 2025 Jimmy Chrismon and Adam W. Carter

The right of Jimmy Chrismon and Adam W. Carter to be identified as authors of this work has been asserted in accordance with sections 77 and 78 of the Copyright, Designs and Patents Act 1988.

All rights reserved. No part of this book may be reprinted or reproduced or utilised in any form or by any electronic, mechanical, or other means, now known or hereafter invented, including photocopying and recording, or in any information storage or retrieval system, without permission in writing from the publishers.

Trademark notice: Product or corporate names may be trademarks or registered trademarks, and are used only for identification and explanation without intent to infringe.

ISBN: 978-1-032-77172-4 (hbk)
ISBN: 978-1-032-77171-7 (pbk)
ISBN: 978-1-003-48222-2 (ebk)

DOI: 10.4324/9781003482222

Typeset in Palatino
by Apex CoVantage, LLC

Contents

Meet the Authors vi
Foreword viii
By Matt Webster
Preface x
Acknowledgements xiv

Part 1 In Theory 1

1 Introduction 3

2 The Essential Role of Self-Care for Theatre Educators 19

3 Intersectionality 31

4 Intimacy Direction, Consent, and Boundaries 46

Part 2 In Practice 61

5 Pre-Production Processes 65

6 During Rehearsal and Run of Production Processes 85

7 Post-Production Processes 116

8 Trauma-Informed Practices in the Theatre Classroom 126

9 Conclusion 158

Glossary 163

Meet the Authors

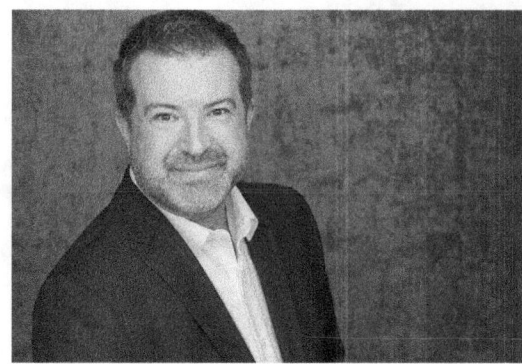

Jimmy Chrismon, EdD, is a theatre educator with 17 years of experience in North and South Carolina public schools. He currently teaches full-time as an Associate Professor of Theatre Teacher Education at Illinois State University. He was an adjunct theatre faculty member at Winthrop University and Central Piedmont Community College. He has also worked for The Children's Theatre of Charlotte and The Lake Norman School of the Arts. He has acted, directed, designed, and produced theatre professionally for over 25 years.

He received his Bachelor of Arts Degree in Theatre Education from The University of North Carolina at Charlotte, where he was a North Carolina Teaching Fellow. He received his Master of Education Degree in Theatre Education from The University of North Carolina at Greensboro. He completed his Doctor of Education Degree in Curriculum and Instruction from Gardner-Webb University.

He is the creator and host of THED Talks podcast with listeners in 98 countries. He has published articles in journals including *Youth Theatre Journal, Drama Research, Pathways to Research in Education, World Federation of Education Associations,* and *The Journal of Educational Leadership in Action.* He received the 2022 Johnny Saldana Outstanding Theatre Education Professor Award from the American Alliance for Theatre Education. He is a sought-after speaker, workshop leader, actor, director, intimacy director, and certified mental health coordinator through the Association of Mental Health Coordinators. He currently resides in Bloomington, Illinois.

Adam W. Carter, PhD, is the Chief Executive Officer of PATH Inc., a nonprofit organization in Bloomington, Illinois, that provides services to unhoused individuals and answers for United Way 211 and the 988 Suicide and Crisis Lifeline. A professional counselor and counselor educator, Dr. Carter earned his doctorate in Counselor Education and Supervision, with a focus on multicultural counseling, from the University of North Carolina at Charlotte.

Throughout his career, Dr. Carter has taught in CACREP-accredited graduate programs and served as the coordinator for the Trauma-Informed Counseling Graduate Certificate at Northern Illinois University. He founded the Center for Grief and Loss at the University's Community Counseling and Training Center, where he trained and supervised counselors-in-training. He also served as the National Clinical Director for the National Alliance for Children's Grief.

Dr. Carter's research and scholarship focus on childhood grief, preparing counselors to work with grieving children, trauma-informed counseling, and play therapy. His clinical experience spans community mental health clinics, advocacy agencies, in-home intensive settings, and private practice.

In recognition of his contributions, Dr. Carter was named one of the inaugural Scholars-in-Residence with the American Counseling Association in 2014. He earned the designation of Fellow in Thanatology in 2020 and, in 2023, received the Fred Rogers Institute Helper Award for his work supporting grieving children and their families.

Foreword
By Matt Webster

Do you remember your first kiss?

For many (if not most) people, this was one of the most stressful moments in their young lives: The crush. The anticipation. The butterflies. The anxiety. The *moment*. It is a moment so powerful that the memory of it can elicit a physical reaction years or even decades later. In fact, I would bet that some of you got a small knot in your stomach just reading this.

Now imagine if your first kiss was on stage. In public. With an audience. And with a person you didn't choose. Can you imagine the trauma this would cause?

Sadly, many people who participated in Theatre during their high school years don't have to imagine. This trauma was their reality. And there were many other traumas, on stage and off, that likely left emotional scars on students who were pushed beyond their comfort levels for the sake of "Art." Realities like: An educator who relentlessly badgered students while side-coaching a scene. Or an acting coach who callously mocked an actor as a way to get them to express more emotion. Or a director who blocked scenes without any regards to the personal boundaries of the performers. Keep in mind, these were *professional* educators who genuinely cared for their students and wanted them to grow and improve as performers. Unfortunately, the history of educational theatre is littered with stories of caring and well-meaning educators who thoughtlessly asked their students to take risks, express emotions, and make physical choices that would be deemed as wholly inappropriate outside of a theatre.

For context, when I say these educators were "thoughtless," I mean it literally. There was no thought about the emotional safety and mental well-being of their students, because that was the way things have always been done. It's how *their* educators were taught. And how their educators' *educators* were taught. No one ever questioned it. In fact, if you *DID* question it, well, maybe you just weren't cut out for the Theatre. You should toughen up. You need a thicker skin . . .

And even though a great deal of traumatic scarring can be linked to traditional theatre practices, trauma is not exclusive to the stage. Nowadays we must also take into account the personal and long-standing traumas that students silently bring into our classrooms and theatres every day: An unstable home life. Anxiety. Relationship issues. LGBTQ+ identity challenges.

Pandemics. The list goes on. It is not the same world us old timers grew up in, that's for sure.

Thankfully, times have changed. Today we recognize that trauma is insidious and comes in many forms. We recognize that the mental health of both students *AND* educators is fundamental to a highly functioning classroom. We recognize that our students are complex and intelligent human beings who are capable of accomplishing amazing things when given protective boundaries and support. Most importantly, we recognize that the world is changing, and educators need to keep up with those changes in order to employ current best practices.

That is where this book comes in. Dr. Jimmy Chrismon (Theatre Education) and Dr. Adam Carter (Mental Health/Counseling) have combined their professional knowledge to explore not just the contextual and theoretical impact of trauma in Educational Theatre, but also provide accessible, practical information educators can utilize to identify and alleviate trauma in their classrooms, stage productions, and personal lives.

However, as useful as these practical measures may be, Drs. Chrismon and Carter recognize that for many established, veteran educators, this information is not only new, it is foreign. It is a literal shift of the entire educational theatre teaching philosophy that has been entrenched for decades, and as such, it can feel both overwhelming and unrealistic to expect educators to adapt these new practices overnight. That is why they propose an "Apply at your own pace" course of action: Some educators will immediately integrate these methods into their established teaching practices without missing a beat. For these folks, this new "trauma-informed" approach to Theatre will resonate at a molecular level and give shape and voice to concepts they have struggled to articulate for years. Other educators, however, may only feel comfortable taking small steps, and applying one or two changes in a measured "wait and see" approach. They recognize the potential of these practices but are wary of a radical overhaul of their entire teaching philosophy. Truth be told there is value in both of these approaches, because in the end, including *any* trauma-informed practices in an educational theatre setting is not only welcome, it is necessary.

The inclusion of these practices, whether gradual or total, will change the foundations of Theatre Education, and champion the authors' mission to reimagine Theatre in a high school setting. With that mission in mind, I encourage you to read this book in its entirety, take its lessons to heart, and begin your journey towards understanding, and applying *Trauma-Informed Practices for 9–12 Theatre Education*.

Preface

In this book, we invite you to explore a profound shift in how we approach teaching, learning, and creating within the theatre classroom. Our mission is clear: to equip you with the knowledge and tools needed to foster inclusive, supportive, and healthier environments for both yourself and your students. Together, we believe we can tell compelling and challenging stories while also taking care of each other in the process.

This work brings together two distinct yet complementary fields: theatre education and mental health. We, Dr. Jimmy Chrismon and Dr. Adam W. Carter, bring unique expertise to this collaboration. Jimmy has over 25 years of experience in theatre education, including 17 years as a high school theatre teacher, with a strong commitment to innovative teaching methods. Adam comes from the mental health sector, specializing in multicultural counseling and children's grief. Together, we are uniquely positioned to provide informed and holistic support for theatre educators by integrating practices from both disciplines to enhance the well-being and effectiveness of your work.

Our collaborative journey began when Jimmy directed a university production of *Spring Awakening* by Frank Wedekind. Adam attended the show and, while impressed by the production, wondered how the students involved were supported, particularly considering the play's heavy themes. At the time, Jimmy did not have an answer. He did not know how to provide that care, nor that he should. This moment sparked hours of conversation between us. How can we take care of the actors? How can we support the designers and crew who repeatedly witness the production? How do we care for the audiences, made up of university students, parents, and community members? And how do we ensure directors are cared for as well?

Later, during a post-mortem with the entire production company, the need for care was already on our minds. One of the actors expressed a desire for a support system to help them ground themselves after heavy scenes or intense run-throughs. That conversation marked the beginning of our shared mission to create safer, more ethically responsible theatre practices and prioritize the well-being of everyone involved.

This desire for change led us to conduct a study in 2021. We interviewed 34 theatre educators, asking, "Are trauma-informed practices being incorporated into 9–12 grade theatre production processes?" The results were eye-opening, revealing a significant gap in trauma-informed approaches.

Why Trauma-Informed Practices Matter

Trauma-informed practices represent a significant paradigm shift in education and the performing arts. Theatre is not just about teaching lines, blocking, and character development; it is about recognizing and responding to the unique needs of each student, considering their experiences and histories. As theatre educators, you are not just instructors. You are mentors, advocates, and empathetic guides on a journey of self-discovery with your students. Effective teaching starts with your own well-being, requiring self-awareness and continuous self-care.

Our work is grounded in the belief that every student deserves a safe space to learn, express, and develop resilience. The trauma-informed approach recognizes that students may carry unseen burdens and seeks to provide them with the tools they need to succeed academically and emotionally. Throughout this book, we will explore strategies for fostering safety and trust, promoting open dialogue, and adapting teaching methods to meet your students' diverse needs.

Chapter Outlines

We want to give you an overview of how the book is laid out so you can easily find your way through it. Each chapter builds on the one before it, starting with the basics to help you understand the "what" and "why" of the topic. From there, we move into practical tips and real-world examples to help you implement things. While jumping ahead to the later chapters for the hands-on strategies might be tempting, we encourage you to start at the beginning. By building a solid foundation, you will find that the practical steps become clearer and more meaningful.

Part 1: In Theory

Chapter 1. Introduction: This chapter introduces the profound impact of trauma on education and the vital role theatre educators play in supporting students. It sets the stage for the transformative practices ahead.

Chapter 2. The Essential Role of Self-Care for Theatre Educators: Effective teaching starts with your well-being. This chapter explores strategies for maintaining mental, emotional, and physical health.

Chapter 3. Intersectionality: In this chapter, we explore intersectionality, where aspects of identity intersect with trauma in K–12 theatre education, fostering a deeper understanding of students' diverse trauma experiences for educators.

Chapter 4. Intimacy Direction, Consent, and Boundaries: We explore promoting safe spaces for creative expression while respecting boundaries and consent through foundational principles of theatrical intimacy.

Part 2: In Practice

Chapter 5. Pre-Production Processes: This chapter discusses the strategies for setting the stage for a supportive and inclusive environment from the beginning of the production process.

Chapter 6. During Rehearsals and Run of the Production Processes: This chapter focuses on maintaining a trauma-informed approach during the creative process.

Chapter 7. Post-Production Processes: In this chapter, we reflect on experiences, offer ongoing support, and embrace the transformative power of reflection as part of the production process.

Chapter 8. Trauma-Informed Practices in the Theatre Classroom: This chapter highlights the need to prioritize trauma-informed practices in 9–12 grade theatre classrooms, ensuring a supportive environment for students who have experienced trauma, guided by SAMHSA's core principles.

Chapter 9. Conclusion: The final chapter provides a roadmap for charting your path forward as a trauma-informed theatre educator and consolidating your learning.

A Call to Action

While we will often reference classrooms and schools, the techniques and principles outlined in this book apply to anyone working with teenagers in theatre settings. This includes community theatre directors, teaching artists, youth theatre program facilitators, after-school drama club advisors, and private acting coaches. Whether you are guiding students through a scripted production, leading improvisational exercises, or mentoring them in individual performance skills, these trauma-informed practices offer tools to create supportive environments. By fostering spaces that balance creativity,

emotional safety, and trust, you can help young people navigate both the artistic challenges and personal growth that come with engaging in theatre.

This book is our invitation to join us on this path toward more ethical, empathetic, and safer theatre practices. Together, we can transform the way theatre education is experienced, ensuring that everyone involved can engage fully, safely, and responsibly.

Acknowledgements

We would like to thank the following people for your contributions to this work and our lives through the writing of this book:

Grayson, Ryann, and Landyn
Our students: past, present, and future
The theatre teachers who contributed to the creation of this work
Matt Webster
To the Winthrop University Production of *Spring Awakening*, 2016: thank you for the inspiration to begin this work.
To the Illinois State University Production of *Equus*, 2023: thank you for allowing us to try these practices out on you, and for your invaluable feedback and contributions to this work.
To Daniel Esquivel and the Lakes Community High School Production of *The Yellow Boat*, 2024: thank you for allowing our work to be part of your work in your beautiful production.
Brad Floden

Thank you to all the theatre educators out there tirelessly, and often thanklessly, doing great work, impacting your students for the better, moving the field forward, and for your commitment to learn new things.

Cover photo by Brad Floden.
See more of his work on Instagram: @photosbycobalt.
www.cobaltphotography.com

Part 1
In Theory

Part 1: *In Theory* lays the essential groundwork for understanding why a trauma-informed approach is necessary in theatre education. Before diving into the practical applications in Part 2, this section explores the critical theories and concepts that inform these practices. By engaging with ideas surrounding trauma's impact on education, self-care, intersectionality, and consent, educators gain the tools to comprehend the deeper "why" behind the strategies they will implement.

Understanding this theoretical foundation is crucial for fostering meaningful change. Trauma-informed practices require more than surface-level adjustments; they demand a shift in mindset that centers empathy, inclusivity, and intentionality. Part 1 challenges educators to reflect on their roles as facilitators of both creativity and safety, emphasizing that effective practice begins with a thorough understanding of the students they serve, the systemic challenges they face, and the environments educators create. This foundation ensures that the "how" in Part 2 is applied with depth, purpose, and a commitment to equity and care.

1

Introduction

What Is Trauma?

Before we explore trauma-informed practices, it is important to understand what trauma is and how it affects individuals. Trauma is an event or series of events that is experienced as harmful or life threatening and has lasting negative effects on a person's well-being (SAMHSA, 2019). It can take many forms, including acute trauma (a single event), chronic trauma (repeated and prolonged events), and complex trauma (exposure to varied and multiple traumatic events) (Crosby, 2018; Morton & Berardi, 2018). Trauma has a far-reaching impact, influencing emotional, psychological, and physical well-being. Whether it results from a single, catastrophic event or accumulates over time, trauma can reshape how people see the world, interact with others, and navigate daily life (Anderson et al., 2015; Cavanaugh, 2016; Crosby, 2015; Knight, 2019; Miller & Flint-Stipp, 2019; Morton & Berardi, 2018).

To understand the complexity of trauma, it is essential to recognize that each person's response is deeply individual, shaped by their unique life experiences and personal history. Consider two people who experience the same tornado. One might feel a brief moment of fear, followed by relief once the storm passes. In contrast, another, who previously lost their home and loved ones in a similar disaster, might experience intense anxiety and be overwhelmed by flashbacks at the sound of sirens or storm warnings. These contrasting reactions demonstrate how trauma is subjective, emphasizing the diverse ways it can take hold and profoundly impact how individuals perceive, engage with, and respond to the world around them.

Facts and Figures

The prevalence of trauma among children is overwhelming, with studies showing that nearly two-thirds of children in the United States experience at least one traumatic event before the age of 16 (Fondren et al., 2020). This highlights the critical need for trauma-informed practices, especially considering that 89% of educators report having worked directly with students affected by trauma (Alisic et al., 2012). Theatre educators, however, report receiving only generalized trauma-informed training that lacks specific application to the unique dynamics of their work, leaving them to adapt these principles on their own (Chrismon & Carter, 2023). These training programs, which range from brief one-hour sessions to comprehensive initiatives lasting several months, are essential for equipping educators with the knowledge and strategies needed to effectively support students who have experienced trauma (Anderson et al., 2015; Miller & Flint-Stipp, 2019).

The COVID-19 pandemic has been a profound collective trauma, exacerbating mental health issues worldwide. Collective trauma refers to the psychological and social impact experienced by a group of people who have undergone a significant, often devastating event together, affecting their collective identity and shared memory. As mentioned above, over two-thirds of children will experience trauma by age 16, a number likely increased by the pandemic. This trauma has impacted not only children but also educators and frontline workers. According to the American Psychological Association, nearly two-thirds of people reported permanent life changes due to the pandemic, leading to a global 25% rise in anxiety and depression (2023). The pandemic has significantly increased the risk of PTSD, especially among those with prior trauma. Frontline workers, particularly in healthcare, have faced severe secondary traumatic stress. Meanwhile, children and adolescents have seen a spike in mental health issues and suicide attempts. The long-term effects of the pandemic on children's mental health, particularly for younger kids who missed crucial social interactions, may become more apparent as they grow and further research is conducted (Reetz, n.d.).

The Brain

In understanding trauma, the brain serves as a crucial orchestrator, directing our responses to external stimuli to ensure our safety and survival (Shively, 2022). Exploring its neurobiological aspects, we uncover the brain's dual role as protector and influencer in trauma contexts. At its core, the brain processes environmental information, assesses threats, and guides responses for

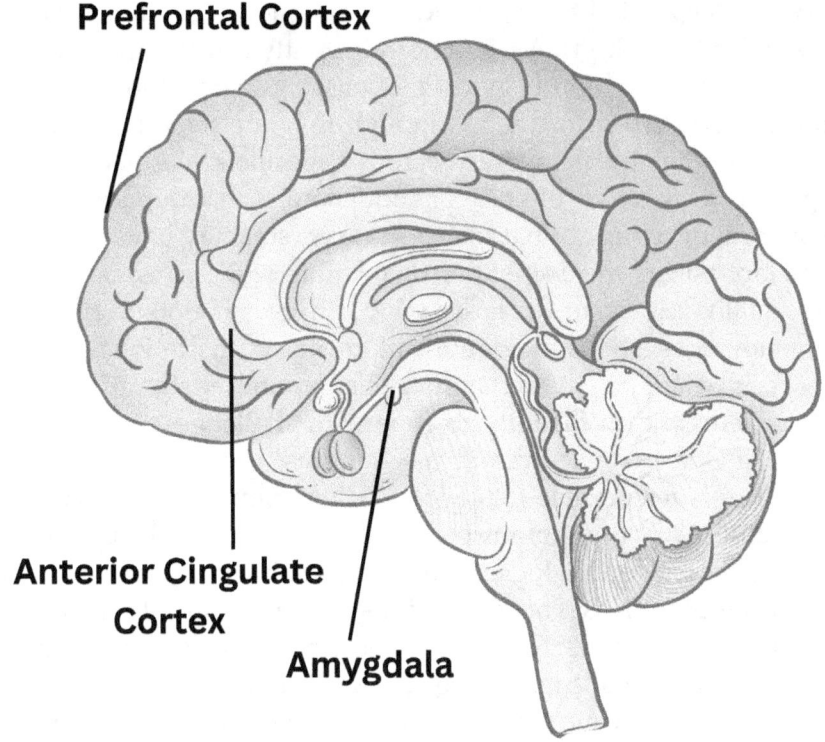

Figure 1.1 Parts of the Brain

survival (Schreyer, 2023). The prefrontal cortex (PFC), responsible for rational decision-making, falters under trauma, leading to impaired information processing and distorted perceptions. Adjacent to the PFC as seen in Figure 1.1, the anterior cingulate cortex (ACC) struggles with emotional regulation, resulting in heightened reactivity and emotional challenges. Meanwhile, the amygdala, the fear processing center, intensifies its activity in response to trauma, triggering the fight-or-flight response and reshaping our perception of the world (Knight, 2019; Morton & Berardi, 2018). Moreover, trauma leaves biochemical imprints on genes, suggesting the potential for transgenerational transmission of its effects (Wagner, 2016).

Understanding the Term "Trigger"

The term "trigger" is often used to describe a stimulus such as a sight, sound, smell, or situation that reminds someone of a past traumatic experience, activating an intense emotional or physical response. These responses are not

arbitrary but deeply tied to an individual's unique history and lived experiences (Van der Kolk, 2014). A trigger can instantly activate the body's fight, flight, freeze, fawn, or flop responses, bypassing logical thought processes and causing the person to react as though they are reliving the traumatic event. Triggers can take many forms, from a specific smell that recalls a distressing memory to a tone of voice or sudden noise that mimics a past experience of harm or danger. What triggers one person may have no impact on another, emphasizing the deeply personal nature of these responses.

It is equally important to clarify what a trigger is not. Triggers are not simple annoyances, slight discomfort, momentary frustrations, or the kind of stressors that arise in everyday life. They are not a sign of weakness, a lack of resilience, or an inability to cope with challenges. Instead, triggers are rooted in the brain's survival mechanisms, specifically in the limbic system, which is responsible for processing emotion and memory (Perry & Szalavitz, 2017). When the brain perceives a stimulus as a threat based on past trauma, it can override logical reasoning, leading to a reaction that prioritizes self-protection. This is not a conscious choice, but an automatic response designed to ensure survival, even when the threat is no longer present.

Understanding what triggers are and what they are not is vital for educators, leaders, and anyone working in environments where individuals may have experienced trauma. Recognizing the impact of triggers fosters empathy and reinforces the importance of creating spaces that support emotional regulation and safety. Acknowledging the personal nature of these responses encourages us to approach others with patience, respect, and an openness to understanding their experiences.

In trauma-informed practices, this understanding is a cornerstone. When we recognize that seemingly minor stimuli can have profound effects on someone who has experienced trauma, we can begin to create environments that are thoughtful and supportive. These environments do not aim to eliminate all potential stressors, an impossible goal, but instead strive to minimize unnecessary stress and build trust. By fostering open communication, setting clear expectations, and cultivating a sense of safety, we can empower individuals to manage their responses and feel valued within the space (SAMHSA, 2014b).

Trauma's Effects on Individuals

When individuals experience traumatic events, their immediate reactions can vary significantly. The body's natural responses, such as Fight, Flight, Freeze, Fawn, and Flop, are instinctual reactions to real or perceived threats.

These responses are driven by the release of stress hormones like adrenaline and cortisol, which activate the body's survival mode. This process bypasses higher level thinking processes, such as reasoning and planning, in favor of self-protection.

- **Fight:** When facing a threat, the fight response engages the body's defense mechanisms. This can manifest as defensiveness, argumentativeness, or even aggression. Physically, the body responds with increased heart rate, adrenaline spikes, and muscle tension, all designed to prepare for confrontation.
- **Flight:** The flight response is triggered when individuals feel the need to escape or avoid a threatening situation. This can manifest as anxiety, restlessness, or a strong impulse to flee. The body gears up to avoid the perceived danger by increasing alertness and readiness to run.
- **Freeze:** In the freeze response, the body may become immobilized, numb, or detached from the situation, reflecting an extreme level of threat. People may feel paralyzed, emotionally shut down, or dissociated. This response is a form of "playing dead," a way the body protects itself when it perceives escape or fight isn't possible.
- **Fawn:** Fawning is a less recognized but equally important response. It involves appeasing or pleasing the perceived threat to avoid conflict. People may over-accommodate others' needs or sacrifice their own boundaries in an attempt to defuse a threatening situation and avoid harm.
- **Flop:** The flop response, or submission, occurs when individuals feel completely overwhelmed and give up in the face of a threat. They may become passive, go along with others' wishes, or even lose consciousness. This response can lead to a dramatic drop in heart rate and blood pressure, as the body shuts down to cope with the overwhelming stress.

Understanding these automatic stress responses is essential in trauma-informed practices, as they reveal how the body and mind react to stressors. When students feel safe and supported, they are better able to regulate their emotions and engage in learning. However, when confronted with perceived threats, students may experience one of these uncontrollable responses, highlighting the importance of promoting a safe and supportive environment. By fostering a sense of security and reducing sources of stress, educators can help students manage their emotions and participate more effectively in the learning process.

Trauma is not solely a psychological experience; it resonates throughout the body, often in subtle and profound ways. It becomes embedded, shaping physiological responses and affecting various bodily systems. For example, a student who has experienced trauma may develop heightened sensitivity to noise or sudden movements, causing them to startle easily or shut down when overwhelmed. Beyond the internal impact, trauma also extends outward, influencing relationships and social connections. A student might struggle to trust peers or adults, finding it difficult to form healthy connections. For educators, understanding these effects is essential, as they directly impact how students engage and learn in the classroom environment.

The multifaceted nature of trauma is reflected in the wide range of responses it elicits. Each person's experience with trauma is shaped by their personal history, perceptions, and coping mechanisms. To manage trauma, individuals often develop survival strategies that vary greatly from person to person. As no two people process trauma the same way, it is challenging to create an exhaustive list of responses. However, common reactions include:

- Anxiety
- Depression
- Guilt
- Shame
- Anger
- Headaches
- Stomach problems
- Muscle tension
- Chronic pain
- Difficulty concentrating
- Sleep problems and nightmares
- Hyper-vigilance
- Heightened reactivity to cues
- Irritability and outbursts
- Mood swings
- Intrusive thoughts and flashbacks
- Re-experiencing the trauma
- Loss of interest or pleasure
- Psychological distress and arousal
- Avoidance
- Detachment and estrangement
- Numbness and emotional disconnection
- Foreboding and limited expectations
- Strained relationships

(Anderson et al., 2015; Cavanaugh, 2016; Crosby, 2015; Crosby et al., 2018; Knight, 2019; Minahan, 2019; Morton & Berardi, 2018; Van der Kolk, 2015; Walton-Fisette, 2020; West et al., 2014).

Certain groups of individuals are more likely to be exposed to traumatic events, with their responses shaped by their identities and lived experiences. Current and former foster youth, refugee students, LGBTQ individuals, and BIPOC (Black, Indigenous, People of Color) students are among those who disproportionately experience the effects of trauma (Knight, 2019; Walton-Fisette, 2020). While research often emphasizes specific groups, the ongoing effects of racial and generational trauma highlight that our understanding of trauma is continually evolving.

Understanding the impact of trauma in education calls for meaningful action. Trauma-informed approaches go beyond merely responding to trauma; they represent a comprehensive framework that acknowledges the potential presence and effects of trauma. These approaches strive to create environments that are attuned to students' emotional needs while actively working to prevent retraumatization (Busselle, 2021; Crosby et al., 2018). Research indicates that trauma-informed practices can enhance student engagement, support self-regulation, and improve academic outcomes when students feel validated and understood (Morton & Berardi, 2018). By adopting trauma-informed practices, educators can establish safe and nurturing environments where students feel valued, heard, and empowered, fostering resilience and growth.

In theatre education, the significance of trauma-informed practices cannot be overstated. Theatre educators have the unique opportunity to honor each student's individual needs, validate their experiences, and provide a secure platform for self-expression. Integrating trauma-informed approaches into theatre classrooms ensures that students can explore their creativity in a space that promotes emotional safety and growth (Carello & Butler, 2014; Knight, 2019; Miller & Flint-Stipp, 2019; Morton & Berardi, 2018; Walton-Fisette, 2020).

The Six Principles of Trauma-Informed Practices

The Substance Abuse Mental Health Services Administration of the USA (SAMHSA) identifies six core principles in a trauma-informed approach. This book is built on the following principles:

Safety: Ensuring a sense of safety for all individuals by considering diverse experiences and demographics, encompassing physical, emotional, and interpersonal safety.

Trustworthiness and Transparency: Building and maintaining trust through transparent operations and decision-making, including openness about difficult decisions and inviting diverse voices to participate.

Peer Support: Integrating the culture and values of peer support throughout the organization, fostering mutuality and authenticity, and providing opportunities for deeper connections among all stakeholders.

Collaboration and Mutuality: Embracing a collaborative approach, breaking down hierarchies, and supporting staff well-being to create healing-centered connections.

Empowerment, Voice, and Choice: Supporting individuals' inner resilience, and emphasizing empowerment derived from personal authority rather than external expertise

Cultural, Historical, and Gender Issues: Moving past cultural stereotypes and biases.

By embracing and effectively applying these principles, theatre educators can transform their classrooms and productions into nurturing spaces where students can grow and thrive. This approach not only benefits individual students but also contributes to the creation of a more empathetic and compassionate society (Knight, 2019; National Child Traumatic Stress Network, Schools Committee, 2017; SAMHSA, n.d.; SAMHSA's Trauma and Justice Strategic Initiative, 2014a).

In Chapters 5–8, we will reference these principles when discussing specific techniques for creating trauma-informed environments in the theatre classroom and throughout the production process. These chapters will provide practical strategies for integrating these core principles into everyday practices, ensuring that both students and educators can experience safety, trust, collaboration, and empowerment in their work.

The Four R's

In addition to its six core principles, SAMHSA outlines the "Four R's" of trauma-informed practices: Realization, Recognition, Response, and Resist Re-traumatization (SAMHSA, 2014b).

- ◆ **Realization** involves understanding the widespread impact of trauma and recognizing that it affects each person differently.
- ◆ **Recognition** focuses on identifying signs of trauma in students, colleagues, and oneself.

- **Response** entails incorporating trauma-informed knowledge into policies, procedures, and practices to promote healing and growth.
- **Resist Re-traumatization** means actively working to prevent creating environments or interactions that could trigger trauma responses.

These Four R's are essential for theatre educators who seek to build a safe and supportive learning environment. Realization encourages educators to approach students with empathy and understanding, appreciating their individual experiences with trauma. Recognition helps educators identify students who may need extra support. Response guides educators in adapting teaching methods, classroom management, and production processes to be trauma-sensitive. Resisting re-traumatization ensures that students feel secure and respected in the learning space.

By integrating these principles, theatre educators can create nurturing environments that foster healing and growth, making the educational experience inclusive, supportive, and fully trauma-informed.

A Cultural Shift

Trauma-informed theatre education represents a profound transformation within the theatre education community. It calls for a departure from traditional practices that may unintentionally cause harm and advocates for creating environments that foster resilience, growth, and empowerment. This shift, recognized by scholars and professionals alike, must extend beyond those in authority positions working with minors in theatrical settings. Our research underscores the importance of integrating trauma-informed practices into every stage of theatre production—from preproduction to casting, rehearsals, and execution, and post-production care (Chrismon & Carter, 2023; St. John, 2022).

This holistic approach acknowledges that trauma-informed practices should not be limited to merely educational settings but should permeate the entire theatre profession. It is a call for the entire industry to embrace a more empathetic and compassionate approach in its operations. For this change to take hold in the professional world, the cultural shift must begin in educational spaces, especially with young students. By embedding trauma-informed practices early in a student's theatre journey, we lay the groundwork for an empathetic, mindful theatre community that extends into professional realms (Shively, 2022; St. John, 2022). This shift is not merely a theoretical

concept, it is an urgent necessity. It is a collective responsibility of educators, practitioners, and industry professionals to prioritize the emotional and psychological well-being of everyone involved. By doing so, we enrich both the artistic and educational experiences for future generations.

Trauma-informed practices require a fundamental shift in how we perceive students. Instead of seeing them solely as performers or technicians, we must recognize their multifaceted identities, which include their diverse backgrounds and experiences. This approach fosters empathy and compassion (Anderson et al., 2015; Crosby et al., 2018; Morton & Berardi, 2018). It acknowledges that students bring their past experiences into the classroom and rehearsal space, which inevitably influences their current engagement. By recognizing this complexity, we can create inclusive environments that honor students' diverse paths. This understanding helps us realize that a student's hesitation or behavior may stem from personal experiences rather than a perceived lack of dedication (SAMHSA's Trauma and Justice Strategic Initiative, 2014a; Walton-Fisette, 2020). This awareness allows educators to tailor their teaching to meet individual needs, encouraging both artistic and personal growth. Ultimately, this shift calls upon us to be compassionate witnesses to our students' journeys, engaging with them on a deeper human level and helping them harness theatre's transformative power.

This cultural shift also highlights the broad-reaching consequences of our choices. It reminds us that the decisions we make affect performers, technicians, audiences, and fellow educators both emotionally and psychologically. Recognizing this empowers us to make informed, compassionate decisions, fostering a sense of responsibility and accountability for the well-being of the entire theatre community. As we embark on this journey, we encourage you to approach this material with an open heart and a commitment to positively impacting your theatre community.

Promoting Safe Spaces

The concept of "safe spaces," which originated from the LGBTQ+ and feminist movements of the 1960s and 1970s, has gained momentum as environments meant to be free from bias and discrimination (Zheng, 2016). However, the term "safe space" can be somewhat misleading, as achieving complete safety is often impossible due to external factors and the potential biases of authority figures. In response, the idea of "brave spaces" has emerged, which emphasizes courage over the promise of absolute safety. These spaces encourage respectful engagement with differing opinions and open communication,

particularly when harm occurs (Arao & Clemens, 2013). Yet, even in brave spaces, power dynamics persist, often placing an undue burden on marginalized individuals to educate others, disproportionately affecting minority students.

In contrast, the concept of a "negotiated space" recognizes the diversity of experiences and perspectives that individuals bring to collaborative settings, fostering ongoing dialogue and empowerment (Macpherson, 2021). This approach, especially relevant in theatrical intimacy practices, seeks to redefine power dynamics to enhance both autonomy and safety, giving students an active role in shaping their own vulnerability and the risks they take (Chrismon & Marlin-Hess, 2023). Acknowledging that a perfectly "safe space" is unattainable, the idea of "acceptable risk" proposes open communication about the inherent risks involved in creative processes (Rikard & Villareal, 2023). This framework emphasizes informed consent, allowing participants to define their own acceptable risks and boundaries while addressing the subjective nature of safety and trauma, alongside systemic power imbalances.

While the concepts of "safe space" and "brave space" are valuable for promoting inclusivity and challenging oppressive systems, it is important to recognize their limitations and embrace the idea of negotiated spaces that prioritize dialogue, collaboration, and shared decision making. These spaces offer a more nuanced understanding of safety by acknowledging its subjective nature and incorporating the concept of acceptable risk. As theatre educators, while we cannot guarantee complete safety or bravery in our classrooms or productions, we can evolve from traditional notions of safe and brave spaces toward creating negotiated spaces that foster open communication, trust, and respect. Throughout this book, we will emphasize practical steps to cultivate inclusive and responsive environments that support all participants (Chrismon & Marlin-Hess, 2023).

Trauma-Informed Care Is Not . . .

Trauma-informed practices are not about coddling or overly protecting our students. It is about creating an environment that acknowledges the impact of trauma while fostering resilience, empowerment, and growth. In theatre education, this means understanding the unique needs and experiences of students who have faced trauma. The goal is to create a space where students can feel supported while they learn and grow. By recognizing their experiences, we can empower them to thrive.

Trauma-informed practices do not focus on the trauma itself but rather on how individuals respond to it. Educators do not need to know the specifics of a student's trauma in order to support them. The priority is promoting a safe, supportive, and responsive environment. This involves recognizing signs of distress, navigating triggers, and encouraging healing through positive, validating interactions. By promoting emotional safety and thoughtful reflection on sensitive topics, educators can help students grow without reopening old wounds. A trauma-informed space fosters healing and growth for all participants.

Trauma-informed practices do not equate to censorship. The goal is not to avoid difficult narratives but to approach them with care, empathy, and respect. Theatre can be a powerful tool for building resilience and fostering education while considering the emotional impact on participants. Trauma-informed theatre education prioritizes the emotional and psychological well-being of everyone involved. It allows us to tell challenging stories ethically, promoting open dialogue and support systems. Through this approach, we can handle sensitive themes while caring for each other throughout the process.

While theatre can offer therapeutic benefits, theatre educators are not therapists (Chrismon & Carter, 2023; Walton-Fisette, 2020). Theatre educators should avoid using the theatrical process as a form of therapy for their student actors, as it is not their role to provide therapeutic interventions. It is important for educators to know their limits and not attempt to act as counselors. Instead, by adopting trauma-informed practices, educators can promote safe, inclusive spaces that support students' emotional well-being. We can foster growth and self-expression by recognizing the boundaries of our professional responsibilities. When mental health concerns arise, referring students to appropriate professionals is crucial.

Not All Good Work Is Our Work

In their training sessions, the Association of Mental Health Coordinators emphasizes that "not all good work is our work." Drawing from this wisdom, we acknowledge and honor the many remarkable individuals who are researching, teaching, and practicing in this field. While some professionals choose not to use the term "trauma-informed" due to its perceived deficit mindset, we have embraced it because it aligns with existing frameworks within educational settings. Trauma-informed practices are widely recognized in education, and by working within these established systems, we can effectively engage educators, administrators, parents, and educator training programs.

Our objective is to offer a salutogenic approach to this work. Salutogenic practices in trauma-informed education focus on promoting health, well-being, and resilience by identifying and enhancing factors that support individuals' ability to cope with stress and adversity. These practices emphasize strengths, resources, and the potential for growth and healing, creating environments that foster a sense of coherence, meaning, and empowerment. In contrast, pathogenic practices focus on diagnosing problems, addressing dysfunctions, and working from a deficit-based mindset. This approach often centers on treating symptoms and damage caused by trauma, sometimes overlooking individuals' inherent strengths and capacity for recovery. By shifting from a pathogenic to a salutogenic approach, trauma-informed work builds on existing strengths and creates a supportive, empowering atmosphere that enhances overall well-being and resilience.

We do not know most of our students' trauma histories, and they do not owe us their stories or explanations. Therefore, we see no value in operating from a deficit perspective. Instead, we focus on looking forward, supporting their growth, and creating spaces where all students can thrive, with systems in place to support every one of them.

Healing-Centered Engagement (HCE), developed by Dr. Shawn Ginwright in 2018, offers a holistic, asset-based approach to trauma that emphasizes resilience and collective healing rather than focusing solely on individual harm. This culturally grounded method has evolved from over 30 years of work with young people and their communities (Ginwright, 2018). Similarly, the Association of Mental Health Coordinators (AMHC), founded by Bridget McCarthy and Amanda Edwards, advocates for the responsible portrayal of mental health and trauma in various media (AMHC, 2024). They provide training, dramaturgy, and crisis management, ensuring that stories are told authentically and sensitively.

It is important to make a distinction: theatre educators are not in the healing business through their art and craft. While the relationships they build with students can indeed have a healing effect, this is not within the scope of their professional practice. Instead, theatre educators should focus on creating safer spaces and finding better ways to care for their students. Fred Rogers once said that the space between himself on television and the child watching was "Holy Ground," a space built on trust and empathy (Sebak, 1990). Similarly, the space between an educator and a student is equally sacred, founded on mutual respect and understanding. Although healing may occur in these special relationships, the primary goal should be to create a nurturing and supportive environment where learning and growth can flourish. This approach recognizes the power of these connections to foster well-being and resilience.

By incorporating trauma-informed practices, theatre educators and directors can create spaces that prioritize safety, trust, and emotional well-being. They can recognize the strengths and vulnerabilities of each student, providing appropriate support and empowering them to explore their creativity and express themselves authentically (Carello & Butler, 2014; Cavanaugh, 2016; Crosby, 2015).

References

Alisic, E., Bus, M., Dulack, W., Pennings, L., & Splinter, J. (2012). Teachers' experiences supporting children after traumatic exposure. *Journal of Traumatic Stress, 25*(1), 98–101. https://doi.org/10.1002/jts.20709

American Psychological Association. (2023). Stress in America 2023: A nation recovering from collective trauma. https://www.apa.org/news/press/releases/stress/2023/collective-trauma-recover

Anderson, E. M., Blitz, L. V., & Saastamoinen, M. (2015). Exploring a school-university model for professional development with classroom staff: Teaching trauma-informed approaches. *The School Community Journal, 25*(2), 113.

Arao, B., & Clemens, K. (2013). From safe spaces to brave spaces: A new way to frame dialogue around diversity and social justice. In *The art of effective facilitation: Reflections from social justice educators* (pp. 135–150). Stylus.

Association of Mental Health Coordinators. (2024). AMHC. https://www.associationmhc.com/

Busselle, K. (2021). De-Roling and debriefing: Essential aftercare for educational theatre. *Theatre Topics, 31*(2), 129–135. https://doi.org/10.1353/tt.2021.0028

Carello, J., & Butler, L. D. (2014). Potentially perilous pedagogies: Teaching trauma is not the same as trauma-informed teaching. *Journal of Trauma & Dissociation, 15*(2), 153–168. https://doi.org/10.1080/15299732.2014.867571

Cavanaugh, B. (2016). Trauma-informed classrooms and schools. *Beyond Behavior, 25*(2), 41–46. https://doi.org/10.1177/107429561602500206

Chrismon, J., & Carter, A. W. (2023). The absence of trauma-informed practices in the high school production process: A qualitative study. *Youth Theatre Journal*, 1–16. https://doi.org/10.1080/08929092.2023.2218719

Chrismon, J., & Marlin-Hess, M. (2023). Intimacy direction best practices for school theatre. *Drama Research, 14*(1).

Crosby, S. D. (2015). An ecological perspective on emerging trauma-informed teaching practices. *Children & Schools, 37*(4), 223–230. https://doi.org/10.1093/cs/cdv027

Crosby, S. D., Howell, P., & Thomas, S. (2018). Social justice education through trauma-informed teaching. *Middle School Journal, 49*(4), 15–23. https://doi.org/10.1080/00940771.2018.1488470

Fondren, K., Lawson, M., Speidel, R., McDonnell, C. G., & Valentino, K. (2020). Buffering the effects of childhood trauma within the school setting: A systematic review of trauma-informed and trauma-responsive interventions among trauma-affected youth. *Children and Youth Services Review, 109,* 104691. https://doi.org/10.1016/j.childyouth.2019.104691

Ginwright, S. (2018). The future of healing: Shifting from trauma informed care to healing centered engagement. *Kinship Carers Victoria, 25,* 1–7.

Knight, C. (2019). Trauma informed practice and care: Implications for field instruction. *Clinical Social Work Journal, 47*(1), 79–89. https://doi.org/10.1007/s10615-018-0661-x

Macpherson, J. (2021). Negotiated space: A reframing of safety and collaboration in the classroom. *Youth Theatre Journal, 35*(1–2), 79–89. https://doi.org/10.1080/08929092.2021.1891165

Miller, K., & Flint-Stipp, K. (2019). Preservice teacher burnout: Secondary trauma and self-care issues in teacher education. *Issues in Teacher Education, 28*(2), 28–45.

Minahan, J. (2019). Trauma-informed teaching strategies. *Educational Leadership, 77*(2), 30.

Morton, B. M., & Berardi, A. A. (2018). Trauma-informed school programming: Applications for mental health professionals and educator partnerships. *Journal of Child & Adolescent Trauma, 11*(4), 487–493. https://doi.org/10.1007/s40653-017-0160-1

National Child Traumatic Stress Network, Schools Committee. (2017). *Creating, supporting, and sustaining trauma-informed schools: A system framework.* National Center for Child Traumatic Stress. https://www.nctsn.org/sites/default/files/resources/creating_supporting_sustaining_trauma_informed_schools_a_systems_framework.pdf

Perry, B. D., & Szalavitz, M. (2017). *The boy who was raised as a dog: And other stories from a child psychiatrist's notebook—What traumatized children can teach us about loss, love, and healing.* Basic Books.

Reetz, N.T. (n.d.). Two years of trauma. *Georgia State University Research Magazine.* https://news.gsu.edu/research-magazine/two-years-of-trauma.

Rikard, L., & Villarreal, A. R. (2023). Focus on impact, not intention: Moving from "safe" spaces to spaces of acceptable risk. *Journal of Consent-Based Performance, 2*(1), 1–16. https://doi.org/10.46787/jcbp.v2i1.3646

SAMHSA. (n.d.). Infographic: 6 guiding principles to a trauma-informed approach. Substance Abuse and Mental Health Services Administration.

SAMHSA. (2014a). SAMHSA's Trauma and justice strategic initiative. SAMHSA's Concept of Trauma and Guidance for a Trauma-Informed Approach. SAMHSA.

SAMHSA. (2014b). *Trauma-informed care in behavioral health services*. US Department of Health and Human Services. https://www.ncbi.nlm.nih.gov/books/NBK207201/pdf/Bookshelf_NBK207201.pdf

SAMHSA. (2019). *Trauma and violence. SAMHSA*. https://www.samhsa.gov/trauma-violence

Schreyer, S. R. (2023). Promoting psychophysiological play: Applying principles of polyvagal theory in the rehearsal room. *Journal of Consent-Based Performance*, 2(1).

Sebak, R. (Producer). (1990). *Our neighbor, Fred Rogers*. QED Communications Inc.

Shively, K. (2022). Using principles of theatrical intimacy to shape consent-based spaces for minors. *Journal of Consent Based Practice*, Spring, 74–80.

St. John, A. (2022). Thought bubble theatre festival: Applying and developing consent-based practices with pre-professional actors. *Journal of Consent-Based Performance*, 1(2), 111–136. https://doi.org/10.46787/jcbp.v1i2.2872

Van der Kolk, B. (2015). *The body keeps the score: Brain, mind, and body in the healing of trauma* (Reprint). Penguin Publishing Group.

Wagner, D. (2016). Polyvagal theory in practice. *Counseling Today*. https://ct.counseling.org/2016/06/polyvagal-theory-practice

Walton-Fisette, J. L. (2020). Fostering resilient learners by implementing trauma-informed and socially just practices. *Journal of Physical Education, Recreation & Dance*, 91(9), 8–15. https://doi.org/10.1080/07303084.2020.1811620

West, S. D., Day, A. G., Somers, C. L., & Baroni, B. A. (2014). Student perspectives on how trauma experiences manifest in the classroom: Engaging court-involved youth in the development of a trauma-informed teaching curriculum. *Children and Youth Services Review*, 38, 58–65. https://doi.org/10.1016/j.childyouth.2014.01.013

Zheng, L. (2016). Why your brave space sucks. *Stanford Daily*. https://stanforddaily.com/2016/05/15/why-your-brave-space-sucks/

2

The Essential Role of Self-Care for Theatre Educators

We have been there. We understand. We still struggle daily to choose wellness and prioritize self-care. Sometimes we succeed, and sometimes we fail. We know the saying about putting on your own oxygen mask first, but we have also been the ones who said, "It is not about me . . . it is for the kids . . . if I do not do it, then who will?" We know that feeling, but we have to do better for ourselves.

When I (Jimmy) started student teaching, my mentor threw me into the deep end right away. I quickly took on a full teaching load, co-directing eight plays and a full-scale musical. Fast forward to my first year of teaching, and I thought producing eight to ten plays was the norm for a school season. I was exhausted, sick, and burnt out before I even reached year two of my career. Despite receiving amazing support from students and colleagues, I was pushing myself well beyond my limits. I worked part-time jobs, ate fast food, and relied heavily on caffeine just to get by.

Instead of scaling back, I continued adding more responsibilities. I acted and directed in local productions, started my own non-profit theatre company, and pursued both master's and doctoral degrees. As a result, my work began to suffer, my personal life unraveled, and my health deteriorated. I gained and lost weight, struggled with sleep apnea, and constantly felt overwhelmed. I was spiraling out of control, and the passion that once fueled my teaching was quickly fading away.

A turning point came when a student asked me to focus on quality over quantity, specifically by not casting everyone in every production. I scaled back, and my work improved. My passion for teaching and directing

returned, but the damage to my personal life had already been done. My long-term relationship ended, and I faced intense stress at work. Over time, I eventually found some balance. I met my future husband, who helped me learn to slow down. Transitioning to higher education improved my quality of life, but I still struggle with finding that balance.

I share my story to let you know that I understand what you may be going through. This cycle has to stop. We owe it to ourselves and our students to find balance. If we are going to create spaces where students can thrive through trauma-informed practices, we must first start with self-care and wellness. We need to model these behaviors for our students. If we do not prioritize our well-being, we cannot provide the best support, regulate our responses, or be the most creative versions of ourselves.

The role of a theatre educator goes far beyond the spotlight. Juggling a full teaching load, running rehearsals, directing performances, managing budgets, and balancing personal commitments can take a heavy toll on well-being (Chrismon & Carter, 2019; McCammon, 1992). The strategies presented in the following pages are designed to help develop healthy habits and redefine the theatre educator's lifestyle. This journey will not be easy, and change will not happen overnight, but starting with small steps can lead to lasting improvements. There is no single right way to achieve balance, the only wrong choice is not trying at all.

Constantly managing these responsibilities often leads to exhaustion and burnout, putting both personal and professional health at risk. Guiding students through emotionally charged material can drain emotional reserves, requiring educators to balance their own emotions while supporting students, which can lead to emotional fatigue. Nurturing students' creativity also depletes an educator's inspiration, making it essential to conserve creative energy and prevent burnout (McLauchlan, 2016). Finding balance is key to maintaining both personal well-being and a successful teaching career.

The nature of a theatre educator's work can also lead to a sense of isolation. Long hours spent rehearsing, planning, and directing can distance educators from their own need for connection and community (Chrismon & Carter, 2019; McLauchlan, 2016). This isolation can feel even more intense when educators are the only theatre professionals in their school or district, making it harder to find peers who truly understand their unique challenges.

Before exploring the consequences of neglecting self-care, it is essential to define wellness and self-care. Wellness is a holistic state of health that goes beyond just physical well-being. It encompasses mental, emotional, social, spiritual, financial, and environmental aspects of life. Achieving wellness

means finding a balance between these areas, all of which contribute to one's overall quality of life. True wellness is about maintaining this balance and continually working toward harmony in these interconnected aspects of health.

The Importance of Self-Care

Self-care is a deliberate and conscious practice of nurturing one's well-being. It involves taking intentional steps to maintain physical, mental, emotional, and other dimensions of health, recognizing that personal well-being forms the foundation for effective professional engagement. By prioritizing self-care, educators are better able to manage stress, prevent burnout, and maintain a balanced approach to both their personal and professional lives.

The importance of self-care for educators cannot be overstated. Research consistently shows that when educators actively engage in self-care, they experience a range of benefits, including increased job satisfaction, improved mental health, and enhanced resilience (Oberle & Schonert-Reichl, 2016). Practicing self-care can reduce stress and anxiety levels, which are common issues among educators due to the demanding nature of their profession. It also leads to better emotional regulation, helping educators maintain composure and patience in stressful classroom situations. Studies show that educators who engage in self-care report higher levels of personal accomplishment and are less likely to suffer from burnout (Dorman, 2003).

Moreover, educators who prioritize self-care tend to foster healthier classroom environments. By modeling self-care practices, educators not only improve their own well-being but also teach students the importance of taking care of their mental and emotional health. Research indicates that when educators practice self-care, they are better equipped to build positive relationships with students, manage their classrooms more effectively, and support students' social-emotional learning (Jennings & Greenberg, 2009).

Most educators are familiar with Abraham Maslow's Hierarchy of Needs, which provides a psychological framework for understanding human motivation. This model arranges human needs in a pyramid structure, as seen in Figure 2.1. At its base are basic physiological needs like food, water, and shelter, followed by safety needs, social belongingness needs, esteem needs, and culminating in self-actualization—the realization of one's full potential (Maslow, 1943; Uysal et al., 2017).

However, rather than viewing this as a rigid hierarchy where one progresses upward step by step, the Swarbrick Model of Wellness offers a more comprehensive approach to understanding well-being. This model

Figure 2.1 Maslow's Hierarchy of Needs Pyramid

Figure 2.2 The Swarbrick Model of Wellness

introduces eight dimensions: emotional, intellectual, physical, social, spiritual, vocational, financial, and environmental (Swarbrick & Yudof, 2015). Unlike Maslow's model, each dimension in the Swarbrick model is interdependent, forming an intricate web of well-being. The inclusion of financial and environmental aspects emphasizes their importance in an individual's overall health. Figure 2.2 illustrates the interconnectedness of these dimensions and how they collectively influence the wellness of an individual.

Ultimately, self-care is not a luxury; it is an essential practice for maintaining a long and fulfilling career in teaching. By investing in their well-being, educators can enhance their professional effectiveness, nurture their passion for teaching, and ensure that they are providing the best possible support to their students.

The Ripple Effects of Neglecting Self-Care

The consequences of neglecting self-care are significant and far-reaching. Chronic stress, burnout, and compassion fatigue that stem from ignoring personal well-being create a ripple effect, gradually wearing down both personal resilience and professional effectiveness. These emotional challenges intertwine and create a complex web that affects an educator's overall wellness and capacity to teach effectively.

Physically, neglecting self-care can result in headaches, fatigue, and more serious conditions like hypertension or heart disease. Chronic stress weakens the immune system, leaving educators more susceptible to illness (Morrison, 2020; Schulte et al., 2019). Over time, this accumulation of stress increases anxiety, irritability, and impairs concentration and memory, potentially leading to feelings of hopelessness. These effects sharply contrast with the creativity and energy educators strive to bring into the classroom (Gray et al., 2017; Morrison, 2020).

Neglecting self-care also takes a toll on personal relationships. Burnout and emotional exhaustion can lead educators to withdraw from social interactions, straining connections with friends, family, and colleagues (Morrison, 2020). In the classroom, a depleted educator's ability to engage and inspire students diminishes. Reduced energy and enthusiasm can lead to disengaged teaching, which may hinder students' growth and enthusiasm, especially in creative disciplines like theatre (Morrison, 2020; Schulte et al., 2019).

Without proper emotional and physical rejuvenation, resilience fades. Educators lose their ability to manage the demands of their profession, which can lead to a downward spiral in both effectiveness and overall well-being (Gray et al., 2017; Schulte et al., 2019).

One extreme consequence of overwork is Karoshi Syndrome, known as "death by overwork," which has been a serious issue in Japan since the 1980s (Smallwood, 2020). In 2021, a report from the World Health Organization (WHO) and the International Labour Organization (ILO) estimated that around 750,000 global deaths were linked to Karoshi (Pega et al., 2021). This phenomenon is caused by excessive working hours, job-related stress, and poor work-life balance. Factors like job insecurity, insufficient rest, and lack of control over work exacerbate chronic stress, burnout, and, in extreme cases, death. Although not recognized as a medical condition in many countries, Karoshi is widely acknowledged as a social phenomenon caused by overwork and excessive stress.

The health complications associated with overwork include cardiovascular issues like heart attacks and strokes, hypertension, sleep deprivation, and exhaustion. Mental health challenges, such as anxiety and depression, increase the risk of self-harm or suicide. Additionally, chronic stress can lead to metabolic issues like diabetes and obesity, immune suppression, and unhealthy behaviors like poor diet and lack of exercise (Al-Madhagi, 2023). These factors show how chronic overwork harms health, influenced by individual susceptibility, genetics, and societal pressures, especially in cultures that emphasize long hours and limited work-life balance.

For theatre educators, the demands of the profession can feel especially overwhelming. Constantly juggling teaching, rehearsals, performances, and personal commitments while also supporting students emotionally can take a significant toll. The effects of neglecting self-care not only impact your own well-being but also the classroom environment and your students' growth. It is easy to feel that the needs of your students and job responsibilities should come first but remember, you cannot pour from an empty cup.

Taking care of yourself is not a luxury; it is essential. When you prioritize your well-being, you set an example for your students, modeling the importance of mental, emotional, and physical health as key to thriving both personally and professionally. By incorporating self-care practices into your daily routine, you build the resilience needed to sustain your passion for teaching, inspire creativity, and effectively nurture your students.

As a theatre educator, you are responsible not only for the performances on stage but for the development of the students behind the scenes. By taking care of yourself, you ensure that you have the energy, creativity, and emotional stability to continue doing what you love: teaching, inspiring, and creating transformative experiences for your students. In doing so, you create a sustainable balance in your own life while fostering an enriching and supportive learning environment for your students.

The Essential Role of Self-Care in Theatre Education

Being a theatre educator requires a balance of passion and dedication, along with managing the complex demands of the profession. Prioritizing self-care is crucial for maintaining both personal well-being and professional success (Kuebel, 2019). Self-care is not just about finding time to relax; it is about regularly nurturing physical, mental, emotional, social, spiritual, financial, and environmental wellness (Gerst, 2014). A holistic approach, such as the Swarbrick model of wellness, helps educators maintain balance in these areas, ensuring they are at their best both inside and outside the classroom (Gerst, 2014; Kuebel, 2019).

Prioritizing self-care also improves professional performance. Educators who focus on their well-being are better equipped to help students handle the emotions that come with theatrical work. With renewed energy and creativity, they can create richer learning experiences. Pursuing personal passions outside of theatre also brings new ideas and innovation into their teaching and performance direction.

Self-care does not just benefit the individual; it too has a ripple effect. A well-rested, emotionally balanced educator spreads positivity to students, colleagues, and the broader community. By taking care of themselves, educators foster a space where genuine connections and growth can thrive. This makes them better able to handle challenges, take advantage of opportunities, and stay focused. When theatre educators prioritize their own health and well-being, they become resilient leaders, inspiring students and helping them succeed. In doing so, both educators and students can truly thrive.

Tactics

In Stanislavski's acting method, tactics refer to the strategies a character uses to achieve their objectives. These tactics shift based on the obstacles the character encounters, reflecting the dynamic and evolving nature of relationships and interactions on stage. Rather than focusing purely on internal emotions, actors concentrate on the actions their characters are taking, using physical movements to drive emotional responses. Every gesture and action are connected to a clear intention or goal, allowing actors to stay grounded in their characters' psychological and physical reality. While not all of Stanislavski's early practices align with the trauma-informed approaches emphasized in this book, his focus on tactics is valuable for its emphasis on adaptability, intentionality, and the integration of both mind and body. These principles align with our advocacy for holistic self-care.

For theatre educators, the concept of tactics can apply directly to self-care. Just as actors use specific strategies to overcome obstacles on stage, educators can adopt intentional and practical tactics for self-care that address their unique challenges. Rather than waiting for the "right feeling" to inspire change, self-care is an active process of identifying and implementing actions that nurture well-being.

Self-care is not a universal solution, and the tactics that work for one person may not be suitable for another. As theatre educators juggle demanding schedules and emotional labor, typical self-care suggestions like crystals or bubble baths may not resonate or meet their deeper needs. In *Real Self-Care: A Transformative Program for Redefining Wellness (Crystals, Cleanses, and Bubble Baths Not Included)*, Dr. Pooja Lakshmin critiques these superficial solutions and emphasizes the importance of more meaningful self-care strategies such as boundary-setting, value-driven decisions, and systemic changes. Her work advocates for long-term, sustainable tactics that genuinely address the emotional and mental demands of high-stress professions like teaching (Lakshmin, 2023).

For self-care to be effective, it must be practical and adaptable, especially for theatre educators dealing with heavy workloads, tight schedules, and personal responsibilities. These obstacles can feel overwhelming, but just as actors adjust their tactics to navigate challenges on stage, educators must be flexible in experimenting with different self-care approaches.

For example, adjusting your schedule to prioritize physical activity or relaxation can be a helpful tactic. Building a support network of fellow educators can also provide accountability and encouragement. The key is to remain persistent, adapting your strategies as needed when certain approaches are not effective. Obstacles are part of the journey, and just as actors continually adjust their tactics to achieve their goals, theatre educators must remain adaptable in their self-care practices.

Progress takes time. Building a sustainable self-care routine is a gradual process, and it is important to celebrate small victories along the way—whether it's setting aside five minutes for yourself, saying "no" to extra responsibilities, or establishing healthier boundaries between work and personal life. Each small step contributes to long-term change.

Table 2.1 provides actionable ideas you can incorporate into your self-care routine. It is not exhaustive, and you do not need to implement every item to practice effective self-care. Think of it as a starting point, offering practical strategies to begin your journey toward a healthier, more balanced lifestyle.

Table 2.1 Practical Strategies for Theatre Educators to Implement Self-Care

Physical	Mental
Exercise Regularly: Get 30 minutes of activity daily—walk, do yoga, or enjoy a workout. **Eat Nutritious Meals:** Plan balanced meals with proteins, veggies, and whole grains; avoid fast food and caffeine. **Drink Water:** Stay hydrated throughout the day. **Take Medications and Vitamins:** Consistently take your prescribed medications and vitamins.	**Mindfulness and Meditation:** Practice daily with guided sessions from meditation apps. **Breaks from Social Media:** Limit your social media time; set specific times to check it. **Counseling/Therapy:** Seek professional help when needed. **Get Outside:** Spend time in nature regularly.
Emotional	**Professional**
Journaling: Reflect daily by keeping a journal to process feelings and identify stressors. **Self-Compassion:** Be kind to yourself during stressful times; acknowledge your efforts and celebrate small victories. **Spend Time Alone:** Enjoy moments by yourself without distractions. **Ask for Help:** Reach out for support when needed.	**Continuing Education:** Pursue professional development to stay inspired and updated. **Advocate for Yourself:** Communicate your needs and seek support to manage your workload. **Identify Goals and Learn New Skills:** Set goals and focus on acquiring new skills. **Set Boundaries:** Clearly define and maintain your personal and professional limits.
Spiritual	**Social**
Acts of Kindness: Volunteer or engage in activities that support others. **Be of Service:** Find ways to help and support your community. **Spend Time in Nature:** Regularly enjoy the outdoors. **Go to a Place of Worship:** Visit a place of worship that resonates with you.	**Connect with Peers:** Join professional networks or forums to share experiences and get support. **Set Boundaries:** Define and communicate your limits with colleagues, students, and family. **Spend Time with Loved Ones:** Make time for friends and family. **Maintain Healthy Relationships:** Keep connections strong with important people in your life.

Environmental	Financial
• **Travel for a Change of Scenery:** Visit new places to refresh your mind. • **Work at a Coffee Shop:** Spend time at a coffee shop working on tasks. • **Explore New Places:** Spend time discovering new locations. • **Set a Calm Mood in the Evenings:** Create a relaxing atmosphere in the evenings.	• **Budgeting:** Create and stick to a budget to manage expenses and save for the future. • **Emergency Fund:** Save money for unexpected expenses to avoid financial strain. • **Plan for Retirement:** Make plans and save for your retirement. • **Use a Money App:** Track your finances with a money management app.

Seeking Professional Support

While self-care is incredibly beneficial, there are times when it is not enough, and seeking professional help becomes essential. Experts recommend reaching out for support when self-care does not resolve ongoing issues, if problems begin to interfere with daily life, or if you experience thoughts of self-harm or suicide. If you are new to mental self-care, a counselor can provide guidance on nurturing practices that enhance your well-being. It is important to remember that while self-care promotes well-being, it should complement professional support, not replace it. Everyone can benefit from mental health support, as improving daily routines and habits is key. Working with a counselor can be transformative, offering valuable tools for managing challenges. If you are unsure where to start, organizations like the National Alliance on Mental Illness (NAMI) and the US Substance Abuse and Mental Health Services Administration (SAMHSA) offer resources. You can also consult your healthcare provider, social worker, or a trusted loved one for recommendations.

A Journey Towards Resilience

Prioritizing self-care offers far-reaching benefits that extend well beyond personal well-being. It strengthens the foundation of effective teaching and directing, supporting educators in their roles. When educators fully embrace self-care, they create space within themselves for creativity to flourish. By dedicating time for rejuvenation, engaging in hobbies, or simply pausing for

mindful reflection, they replenish their mental and emotional reserves. These moments of renewal often lead to fresh perspectives and innovative teaching methods. As educators nurture their own creativity, they inspire a similar enthusiasm in their students, igniting a cycle of inspiration and engagement.

When stress is managed effectively and well-being is prioritized, patience and empathy come more naturally. Educators become a source of positivity, creating an environment where strong student-educator connections thrive. This, in turn, supports not only the academic growth of students but also their emotional well-being, as they feel heard, supported, and genuinely understood. By caring for themselves, educators foster resilience that resonates throughout their classrooms, benefiting everyone involved.

References

Al-Madhagi H.A. (2023). Unveiling the global surge: Unraveling the factors fueling the spread of karoshi syndrome. *Risk Manag Healthc Policy, 18*(16), 2779–2782. doi: 10.2147/RMHP.S444900

Chrismon, J., & Carter, A. (2019). Teacher and administrator perceptions of traits, characteristics, and instructional practices of effective theater teachers. *Journal of Educational Leadership in Action, 6*(1). https://digitalcommons.lindenwood.edu/ela/vol6/iss1/8

Dorman, J. P. (2003). Testing a model for teacher burnout. *Australian Journal of Educational & Developmental Psychology, 3*(1), 35–47.

Gerst, A. (2014). *A wellness handbook for the performing artist: The performer's essential guide to staying healthy in body, mind, and spirit.* Balboa Press.

Gray, C., Wright, P., & Pascoe, R. (2017). There's a lot to learn about being a drama teacher: Pre-service drama teachers' experience of stress and vulnerability during an extended practicum. *Teaching and Teacher Education, 67,* 270–277. https://doi.org/10.1016/j.tate.2017.06.015

Jennings, P. A., & Greenberg, M. T. (2009). The prosocial classroom: Teacher social and emotional competence in relation to student and classroom outcomes. *Review of Educational Research, 79*(1), 491–525. https://doi.org/10.3102/0034654308325693

Kuebel, C. (2019). Health and wellness for in-service and future music teachers: Developing a self-care plan. *Music Educators Journal, 105*(4), 52–58. https://doi.org/10.1177/0027432119846950

Lakshmin, P. (2023). *Real self-care: A transformative program for redefining wellness.* Penguin Random House.

Maslow, A. H. (1943). A theory of human motivation. *Psychological Review, 50,* 370–396.

McCammon, L. A. (1992). The story of Marty: A case study of teacher burnout. *Youth Theatre Journal, 7*(2), 17–22.

McLauchlan, D. (2016). Factors of resilience in secondary school drama/theatre teachers. *Youth Theatre Journal, 30*(2), 171–183. https://doi.org/10.1080/08929092.2016.1225610

Morrison, S. (2020). Choral music and wellness: The potential impact of mentoring. *Canadian Music Educator, 62*(2), 27–32.

Oberle, E., & Schonert-Reichl, K. A. (2016). Stress contagion in the classroom? The link between classroom teacher burnout and morning cortisol in elementary school students. *Social Science & Medicine, 159,* 30–37. https://doi.org/10.1016/j.socscimed.2016.04.031

Pega, F., Náfrádi, B., Momen, N. C., Ujita, Y., Streicher, K. N., Prüss-Üstün, A. M., . . . & Woodruff, T. J. (2021). Global, regional, and national burdens of ischemic heart disease and stroke attributable to exposure to long working hours for 194 countries, 2000–2016: A systematic analysis from the WHO/ILO Joint Estimates of the Work-related Burden of Disease and Injury. *Environment International, 154,* 106595. https://doi.org/10.1016/j.envint.2021.106595

Schulte, C. M., Gray, C., & Lowe, G. (2019). "I feel very fortunate to still be doing what I Love": Later career performing arts teachers still keen and committed. *International Journal of Education & the Arts, 20*(7), 22. https://doi.org/10.26209/ijea20n7

Smallwood, B. M. (2020). *Productivity through wellness for live entertainment and theatre technicians: Increasing productivity, avoiding burnout, and maximizing the value of an hour.* Routledge.

Swarbrick, P., & Yudof, J. (2015). *Wellness in eight dimensions.* Collaborative Support Programs of NJ Inc. https://www.center4healthandsdc.org/uploads/7/1/1/4/71142589/wellness_in_8_dimensions_booklet_with_daily_plan.pdf

Uysal, H. T., Aydemir, S., & Genc, E. (2017). Maslow's hierarchy of needs in the 21st century: The examination of vocational differences. *Researches on Science and Art in 21st Century Turkey*, Gece Kitapligi.

3

Intersectionality

Intersectionality is a vital framework for understanding how individual identities intersect to shape experiences within the theatre classroom. It challenges us to consider how aspects such as race, gender, class, sexuality, and ability interact, influencing the ways students engage with and experience the creative process. As you explore these concepts, keep in mind that the identity markers, research, and terminology presented reflect the time in which they were written. Language and social perspectives are always evolving, and what feels relevant today may shift over time. However, one thing remains constant: students bring their lived experiences into the classroom, and it is our responsibility as educators to embrace these narratives. For theatre educators, understanding intersectionality equips us to create more inclusive, responsive, and empowering spaces where every student feels valued. We encourage you to engage actively with this chapter. Make notes, reflect, and consider how these insights can shape your approach to teaching, directing, and fostering collaboration in the theatre classroom.

What Is Intersectionality?

Intersectionality, a concept pioneered by Dr. Kimberlé Crenshaw in 1989, highlights how overlapping identities create unique experiences of privilege and oppression. Originally introduced to address the invisibility of marginalized groups, intersectionality explores how social markers, such as race,

gender, class, sexuality, and ability, interact to produce complex systems of advantage and disadvantage (Crenshaw, 2015) as shown in Figure 3.1. It reveals that a person's experiences cannot be understood by looking at just one identity in isolation. Instead, intersectionality offers a lens to see how different identities converge, creating new challenges or opportunities (Bryant-Davis, 2019; Voith et al., 2020). For theatre educators, intersectionality provides a crucial framework to understand how power dynamics and identity influence students' experiences. When we recognize the ways identity impacts learning and expression, we can create more inclusive spaces that honor each student's full humanity.

Theatre offers students the chance to explore themselves and the world around them—but only if they feel safe, respected, and free to express their authentic selves. Understanding the broader social, cultural, and historical contexts that shape students' identities helps educators identify both strengths and challenges within their classroom. This awareness reveals patterns of privilege and marginalization, motivating us to address systemic biases and

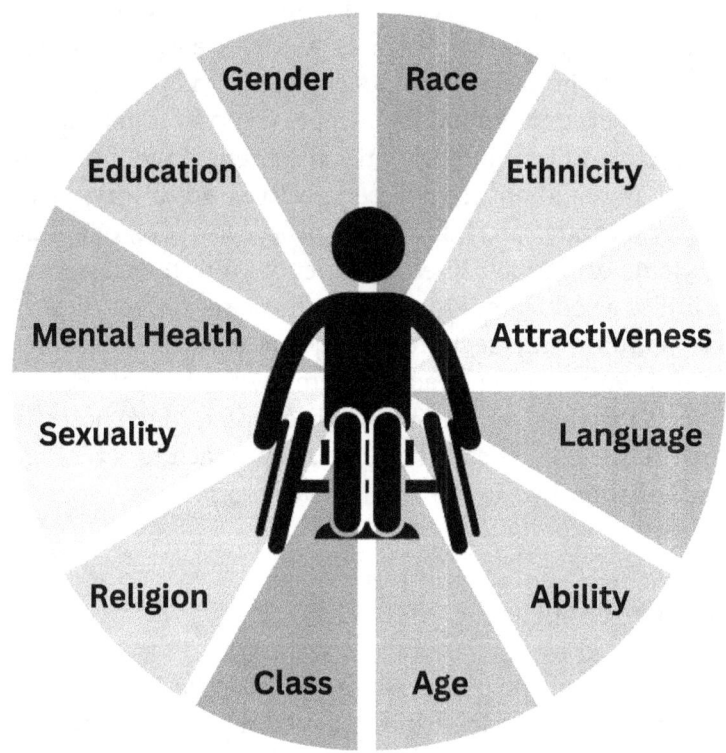

Figure 3.1 Wheel of Intersectionality

cultivate equitable learning spaces. Creating inclusive environments requires more than surface-level inclusion. Cultural responsiveness becomes essential as educators actively learn about students' backgrounds, traditions, and values. These efforts foster a theatre space where students do not just feel accepted, they feel empowered to express themselves fully, without fear of judgment or exclusion.

When we center intersectionality, we can better tailor support to meet the diverse needs of our students. Consider a student who identifies as nonbinary and lives with a learning disability. This student may require academic accommodations, such as extended time on assignments, alongside personal support such as using their correct pronouns and ensuring they feel safe in casting discussions and performance exercises. Addressing both academic and personal needs sends a powerful message: we see and value the whole person. This kind of holistic support fosters a deep sense of belonging, showing students that their identities are not barriers but essential parts of their contribution to the classroom and community.

This personalized approach strengthens teacher-student relationships, fostering trust and mutual understanding. When students feel seen and valued, they are more likely to take creative risks and engage in the collaborative process with confidence. By embracing each student's unique identity, educators not only support individual growth but also enrich the collective learning experience, creating a classroom where everyone thrives. Empathy is key here. When we understand our students' challenges and strengths through the lens of intersectionality, we create deeper connections that transform the classroom into a community. Theatre becomes not just a place to rehearse, it becomes a space where learning, expression, and belonging flourish.

Just as students bring diverse identities into the theatre classroom, so do educators. An educator's race, gender, sexuality, and other identity markers shape their worldview, teaching methods, and interactions with students. These identities also influence the content they select for productions and how they approach sensitive topics within theatre education. Reflecting on our own intersecting identities allows us to recognize biases, refine our teaching strategies, and create more responsive, inclusive practices. This self-awareness enables us to model vulnerability and authenticity, inviting students to do the same. In doing so, we build theatre spaces that honor the diverse experiences of everyone involved, students and educators alike.

When informed by intersectionality, theatre education becomes more than a space to perform. It becomes a dynamic, transformative community. By recognizing and addressing the complexities of identity, educators can

create classrooms where empathy, inclusion, and creativity thrive. As you reflect on the ideas in this chapter, we encourage you to consider how your evolving perspectives can shape the future of trauma-informed theatre education. Your insights, experiences, and actions will contribute to keeping theatre classrooms responsive, equitable, and inspiring spaces for generations to come.

Addressing Trauma Through an Intersectional Lens

In a trauma-informed theatre space, we seek to move beyond a one-size-fits-all approach to support. Even when multiple students experience similar traumas, the ways they process and express those experiences can vary greatly based on their identities. Intersectionality helps educators recognize and address these differences, ensuring that support strategies reflect the full range of students' lived experiences.

While theatre offers powerful opportunities for self-expression, it also requires vulnerability, a challenge for students with trauma histories. An intersectional approach encourages educators to consider how power dynamics, such as racial or gender hierarchies, show up in the classroom, rehearsal spaces, and performance choices. This awareness helps educators identify barriers to participation and take steps to remove them. For example, casting practices that challenge traditional gender roles or discussions about representation within a play's text can foster a safer environment where students feel recognized and respected.

Intersectionality also sheds light on how systemic inequalities impact students' access to theatre programs. Students from marginalized communities often face external challenges like limited transportation, financial instability, or language barriers that hinder their ability to participate fully. Trauma informed theatre education, with intersectionality at its core, considers these obstacles and adapts practices to reduce exclusion. This might include offering flexible schedules, providing free or low-cost materials, or creating alternative performance opportunities that align with students' realities.

By integrating intersectionality, educators develop a deeper understanding of trauma not just as an individual experience but as one shaped by cultural, historical, and societal forces. This aligns with trauma informed principles, such as cultural, historical, and gender sensitivity, helping educators cultivate empathy and inclusivity. In these environments, students feel safe to explore complex topics, process emotions, and express their identities without fear of being judged. This sense of safety is essential for personal growth, healing, and meaningful creative work.

A Framework for Equity-Driven Practices

Thompson and Carello's (2022) Equity Centered Trauma-Informed Care model re-envisions the trauma-informed framework as a wheel, providing a practical "how" for theatre educators to implement trauma informed practices. In this model, Cultural, Historical, and Gender Issues (Principle Six) functions as the hub of the wheel, stabilizing and connecting the other principles: safety, trustworthiness, peer support, collaboration, and empowerment. For theatre educators, this approach underscores the importance of using cultural and gender-based contexts to guide how they implement trauma informed care, ensuring that students' diverse experiences are recognized and valued.

By centering Cultural, Historical, and Gender Issues at the heart of trauma informed practices, theatre educators shift from a one-size-fits-all approach to one that is equity driven. This reflects bell hooks' (2015) idea of moving the "margin to the center," emphasizing the importance of placing marginalized experiences at the core of educational practices. For theatre educators, this means that every other trauma-informed principle, such as safety and collaboration, must be filtered through an understanding of students' unique cultural and historical contexts. This ensures that theatre classrooms become spaces where students feel seen, supported, and empowered, allowing them to fully engage in the creative process while honoring their individual identities and experiences. Ultimately, embedding intersectionality within trauma-informed theatre education transforms the classroom into a space where all students, not just those with privileged identities, can thrive.

We wholeheartedly acknowledge that this chapter cannot encompass every facet of intersectionality, as the concept is vast and ever-evolving. Our goal is not to provide a comprehensive exploration but rather to offer key insights and considerations to help you begin or continue guiding your work as a theatre educator. Intersectionality reveals the complex interplay of identity and experience, and no single approach can address every nuance. However, by engaging with the ideas presented here, we hope you will uncover new ways to foster inclusive, empathetic, and responsive spaces within your practice. Consider the following as a starting point, an invitation to reflect deeply on how intersectionality shapes your students' experiences and to further explore its influence on your teaching.

Cultural and Racial Identity

Individuals' experiences, processing, and recovery from trauma are profoundly shaped by their cultural and racial identities, with marginalized communities facing additional layers influenced by historical traumas,

systemic racism, and cultural values that affect both coping mechanisms and perceptions of trauma. In trauma-informed theatre spaces, recognizing these intersections is essential for creating environments that are inclusive, empathetic, and responsive to the diverse needs of students. Ethnoracial trauma, such as that experienced by Black, Latinx, Asian, Middle Eastern, and Indigenous communities, reveals how historical injustices and systemic discrimination continue to impact students' well-being and academic success.

When theatre educators integrate an understanding of cultural and racial identity into their practices, they create spaces where students feel safe to express their full selves without fear of judgment or exclusion (Barron & Abdallah, 2015; Chavez Dueñas et al., 2019; Daud et al., 2005; De Arellano et al., 2018; Estrada, 2009; Krieg, 2009; Phipps & Degges White, 2014; Pumariega et al., 2022; Richardson et al., 2022; Trautman et al., 2002; Wilkins et al., 2013; Yildirim, 2021). A trauma-informed theatre space that honors cultural and racial identity becomes more than a classroom. It becomes a place for reflection, personal growth, and transformation. Within this space, students can confront past traumas, build confidence in their identities, and develop the resilience needed to succeed both academically and beyond. By embracing culturally sensitive practices, theatre educators foster environments where all students, regardless of background, can find restoration, empowerment, and the freedom to express themselves creatively. In these supportive environments, students are more likely to engage fully in the creative process, explore challenging topics, and take meaningful risks in their artistic work.

Gender Identity

Gender identity and societal norms deeply influence how students experience, process, and recover from trauma. Gender-based power structures and expectations dictate whose voices are heard, whose pain is believed, and whose trauma is dismissed. Women often remain silent about their trauma, fearing victim-blaming and disbelief. Transgender students face heightened risks of discrimination, erasure, and exclusion—issues made even more acute as their rights and identities become a hot-button topic in today's educational climate. Non-binary students contend with the constant struggle of navigating a world that often refuses to recognize them. These barriers not only silence students but also exacerbate their trauma, highlighting the urgent need for trauma-informed practices that center inclusivity and gender equity.

Recognizing the impact of gender-related trauma is essential, as it can affect students' academic performance, emotional well-being, and capacity to engage fully in the creative process. For theatre educators, understanding these dynamics means adopting practices that empower students to express their identities authentically. This might involve intentional casting choices that reflect diverse gender identities or fostering open conversations about gender representation within scripts and performances. Tailoring trauma-informed support to meet the unique needs of students based on their gender identity ensures that every individual, regardless of how they identify, feels valued, included, and supported throughout their personal and artistic journeys (Abedzadeh-Kalahroudi et al., 2018; Allwood et al., 2022; Tahirih Justice Center, 2023; Valentine et al., 2023).

Socioeconomic Status

Economic hardship can bring significant trauma, often stemming from community violence, housing instability, and food insecurity. These stressors can take a heavy toll on students, leading to academic disruptions, emotional distress, and mental health challenges. For students from low-income backgrounds, these difficulties are often compounded by barriers to accessing mental health services, including high costs, limited insurance coverage, transportation difficulties, and long wait times. In trauma-informed theatre education, it is essential to recognize these socioeconomic realities to create compassionate, inclusive spaces where all students have the opportunity to thrive (Abedzadeh-Kalahroudi et al., 2018; Brattstrom et al., 2015).

When educators understand how financial challenges affect students' ability to engage fully, they can provide thoughtful, practical support that eases the burden. Theatre educators play a pivotal role by offering free materials, connecting students with community resources, and adjusting rehearsal schedules to meet students' needs, such as accommodating those who must work during traditional practice hours. These small but meaningful efforts ensure that students can participate without added stress, allowing them to focus on their creative and personal development.

Sexual Identity

LGBTQ+ individuals may experience unique trauma tied to their sexual identity, including discrimination, harassment, and family rejection. While the "coming out" process can be empowering to some, it can also be deeply

traumatic to others depending on the social environment. Bullying and harassment may make LGBTQ+ students particularly vulnerable to mental health struggles such as anxiety, depression, PTSD, and suicidal ideation. These experiences can foster isolation, stigma, and low self-worth, with barriers to disclosure further complicating access to support. The intersection of sexual identity with race, gender, and socioeconomic status adds even more complexity, with LGBTQ+ youth of color facing heightened discrimination and systemic challenges that demand culturally competent care and targeted interventions.

In trauma-informed theatre spaces, educators play a crucial role in fostering empathy, respect, and acceptance, creating environments where LGBTQ+ students feel seen, valued, and safe to express their authentic selves. Promoting inclusion requires intentional decisions around casting, script selection, and rehearsal practices to reflect and celebrate diverse identities. Through empathy-driven practices and personalized support, trauma-informed theatre education provides LGBTQ+ students with a space to explore their identities, build resilience, and experience meaningful personal and artistic growth, empowering them to thrive both on and off the stage (Kalin, 2023; Tahirih Justice Center, 2023; The Trevor Project, 2021; The Trevor Project, 2022).

Disability Identity

Individuals with disabilities may experience trauma connected to their disability status, including discrimination, bullying, medical trauma, and barriers to accessibility. These challenges can lead to emotional distress, chronic stress, and feelings of isolation, contributing to anxiety, depression, or PTSD. In trauma-informed theatre spaces, educators must prioritize accessible practices, advocate for disability rights, and provide emotional support to ensure all students feel valued and included. Addressing socioeconomic disparities is also essential, as students with disabilities often face financial hardship, limited insurance, geographic barriers, educational inequities, stigmatization, and social isolation. A comprehensive approach includes advocating for equitable access to healthcare and education, expanding affordable services, raising awareness, and offering financial assistance.

Theatre spaces offer powerful opportunities for students with disabilities to express themselves and build community. However, trauma can disrupt focus, emotional regulation, and participation, often leading to academic challenges. It can also complicate communication, making it difficult for students to advocate for the accommodations they need. Trauma-informed theatre educators must implement proactive strategies to support emotional

regulation and reduce potential triggers during rehearsals and performances. Integrating Universal Design for Learning (UDL) principles ensures that theatre spaces are adaptable, accessible, and responsive to the diverse needs of all students. By cultivating an inclusive environment, educators empower students with disabilities to navigate trauma, build resilience, and flourish both artistically and academically (Hatzikiriakidis et al., 2023; Liasidou, 2023).

Immigrant and Refugee Identity

Students from immigrant or refugee backgrounds may carry trauma rooted in displacement, family separation, and the challenges of migration. Many have fled violence or persecution, bearing the emotional weight of loss, uncertainty, and upheaval. Adjusting to new environments can be further complicated by post-migration stressors, including language barriers, discrimination, and cultural conflicts. In trauma-informed theatre spaces, it is essential for educators to approach these students with cultural responsiveness, recognizing the unique experiences that shape their needs and responses (Pumariega et al., 2022; Tahirih Justice Center, 2023).

Theatre educators can create these supportive spaces by practicing cultural humility—committing to continuous learning about diverse backgrounds and offering thoughtful, compassionate support. Theatre can serve as a powerful outlet for students to process their migration experiences, explore their identities, and cultivate a sense of belonging. This requires building inclusive environments that honor cultural values, foster psychological safety, and celebrate the resilience these students bring. By embedding trauma-informed practices into every aspect of theatre education, educators empower immigrant and refugee students to adjust, connect, and thrive, both personally and artistically, within a supportive creative community.

Religious and Spiritual Identity

Religious and spiritual beliefs play a complex role in how individuals understand, process, and cope with trauma. While spiritual communities can provide support and comfort, they may also perpetuate stigma or silence around trauma, making it harder for some students to seek help (Hollier et al., 2022; Kucharska, 2020; Milstein, 2019). For others, trauma may spark existential crises, causing them to question their faith, beliefs, and sense of purpose. This internal conflict can add emotional distress, particularly for students struggling with issues of justice, suffering, or meaning.

In trauma-informed theatre spaces, educators seek to foster environments that respect and embrace diverse spiritual perspectives, allowing students to explore their values and beliefs without fear of judgment. Recognizing the importance of spirituality in healing can provide students with a powerful source of strength, comfort, and meaning. By integrating students' beliefs into personalized support plans, educators create inclusive spaces where they can navigate trauma through self-discovery and creative expression. This thoughtful approach helps students build resilience, empowering them to engage authentically in the artistic process and thrive within a supportive community.

Healthcare and Mental Health Access

Inequities in healthcare access, shaped by race, socioeconomic status, gender, disability, and geographic location, create disparities in both the availability and quality of services. These gaps can significantly impact students' ability to manage trauma. Some students may face discrimination or language barriers in healthcare settings, while others struggle to access gender-affirming care. For students from low-income backgrounds, challenges such as long wait times, limited insurance coverage, and transportation barriers can further restrict access to essential mental health services.

In trauma-informed theatre spaces, educators must be aware of these healthcare disparities and actively advocate for culturally competent mental health resources. Recognizing and addressing students' diverse needs ensures that theatre spaces remain supportive environments where they feel empowered to care for their well-being. By promoting health-conscious practices and fostering an open, inclusive atmosphere, theatre educators can create safe spaces where students feel comfortable seeking the support they need to thrive both personally and artistically (Kalin, 2023; The Lancet, 2021; Pumariega et al., 2022).

Collective Trauma

Shared traumatic events such as natural disasters, systemic injustices, or the COVID-19 pandemic, profoundly affect communities, shaping group identity and social norms. While collective trauma brings grief, fear, and uncertainty, it can also foster resilience and solidarity. However, it is important to recognize that everyone processes collective trauma differently, which can sometimes make it more challenging to empathize with others' experiences (Ashby et al., 2022; Kalsched, 2021). As individuals cope in varied ways,

tension and misunderstanding may arise. For theatre educators, maintaining empathy requires recognizing these differences and practicing self-care to sustain the energy needed to hold space for others.

Theatre educators showed remarkable adaptability during the COVID-19 pandemic, shifting to remote teaching and advocating for the value of arts education in the face of immense challenges. These experiences underscore the resilience required to support students through collective trauma. In trauma-informed theatre spaces, educators can foster communities where students feel safe to process their experiences, express emotions, and reconnect with others (MacArthur et al., 2023; Prendergast, 2021). By practicing self-care, educators can better nurture these supportive environments, ensuring they remain places where students build resilience, discover strength, and learn through creative expression.

The Theatre Educator's Intersections and Traumas

The teaching practices of theatre educators are shaped not only by our training but also by our intersectional identities and personal traumas. Factors such as race, gender, socioeconomic background, and lived experiences influence how educators approach their work, interact with students, and manage the dynamics within the classroom. Personal trauma, whether rooted in individual experiences, family histories, or larger societal events, affects how educators regulate emotions, navigate challenges, and build relationships with students. These experiences can enrich our ability to connect with students but may also create complexities in fostering safe and supportive learning environments.

Educators who are aware of their intersectional identities often develop a heightened sense of empathy, enabling them to create inclusive spaces where students feel seen, valued, and supported. However, this awareness also requires recognizing situations that may provoke strong emotional reactions. Developing strategies to manage these moments helps educators maintain thoughtful, balanced interactions and ensures they respond intentionally rather than reactively. This mindfulness allows educators to provide a stable, nurturing environment where students can thrive.

Striving for Safety and Inclusivity

Recognizing the diverse trauma experiences students bring into theatre education is essential for creating emotionally and psychologically safe spaces. By approaching sensitive moments with care and fostering an inclusive

environment, educators can help prevent retraumatization and empower marginalized students to feel seen and supported. Tailored support such as thoughtful acting techniques and access to mental health resources, plays a crucial role in enhancing both student well-being and the overall learning process. Inclusive environments encourage deeper engagement, resulting in stronger artistic expression and academic outcomes while fostering empathetic, resilient learners.

Maintaining a balance between safety and support requires clear communication, ongoing professional development, and open dialogue with students, caregivers, and communities. Educators must also navigate situations where local laws or community standards may challenge inclusive practices, striving to create spaces where all students feel valued, respected, and supported. Later chapters will provide strategies for working with students' intersecting identities through a trauma-informed lens, offering practical tools to build learning environments that are both safe and empowering.

Once again, we acknowledge that this chapter has covered a substantial amount of complex and multifaceted information. It is important to recognize that this discussion is not exhaustive, and we have used generalizations to provide a broad overview of the topic. We also understand that we cannot possibly know everything about each of our students, nor are they obligated to disclose their experiences to us. Instead, our goal is to foster greater awareness of the diverse experiences and backgrounds students bring with them, so we can respond with empathy, care, and meaningful support.

Many students who are labeled as acting out, defiant, or troublesome are often misunderstood. It is time for a shift in how we approach these behaviors. Instead of asking, "Why is this student behaving this way?" we should ask, "What has this student experienced that has shaped their worldview and actions? How can I provide the support they need?" This shift in perspective opens the door to more compassionate and effective interactions. By responding with empathy, we foster a more inclusive, understanding, and supportive educational environment where all students have the opportunity to grow, express themselves, and succeed.

References

Abedzadeh-Kalahroudi, M., Razi, E., & Sehat, M. (2018). The relationship between socioeconomic status and trauma outcomes. *Journal of Public Health*, 40(4), 431–439.

Allwood, M., Ghafoori, B., Salgado, C., Slobodin, O., Kreither, J., Waelde, L. C., . . . & Ramos, N. (2022). Identity-based hate and violence as trauma:

Current research, clinical implications, and advocacy in a globally connected world. *Journal of Traumatic Stress*, 35(2), 349–361. https://doi.org/10.1002/jts.22748

Ashby, J. S., Rice, K. G., Kira, I. A., & Davari, J. (2022). The relationship of COVID-19 traumatic stress, cumulative trauma, and race to posttraumatic stress disorder symptoms. *Journal of Community Psychology*, 50(6), 2597–2610. https://doi.org/10.1002/jcop.22762

Barron, I. G., & Abdallah, G. (2015). Intergenerational trauma in the occupied Palestinian territories: Effects on children and promotion of healing. *Journal of Child and Adolescent Trauma*, 8(2), 103–110.

Brattstrom, O., Eriksson, M., Larsson, E., & Oldner, A. (2015). Socio-economic status and co-morbidity as risk factors for trauma. *European Journal of Epidemiology*, 30(2), 151–157.

Bryant-Davis, T. (2019). The cultural context of trauma recovery: Considering the posttraumatic stress disorder practice guideline and intersectionality. *Psychotherapy*, 56(3), 400–408. https://doi.org/10.1037/pst0000241

Chavez-Dueñas, N. Y., Adames, H. Y., Perez-Chavez, J. G., & Salas, S. P. (2019). Healing ethnoracial trauma in Latinx immigrant communities: Cultivating hope, resistance, and action. *American Psychologist*, 74(1), 49–62. https://doi.org/10.1037/amp0000289

Crenshaw, K. (2015). Why intersectionality can't wait. *The Washington Post*. https://www.washingtonpost.com/news/in-theory/wp/2015/09/24/why-intersectionality-cant-wait/

Daud, A., Skoglund, E., & Rydelius, P. A. (2005). Children in families of torture victims: Transgenerational transmission of parents' traumatic experiences to their children. *International Journal of Social Welfare*, 14(1), 23–32. https://doi.org/10.1111/j.1468-2397.2005.00336.x

De Arellano, M. A., Andrews, A. R., Reid-Quiñones, K., Vasquez, D., Doherty, L. S., Danielson, C. K., & Rheingold, A. (2018). Immigration trauma among Hispanic youth: Missed by trauma assessments and predictive of depression and PTSD symptoms. *Journal of Latina/o Psychology*, 6(3), 159–174. https://doi.org/10.1037/lat0000090

Estrada, A. L. (2009). Mexican Americans and historical trauma theory: A theoretical perspective. *Journal of Ethnicity in Substance Abuse*, 8(3), 330–340. https://doi.org/10.1080/15332640903110500

Hatzikiriakidis, K., O'Connor, A., Savaglio, M., Skouteris, H., & Green, R. (2023). The interconnectedness of disability and trauma in foster and kinship care: The importance of trauma. *International Journal of Disability, Development and Education*, 70(5), 899–910. https://doi.org/10.1080/1034912X.2021.1921126

Hollier, J., Clifton, S., & Smith-Merry, J. (2022). Mechanisms of religious trauma amongst queer people in Australia's evangelical churches. *Clinical Social Work Journal, 50*(3), 275–285. https://doi.org/10.1007/s10615-022-00839-x

hooks, b. (2015). *Feminist theory: From margin to center*. Routledge.

Kalin, N. H. (2023). Seeking new solutions addressing structural racism, childhood trauma, suicidal behaviors across sexual orientations, and postpartum depression. *The American Journal of Psychiatry, 180*(9), 625–628.

Kalsched, D. (2021). Intersections of personal vs. collective trauma during the COVID-19 pandemic: The hijacking of the human imagination. *Journal of Analytical Psychology, 66*(3), 443–462. https://doi.org/10.1111/1468-5922.12697

Krieg, A. (2009). The experience of collective trauma in Australian indigenous communities. *Australasian Psychiatry, 17*(1_suppl), S28–S32. https://doi.org/10.1080/10398560902948621

Kucharska, J. (2020). Religiosity and the psychological outcomes of trauma: A systematic review of quantitative studies. *Journal of Clinical Psychology, 76*(1), 40–58. https://doi.org/10.1002/jclp.22867

Liasidou, A. (2023). Trauma-informed disability politics: Interdisciplinary navigations and implications. *Disability and Society, 38*(4), 683–699. https://doi.org/DOI: 10.1080/09687599.2021.1946679

MacArthur, M., McLeod, K., & Mealey, S. (2023). Distance, disruption, and de-hierarchisation: Negotiating care in the virtual space of Zoom theatre. *Research in Drama Education: The Journal of Applied Theatre and Performance*, 1–19. https://doi.org/10.1080/13569783.2023.2247335

Milstein, G. (2019). Disasters, psychological traumas, and religions: Resiliencies examined. *Psychological Trauma: Theory, Research, Practice, and Policy, 11*(6), 559–562. https://doi.org/10.1037/tra0000510

Peterson, J., Sackrison, E., & Polland, A. (2015). Training students to respond to shootings on campus: Is it worth it? *Journal of Threat Assessment and Management, 2*(2), 127–138. https://doi.org/10.1037/tam0000042

Phipps, R. M., & Degges-White, S. (2014). A new look at transgenerational trauma transmission: Second-generation Latino immigrant youth. *Journal of Multicultural Counseling and Development, 42*(3), 174–187. https://doi.org/10.1002/j.2161-1912.2014.00053.x

Pumariega, A. J., Jo, Y., Beck, B., & Rahmani, M. (2022). Trauma and US minority children and youth. *Current Psychiatry Reports, 24*(4), 285–295. https://doi.org/10.1007/s11920-022-01336-1

Richardson, M., Big Eagle, T., & Waters, S. F. (2022). A systematic review of trauma intervention adaptations for indigenous caregivers and children: Insights and implications for reciprocal collaboration. *Psychological*

Trauma: Theory, Research, Practice, and Policy, 14(6), 972–982. https://doi.org/10.1037/tra0001225

Tahirih Justice Center. (2023). *Understanding intersectionality: Overlapping identities and obstacles*. Tahirih Justice Center. https://www.tahirih.org/news/understanding-intersectionality-overlapping-identities-and-obstacles/

The Lancet. (2021). Racism in the USA: Ensuring Asian American health equity. *The Lancet*, 397(10281), 1237. https://doi.org/10.1016/S0140-6736(21)00769-8

The Trevor Project. (2021). *Facts about LGBTQ youth suicide*. The Trevor Project. https://www.thetrevorproject.org/resources/article/facts-about-lgbtq-youth-suicide/

The Trevor Project. (2022). *Homelessness and housing instability among LGBTQ youth*. The Trevor Project. https://www.thetrevorproject.org/research-briefs/homelessness-and-housing-instability-among-lgbtq-youth-feb-2022/

Thompson, P., & Carello, J. (2022). *Trauma-informed pedagogies: A guide for responding to crisis and inequality in higher education* (1st ed., Vol. 1). Palgrave Macmillan.

Trautman, R., Tucker, P., Pfefferbaum, B., & Lensgraf, S. J. (2002). Effects of prior trauma and age on posttraumatic stress symptoms in Asian and Middle Eastern immigrants after terrorism in the community. *Community Mental Health Journal*, 38(6), 459–474. https://doi.org/DOI:10.1023/A:1020828117698

Valentine, S. E., Smith, A. M., Miller, K., Hadden, L., & Shipherd, J. C. (2023). Considerations and complexities of accurate PTSD assessment among transgender and gender diverse adults. *Psychological Assessment*, 35(5), 383–395. https://doi.org/10.1037/pas0001215

Voith, L. A., Hamler, T., Francis, M. W., Lee, H., & Korsch-Williams, A. (2020). Using a trauma-informed, socially just research framework with marginalized populations: Practices and barriers to implementation. *Social Work Research*, 44(3).

Wilkins, E. J., Whiting, J. B., Watson, M. F., Russon, J. M., & Moncrief, A. M. (2013). Residual effects of slavery: What clinicians need to know. *Contemporary Family Therapy*, 35(1), 14–28. https://doi.org/10.1007/s10591-012-9219-1

Yıldırım, U. (2021). Spaced-out states: Decolonizing trauma in a war-torn middle eastern city. *Current Anthropology*, 62(6), 717–740. https://doi.org/10.1086/718206

4

Intimacy Direction, Consent, and Boundaries

Consent, boundaries, and theatrical intimacy are essential components of 9–12 grade theatre, especially when applied through trauma-informed practices. Theatre educators play a crucial role in creating safe and supportive spaces by prioritizing these principles. Trauma-informed education emphasizes being mindful of students' past experiences and emotional well-being, making it critical to set clear boundaries and obtain explicit consent. This chapter also explores the complexities of theatrical intimacy, highlighting the importance of thoughtful preparation when working through scenes that could evoke strong emotions or trigger trauma responses. These conversations not only help students feel supported throughout productions but also offer meaningful opportunities to apply classroom learning in real-world situations. Addressing these topics early in students' theatre education builds a foundation for more advanced discussions on trauma-informed practices in later chapters. While this chapter provides important guidance, the authors acknowledge that it is not exhaustive and recommend further training to help educators develop the expertise needed to navigate these areas effectively.

Overview of Intimacy Direction and Its Importance

Theatrical intimacy direction is a relatively new practice in professional theatre, rapidly becoming a standard approach (Kamminga-Peck, 2020). It prioritizes the emotional, mental, and physical well-being of actors by establishing clear boundaries and fostering trust in collaborative storytelling

(Shawyer & Shively, 2019). Intimacy direction involves moments requiring vulnerability, which can range from physical contact, such as handshakes or simulated sexual acts, to scenes with no direct interaction. It also includes situations where performers engage in self-directed actions that suggest exposure or sexuality, as well as instances where they appear nude, semi-nude, or scantily clad, regardless of whether they interact physically with others. By choreographing these moments with specific, repeatable actions, intimacy directors ensure actors feel safe and supported. Their work helps distinguish personal boundaries from the demands of the character, promoting trust, comfort, and a deeper artistic understanding throughout the production process (Daugherty, Hertzberg, & Wagner, 2020).

In the field of intimacy work, the terms intimacy professional, intimacy choreographer, intimacy director, and intimacy coordinator are often used interchangeably, but they carry distinct meanings that reflect the specific medium and scope of the work. An intimacy professional serves as an umbrella term that can be applied across various areas of the arts, encompassing roles that address the staging of intimate scenes and prioritize actor safety and consent. Within this broader category, an intimacy director works specifically in live performance settings like theatre, dance, and opera, while an intimacy coordinator is employed in recorded media such as film and television (Intimacy Directors and Coordinators, 2024). These titles mirror the distinctions seen in choreographed violence, where fight directors are utilized for live performance and stunt coordinators for recorded media.

Both intimacy directors and coordinators act as choreographers, advocates for actors, and liaisons between the performers and the production team (Intimacy Directors and Coordinators, 2024). Movement specialists, like Nicole Perry of Momentum Stage, employ the term intimacy choreographer due to their expertise in body movement and choreography. This title is sometimes favored in dance and movement-based mediums, highlighting the professional's specialized skills in shaping the physical aspects of intimate scenes (Perry, n.d.).

While intimacy direction shares origins with stage combat, it expands beyond physical boundaries to address emotional well-being. Leaders in the field, such as Tonia Sina, Siobhan Richardson, and Chelsea Pace, developed practices grounded in psychology, dance, yoga, movement, self-care, and trauma-informed education. Movements like #MeToo further highlight the need for such practices by addressing power imbalances and ensuring actors' autonomy (Jones, 2019).

Tonia Sina introduced intimacy direction in her 2006 MFA thesis and later co-founded Intimacy Directors International (IDI) in 2016 with Alicia Rodis and Siobhan Richardson, promoting "The Pillars of Intimacy"

(Intimacy Directors International, 2016). IDI later evolved into Intimacy Directors and Coordinators in 2020, offering training and certification. Around the same time, Chelsea Pace published *Staging Sex* (2020), the first book dedicated to best practices in theatrical intimacy and co-founded Theatrical Intimacy Education (TIE) with Laura Rickard.

The field has also grown to address unique challenges. Kaja Dunn applied critical race theory to intimacy choreography, highlighting the experiences of performers of color, while Ann C. James created Intimacy Directors of Color to improve training access to artists of color while centering identity in the rehearsal process (Fairfield et al., 2019; Villarreal, 2022).

In educational theatre, intimacy direction is essential for working with minors, who have distinct needs from adult actors (Shively, 2022). Integrating consent-based practices in 9–12 grade theatre ensures educators can provide safe, practical training for students. These practices foster trust, respect, and creative freedom, supporting young actors' development in productions and classes.

Intimacy and Minors

Working with minors in theatrical intimacy within an educational setting requires a thoughtful, well-rounded approach that prioritizes ethics, legal compliance, and the well-being of young performers. Educators and theatre professionals must follow strict guidelines to create a safe environment where students can explore their craft while ensuring their dignity and rights are fully respected.

A key consideration is selecting age-appropriate content. Directors and educators must carefully assess scripts and scenes to ensure they align with the emotional maturity and developmental readiness of their students. This involves evaluating themes, language, and subject matter to avoid exposing young performers to material that may be emotionally distressing or inappropriate. When content matches the students' readiness, it creates a positive environment for artistic growth, allowing young actors to engage with their roles confidently and without undue stress.

Another essential aspect is obtaining informed consent. Since minors cannot legally provide consent, caregivers must approve their involvement in any scenes involving intimacy. Open, transparent communication with caregivers ensures they fully understand the nature of these scenes and any potential emotional impact. This process fosters trust within the theatre community, supports ethical transparency, and safeguards young performers. Additionally, securing informed consent protects directors, educators, and

production teams by ensuring compliance with legal requirements and mitigating potential risks.

The design of sensitive choreography is equally important. Choreographers must carefully plan movements that prioritize the performers' physical and emotional safety while maintaining the artistic integrity of the production. This means minimizing physical contact, considering the emotional impact of movements, and ensuring all choreography aligns with the comfort levels of the young actors. Sensitive choreography empowers students to fully engage with their roles in a secure environment, fostering both artistic expression and emotional well-being. Beyond physical movements, it also ensures the portrayal of mature themes is handled in ways that respect the developmental stage of the performers, creating a respectful and inclusive experience for everyone involved.

Maintaining accurate documentation is crucial for transparency and accountability. Keeping detailed records—such as consent forms, rehearsal logs, and performance notes—ensures compliance with ethical standards and provides clarity in the event of disputes. Thorough documentation promotes effective communication among all stakeholders, including caregivers, educators, performers, and production staff. It also serves as a valuable resource for improving protocols in future productions, reinforcing the professionalism expected in educational theatre settings.

Finally, educators must remain aware of state laws, local regulations, and community norms related to minors in theatrical settings. These laws can vary widely and may change over time, making it essential for theatre professionals to stay informed. Adherence to legal and cultural standards is not only a legal obligation but also a fundamental part of protecting young actors. Being attuned to evolving community expectations ensures that theatre productions remain safe, inclusive, and respectful. Educators who prioritize legal compliance and align with community values foster trust among students, parents, and the broader community, enriching the educational and artistic experience (Chrismon & Marlin-Hess, 2023).

What If You Can't Hire an Intimacy Director?

Most theatre educators recognize the importance of hiring or enlisting the services of a trained stage combat professional to support their work with fight choreography, understanding the safety, expertise, and specialized skills required. Intimacy should be treated with the same level of care and respect. While fight choreography and intimacy choreography are often considered related disciplines due to their focus on staging physical interactions

safely, they are distinct skill sets requiring specialized training and expertise. Although some artists may be trained in both areas, it should not be assumed that a fight choreographer can effectively manage intimacy scenes, or vice versa, without specific training. Productions typically employ separate specialists for each role to meet the unique needs of the scenes, ensuring a high level of safety and professionalism tailored to the context of the performance (Intimacy Directors and Coordinators, 2024).

While hiring a professional intimacy director is the industry standard in professional theatre to ensure actor safety during intimate scenes, budget constraints or administrative limitations may make this challenging for some school theatre programs (Mackie-Stephenson, 2021). If hiring an intimacy director is not feasible, theatre educators can still prioritize student safety by consulting with professionals on an as-needed basis for guidance and support and by incorporating key strategies into their classes and productions.

Pursuing training or professional development in theatrical intimacy direction equips theatre educators with essential tools such as communication techniques, consent-based practices, and boundary-setting strategies to foster safe and ethical spaces for students. Staying current with best practices through books, online courses, and industry updates further enhances their ability to provide a supportive learning environment. Theatre educators can benefit from mental health first aid training, which equips them to recognize and respond to student mental health challenges, offering initial support and guiding students to appropriate resources. This training enhances their ability to create a supportive and empathetic environment in the classroom and productions. The tools and strategies outlined in the remainder of this chapter offer practical ways for theatre educators to cultivate safe, creative spaces where student well-being is always the top priority.

Three Principles of Intimacy Direction: Communication, Consent, and Boundaries

In theatre education, communication, consent, and boundaries form the essential framework for intimacy direction, fostering an environment grounded in trust, respect, and safety. These principles empower young performers to engage with intimate scenes confidently and authentically, enriching storytelling while supporting their emotional growth. In trauma-informed theatre spaces, intimacy direction plays a crucial role by recognizing the emotional and physical well-being of students, ensuring that all interactions are safe, intentional, and respectful of individual boundaries. Prioritizing these

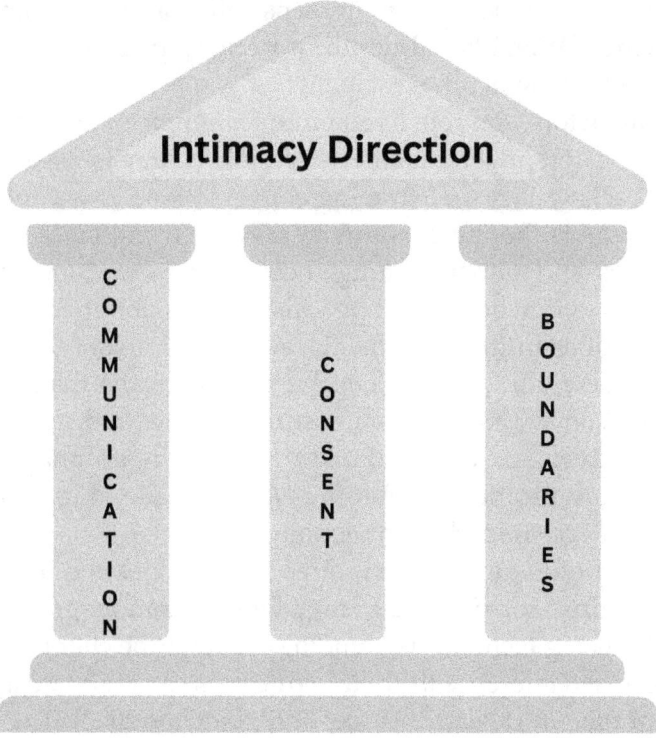

Figure 4.1 The Three Pillars of Intimacy Direction

pillars, as seen in Figure 4.1, not only enhances the artistic process but also promotes collaboration between students, educators, and intimacy coordinators, creating a space where performers can explore their craft without fear of harm or discomfort. By integrating intimacy direction into theatre education, programs can align with trauma-informed practices, providing young actors with the tools to navigate challenging material while maintaining their personal well-being and artistic integrity.

The Role of Communication in Intimacy Direction

Communication is the pillar that supports every aspect of intimacy direction, ensuring trust, safety, and collaboration throughout the creative process. Open, honest, and continuous dialogue between actors, theatre educators, and directors ensures that consent is freely given, boundaries are understood, and any concerns are promptly addressed. This ongoing exchange empowers performers to voice their needs and limits without fear of judgment or

pressure. Clear communication strengthens collaboration within the creative team, enhancing the emotional depth of performances while safeguarding the personal well-being of all participants.

With young actors, the role of communication becomes even more critical. Theatre educators must establish accessible channels for dialogue, using age-appropriate language and framing conversations in ways that are comfortable for students. Young performers may need guidance in articulating their boundaries and understanding their right to say "no" at any point during the process. Encouraging open discussions about scenes and choreography demystifies intimate moments, alleviating anxiety, and creating an environment where students can engage fully with the material. Transparent communication with caregivers ensures parents and guardians remain informed and involved, further building trust. In trauma-informed theatre spaces, communication reinforces autonomy, allowing young actors to explore their roles confidently and securely.

A central technique in intimacy direction involves the use of desexualized, depersonalized, or deloaded language—a strategy grounded in communication. By using technical terminology to describe character actions and anatomical terms to reference the body, educators can maintain a professional and respectful tone in rehearsal (Pace, 2020; Barclay, 2022). This approach is particularly important in 9–12 grade theatre, where scenes may involve intimate relationships, physical contact, or kissing. Clear, neutral language helps maintain a safe atmosphere and ensures students and educators alike remain mindful of the words they use.

The Role of Consent in Intimacy Direction

In trauma-informed theatre spaces, consent is not a one-time agreement but an ongoing, flexible process that empowers young actors to maintain control over their physical, emotional, and mental well-being. It allows students to decide if, when, and how they participate in scenes involving physical contact, intimacy, or emotional vulnerability. Consent in this context extends beyond mere compliance—it requires enthusiastic, informed participation, where students fully understand what they are agreeing to and feel free to decline or modify their involvement at any point, without fear of repercussion.

Theatre educators play a crucial role in helping students understand that consent is reversible, specific, and continuous. For example, agreeing to hold hands in one scene does not imply permission to do so in future scenes or rehearsals. This practice encourages students to regularly reflect on their

comfort levels and communicate any changes that arise. In trauma-informed spaces, educators must emphasize that students have the right to adjust or withdraw consent at any moment—whether mid-rehearsal or after further reflection—ensuring their well-being remains the top priority throughout the creative process.

Consent-based practices also establish clear boundaries within student-teacher relationships, reducing the risk of boundary violations and misconduct. When educators actively seek input from students and respect their limits, they foster an atmosphere of trust that promotes safe and meaningful artistic exploration. This support encourages students to fully engage in the creative process, knowing their autonomy will be honored and protected at all times.

The CRISP framework—Considered, Reversible, Informed, Specific, and Participatory consent—provides a comprehensive approach to navigating consent within theatrical intimacy (Intimacy Directors and Coordinators, 2022). This model, shown in Figure 4.2, addresses the unique challenges of performance environments, especially in managing power dynamics. "Considered" focuses on allowing students ample time and information to thoughtfully evaluate their decisions, ensuring they are not pressured into

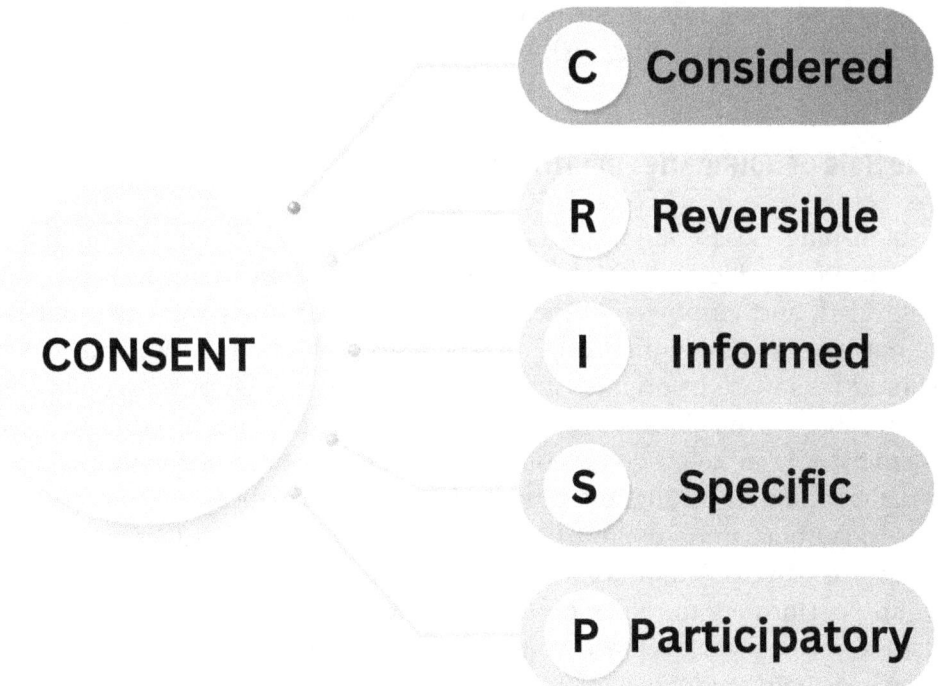

Figure 4.2 Intimacy Directors and Coordinators' CRISP Model of Consent

participation. "Reversible" reinforces that consent can be withdrawn at any time, validating each individual's autonomy over their choices. "Informed" emphasizes the importance of transparency, ensuring students understand all relevant details before consenting to participate. "Specific" underscores that consent is given only for particular actions, preventing assumptions about boundaries. Finally, "Participatory" advocates for students to be active decision-makers regarding their bodies, empowering them to assert their boundaries and actively shape the creative approach to intimate scenes (Intimacy Directors and Coordinators, 2022; Shively, 2022).

These consent-based practices foster a student-centered environment where young performers can explore and develop personal boundaries while applying acting techniques tailored to their individual comfort levels. By prioritizing autonomy and safety, this approach not only enriches the creative process but also ensures a safer and more inclusive theatre space where every student feels respected and supported.

Teaching consent also equips young performers with essential life skills, including the ability to communicate needs, set boundaries, and make empowered decisions. These skills extend far beyond the stage, helping students navigate personal relationships and professional environments with confidence and self-awareness (Schreyer, 2023; Shively, 2022; St. John, 2022; Venet, 2019). A trauma-informed approach to consent ensures that students are not only free to explore their creative potential but also supported in maintaining their personal well-being at all times.

The Role of Boundaries in Intimacy Direction

Establishing clear boundaries is essential to fostering a culture of consent that promotes the well-being of young actors. When performers feel safe, respected, and empowered, they can engage with their roles without fear of harm or emotional distress. Conversations about boundaries and consent should take place in private, supportive settings that emphasize open communication, active listening, and respectful dialogue. Theatre educators play a crucial role in helping students identify, express, and negotiate their personal boundaries throughout rehearsals and performances.

To support students in articulating their boundaries, educators can use structured discussions and role-playing scenarios. These exercises encourage young performers to reflect on their physical and emotional comfort levels across various performance contexts. Low-stakes activities and "what-if" scenarios help students explore situations that may challenge their comfort

zones, making it easier for them to express their limits with confidence. A shared vocabulary—such as using "green light," "yellow light," and "red light" to describe levels of comfort—further ensures that students can communicate their needs clearly throughout the creative process.

Since comfort levels naturally evolve over time, especially as students grow, build trust with peers, or encounter emotionally challenging material, ongoing conversations about boundaries are necessary. Regular "check-ins" at the start of rehearsals provide students with the opportunity to express their needs and adjust boundaries as required. Implementing self-care cues such as "button," "hold," "pause," or "stop" gives students the agency to advocate for their safety and well-being. When a student uses a self-care cue, educators should respond with empathy and curiosity, asking about the student's needs without pressuring for details. The student can then suggest an alternative action that respects their boundaries, fostering a collaborative and While clear boundaries are essential, they can become blurred when the line between an actor and the character they portray begins to fade, affecting both on-stage and off-stage lives. Boundary blurring can arise from both inside-out methods, which emphasize emotional recall, and outside-in approaches, which rely on physical embodiment. Without strategies to manage this phenomenon, actors may lose control during performances or inadvertently carry character traits into their personal lives. Theatre educators can help students manage boundary blurring by introducing practices such as grounding in everyday activities, mask work, referring to characters in the third person, and listing character likes and dislikes (Burgoyne, Poulin, & Rearden, 1999). These techniques allow students to maintain a healthy distinction between their personal identities and the characters they play, preserving their emotional and mental well-being.

In addition to managing boundary blurring, theatre educators must address the potential for showmances—romantic relationships between cast and crew members. Consent-based practices are essential for mitigating these risks. Open and respectful communication about intentions and boundaries helps prevent misunderstandings that could lead to showmances. Teaching boundaries and self-care cues equips students to navigate complex emotional situations and consider the potential consequences of romantic involvement within the production (Saslove et al., 2022).

It is essential for theatre educators to emphasize that boundaries are non-negotiable and that saying "no" will always be respected. However, if a boundary is crossed after it has been clearly established, addressing the situation promptly and thoughtfully is crucial to restoring trust and maintaining a safe environment. This approach applies to boundary violations between

students, as well as between students and educators; educators should intervene if they observe any breaches between students to ensure that boundaries are upheld. In these cases, educators should openly acknowledge the mistake with all parties involved, reaffirm the boundary, and collaborate with the individuals involved to determine the best path forward. This approach demonstrates accountability and reinforces a commitment to respecting personal limits. To further repair trust, educators can employ a four-part apology—a structured approach to show sincerity and responsibility when addressing boundary violations.

The Four-Part Apology

A four-part apology can be particularly effective in helping students navigate boundary crossings: first, acknowledge the mistake; second, apologize sincerely; third, express gratitude for the boundary being highlighted; and fourth, discuss a path forward (Pace, 2020). This approach demonstrates accountability and validates the person whose boundary was crossed, reinforcing the significance of clear boundaries and mutual respect. Importantly, the student whose boundary was crossed can initiate this process if the educator does not witness the violation, using a self-care cue or other agreed-upon signal to communicate the need to address the situation. This empowers students to advocate for their own boundaries and ensures that boundary crossings are recognized and addressed, even when not immediately observed by educators.

For example, when an educator observes one student touching another student's thigh despite an agreement that choreography would involve only holding hands, this situation presents an opportunity to teach the four-part apology. The educator pauses the rehearsal to address the issue in a way that models accountability and respect. Here is how an educator might guide students through the four-part apology process in this context:

- **Acknowledge the Mistake:** The educator can start by helping the student who crossed the boundary to understand the importance of acknowledging the action. The educator might say, "Let's begin by recognizing what happened. In this case, the choreography agreement was to hold hands only, but a different type of contact occurred. Am I correct in saying that?"
- **Offer a Sincere Apology:** The educator can then guide the student who crossed the boundary to offer a genuine apology. For example,

the educator might prompt, "Now that we have acknowledged the action, it is important to apologize sincerely. Can you apologize to your partner in a way that shows you understand how this might have impacted them?"
- **Express Gratitude for the Boundary:** The educator can encourage the student to thank their scene partner for setting the boundary and being open about it, reinforcing respect for boundaries. The educator could explain, "Expressing gratitude is recognizing that boundaries help everyone feel safe and respected. You might say something like, 'Thank you for reminding me of our agreement and for setting a clear boundary.'"
- **Discuss a Path Forward:** Finally, the educator can guide both students in discussing how they will proceed. This might involve reaffirming the choreography or establishing additional reminders if needed. The educator might ask, "How can we ensure this agreement is honored moving forward? What steps could we take to ensure this boundary is fully respected?"

By guiding students through a four-part apology, theatre educators model accountability and demonstrate how to address boundary crossings respectfully, fostering a culture of trust, respect, and open communication within the theatre space. This approach helps repair relational harm and reinforces that while mistakes are a natural part of learning, accountability is essential. Through this structured apology as shown in Figure 4.3, educators set a standard for navigating and learning from boundary crossings, allowing all parties to move forward with a clearer understanding of each other's needs (Vallade, 2020).

A Note on Instructional Touch

Instructional Touch refers to any physical contact initiated by an educator to guide or correct a student's movement, posture, or positioning. In theatre education, this type of touch was traditionally used to demonstrate alignment, body positioning, or subtle movement adjustments, particularly in activities requiring precise physical expression, such as stage combat, dance, or specific blocking on stage. For instance, an educator might adjust a student's arm during a dance routine, guide head positioning for sightlines, or help stabilize stance in a combat scene. While these actions were typically intended to improve technique, we now advocate for avoiding instructional

Figure 4.3 The Four-Part Apology

touch altogether, prioritizing students' personal boundaries and comfort through trauma-informed practices. We recommend the use of verbal instructions, visual demonstrations, mirrors, and peer feedback to achieve similar results without physical contact.

It is important to distinguish instructional touch from contact in emergency situations, where immediate action may be necessary to prevent or reduce injury, in line with safety protocols. In such cases, all involved parties should act promptly to mitigate risk, with follow-up discussions about the use of touch as necessary.

Consent-based practices require consistent reinforcement to become deeply ingrained in students' work. When theatre educators fully integrate these practices into the classroom and rehearsal culture, young artists learn to prioritize their well-being, maintain self-respect, and uphold their boundaries both on and off the stage. This not only strengthens their ability to navigate emotional challenges but also ensures that theatre remains a space where creativity, safety, and mutual respect thrive (Chrismon & Marlin-Hess, 2023).

References

Barclay, K. (2022). Impersonal intimacies: Reflections on desexualized language in intimacy choreography. *The Journal of Consent-Based Performance*, Spring, 24–34.

Burgoyne, S., Poulin, K., & Rearden, A. (1999). The impact of acting on student actors: Boundary blurring, growth, and emotional distress. *Theatre Topics*, 9(2), 157–179. https://doi.org/10.1353/tt.1999.0011

Chrismon, J., & Marlin-Hess, M. (2023). Intimacy direction best practices for school theatre. *Drama Research*, 14(1).

Daugherty, E. D., Hertzberg, D., & Wagner, D. (2020). Offstage intimacy: Best practices for navigating the intimacy of costuming. *Theatre Topics*, 30(3), 211–216. https://doi.org/10.1353/tt.2020.0039

Fairfield, J. B., Sina, T., Rikard, L., & Dunn, K. (2019). Intimacy choreography and cultural change: An interview with leaders in the field. *Journal of Dramatic Theory and Criticism*, 34(1), 77–85. https://doi.org/10.1353/dtc.2019.0024

Intimacy Directors and Coordinators. (2022). *Intimacy directors and coordinators*. https://www.idcprofessionals.com/

Intimacy Directors and Coordinators. (2024). *What is an intimacy director or coordinator?* https://www.idcprofessionals.com/blog/what-is-an-intimacy-director-or-coordinator

Intimacy Directors International. (2016). *The pillars*. https://docs.wixstatic.com/ugd/924101_2e8c624bcf394166bc0443c1f35efe1d.pdf

Jones, S.A. (2019). An intimacy choreography for sexual justice: Considering racism and ableism as forms of sexual violence. *Journal of Dramatic Theory and Criticism*, 34(1), 143–161. https://doi.org/10.1353/dtc.2019.0028

Kamminga-Peck, H. (2020). Make it less weird: Theatrical intimacy education and how a fence can lead to intimacy. *Theatre Topics*, 30(3), 203–209. https://doi.org/10.1353/tt.2020.0038

Mackie-Stephenson, A. (2021). Virtual intimacy directing: Building best practices for safety and consent. *Theatre Topics*, 31(3), 265–268. https://doi.org/10.1353/tt.2021.0049

Pace, C. (2020). *Staging Sex: Best practices, tools, and techniques for theatrical intimacy* (1st ed.). Routledge.

Perry, N. (n.d.). *Why hire an intimacy coordinator*. Nicole Perry. https://nicoleperry.org/why-hire-an-intimacy-choreographer

Saslove, J., Gormezano, A. M., Schudson, Z. C., & Van Anders, S. M. (2022). "Showmance": Is performing intimacy associated with feelings of intimacy? *The Canadian Journal of Human Sexuality*, 31(3), 329–341. https://doi.org/10.3138/cjhs.2021-0066

Schreyer, S. R. (2023). Promoting psychophysiological play: Applying principles of polyvagal theory in the rehearsal room. *Journal of Consent-Based Performance*, 2(1).

Shawyer, S., & Shively, K. (2019). Education in theatrical intimacy as ethical practice for university theatre. *Journal of Dramatic Theory and Criticism*, 34(1), 87–104. https://doi.org/10.1353/dtc.2019.0025

Shively, K. (2022). Using principles of theatrical intimacy to shape consent-based spaces for minors. *Journal of Consent-Based Practice*, Spring, 74–80.

Sina, T. (2014). Safe sex: A look at the intimacy choreographer. *Fight Master: Journal of the Society of American Fight Directors*, 36(1), 12–15.

St. John, A. (2022). Thought bubble theatre festival: Applying and developing consent-based practices with pre-professional actors. *Journal of Consent-Based Performance*, 1(2), 111–136. https://doi.org/10.46787/jcbp.v1i2.2872

Venet, A. S. (2019). Role-clarity and boundaries for trauma-informed teachers. *Educational Considerations*, 44(2). https://doi.org/10.4148/0146-9282.2175

Villarreal, A. (2022). The evolution of consent-based performance: A literature review. *Journal of Consent-Based Performance*, Spring, 5–25.

Part 2

In Practice

While directing productions is a key responsibility of theatre educators, the essence of this role lies in fostering meaningful learning experiences. Theatre education goes beyond staging performances; it creates a space where students can grow emotionally, socially, and artistically. This focus on education is essential, as it underscores the importance of trauma-informed practices within the learning environment. Whether in the classroom or during production, theatre spaces must prioritize the well-being of students, ensuring they feel safe, supported, and valued. Part two reminds us that creating inclusive and nurturing spaces is not just beneficial but essential for student success, both on stage and in life.

As theatre educators, it is essential to be knowledgeable about the laws, rules, policies, and procedures specific to our unique environments. These guidelines are established to uphold safety, ethical standards, and best practices within our programs. While trauma-informed practices are designed to align with these standards, if any recommended technique in this text conflicts with local regulations or institutional rules, prioritize compliance with those guidelines and explore ways to incorporate the underlying principles of trauma-informed care in a manner that adheres to these requirements.

Implementing trauma-informed practices in 9–12 grade theatre settings is critical, especially for students carrying the burden of trauma. Theatre educators must recognize that attending to students' emotional and psychological needs not only supports their personal well-being but also unlocks their creative potential. Drawing on the six core principles outlined by the Substance

Abuse and Mental Health Services Administration (SAMHSA), this approach offers a framework for developing both classroom and production environments that respond to students' unique needs.

Trauma-informed practices equip theatre educators with teaching, directing, and rehearsal techniques that foster emotional safety and growth. While these practices enhance artistic quality, they also prioritize well-being, empowering students to explore difficult themes without fear of emotional harm. Although embracing trauma-informed care can seem overwhelming at first, progress is a gradual journey. Each chapter in this book provides practical strategies for incorporating trauma-informed principles across various stages—whether in the classroom, during pre-production planning, in rehearsals, or throughout performances and post-production. We encourage educators to begin by identifying areas where their existing practices align with these principles and to integrate new strategies incrementally, focusing on steady, intentional growth.

A key principle to understand is that trauma-informed practices are not about shielding individuals from difficult topics or overprotecting them. Rather, these practices focus on creating an environment where challenging material can be explored in a way that is both safe and empowering. Theatre educators are not therapists, but they play a vital role in fostering spaces where students can engage with complex themes productively. Trauma-informed theatre spaces are designed to encourage both emotional resilience and artistic growth by integrating thoughtful exploration with a foundation of care and respect.

The Power of Intentionality

At the heart of trauma-informed theatre education is intentionality—making deliberate choices at every stage of the creative process, from conception to performance. Intentionality ensures that every element of a theatre production promotes emotional safety and well-being. This extends beyond artistic vision to encompass thoughtful decisions about content, staging, and communication, minimizing triggers and supporting participants' mental health.

Intentionality serves multiple purposes in trauma-informed theatre spaces.

- ◆ **Promoting a Safe Environment:** Every decision should ensure participants feel secure and valued, with emotional well-being respected throughout the process.

- **Minimizing Harm:** Thoughtfully weigh the benefits of engaging with difficult content against potential risks, using strategies to reduce adverse effects and prioritize students' mental health.
- **Establishing Trust:** Build trust through clear communication, fostering a collaborative environment where students feel heard, respected, and empowered to contribute fully.
- **Being Adaptable:** Stay open to modifying schedules, content, or support systems to meet the evolving needs of students, ensuring the program remains responsive and inclusive.
- **Modeling Healthy Practices:** Lead by example by prioritizing self-care and boundary-setting, demonstrating the importance of wellness to students and creating a culture of balance.
- **Having a Long-Term Impact:** Equip students with resilience, empathy, and self-awareness, providing them with the tools to navigate challenges in theatre and beyond, contributing meaningfully to their communities.

By weaving intentionality into teaching, directing, and community involvement, theatre educators create safe spaces where students can explore complex themes while building essential life skills, such as empathy, self-reflection, and emotional resilience.

The Importance of Relationships

Building strong, trusting relationships is fundamental to trauma-informed theatre education. The four R's—Realization, Recognition, Response, and Resistance to Re-traumatization—together with SAMHSA's six core principles, guide theatre educators in cultivating meaningful connections with students, caregivers, administrators, and community members. These relationships form the foundation of a supportive environment where all participants feel understood and valued.

Engaging caregivers and administrators ensures that theatre programs align with broader educational goals and receive essential support. Understanding students' diverse backgrounds allows educators to tailor their approaches, creating experiences that resonate with students and deepen their engagement in the creative process. Building strong connections with the wider community fosters a sense of shared purpose, strengthens program participation, and reinforces the idea that theatre is an essential component of education and civic life.

Self-Care and Wellness

Throughout this book, you will encounter reminders to prioritize your own well-being. Teaching, directing, and managing productions demand significant emotional and physical energy, making self-care vital for sustaining a long and fulfilling career. Each chapter offers practical self-care strategies tailored to the specific challenges theatre educators face. These practices not only support personal well-being but also model healthy behaviors for students, promoting a culture of resilience and balance within the theatre space.

Theatre educators hold a unique position of influence, shaping students' artistic journeys and personal growth. By embracing trauma-informed practices, fostering intentional relationships, and prioritizing self-care, educators create environments where students can thrive creatively and emotionally. As you progress through this book, consider how each strategy can enhance your evolving practice, enabling you to lead with passion, empathy, and resilience. Through this work, you will inspire students not only to excel artistically but also to develop the emotional tools they need to navigate life's challenges with confidence and compassion.

5
Pre-Production Processes

We now shift our focus to exploring the integration of trauma informed practices across every stage of the theatrical process, spanning preproduction, production, and postproduction. Each phase presents unique opportunities to foster emotional safety, empathy, and personal growth for students. We will examine how intentional planning, communication, and collaboration can align every step, from script selection to final performances, with trauma informed principles.

The pre-production phase in theatre education is more than an administrative task; it serves as the foundation for the entire creative journey. It sets the tone for what follows, creating opportunities to engage students meaningfully, promote collaboration, and establish a safe, supportive environment. In trauma informed theatre education, this phase is particularly critical, as every decision, from selecting a script to preparing for auditions, must reflect a commitment to emotional well-being, intentionality, and cultural responsiveness. This chapter explores how educators can adapt traditional preproduction practices to build a trauma informed environment that prioritizes wellness, fosters trust, and nurtures both artistic and personal development.

To examine the pre-production phase in depth, we will break it down into key components, demonstrating how trauma-informed practices can be woven into each step of the process. This framework will guide our exploration, showing how intentional strategies can be applied at every stage to create a supportive and inclusive environment.

Typical Pre-Production Preparation Process:

1. **Script Selection:** The script is chosen based on multiple considerations, such as educational goals, thematic relevance, and the needs of the students.
2. **Production Planning:** The director and production team develop the schedule, design concepts, and logistical framework for the production.
3. **Audition Preparation:** Students prepare monologues or scenes to demonstrate their abilities during auditions.
4. **Auditions:** Students perform their prepared pieces, highlighting their skills and suitability for various roles.
5. **Casting:** The production team selects the actors for each role based on audition performances and overall production needs.

Script Selection

The first step in the creative process is selecting the script, and this choice must be guided by a clear purpose. It involves more than simply choosing a piece to perform; it is an intentional decision to align the production with the principles of trauma-informed education. This requires a thoughtful examination of the script's themes and content, with careful attention to how they may impact students and the broader community. The selection process balances the potential benefits of exploring complex or sensitive topics with the need to maintain emotional safety, ensuring the production fosters growth without causing harm.

The selection of a production carries profound implications that extend beyond the stage. It demands consideration of the show's impact from an educational and community-building perspective, not a therapeutic one. While theatre educators are not therapists, it is important to recognize that theatre can have therapeutic benefits for students. Research shows that participation in theatre activities can enhance self-esteem and reduce anxiety and depression symptoms. However, the healing power lies in the art itself, not in an attempt to use theatre as therapy (Chrismon & Carter, 2023; Venet, 2019). Asking "Why this show? Why now?" enables educators to make intentional choices that align with educational and community goals, rather than seeking therapeutic outcomes (Lazarus, 2005). In this way, theatre serves as a vehicle for both education and engagement with the community.

Selecting productions in a trauma-informed way does not require knowing individual students' trauma histories; rather, it requires understanding that trauma exists and may affect students, even if it is never disclosed

(as discussed in Chapter 1). The goal is to approach the selection process with an awareness that some students may carry unseen emotional burdens. While collaboration with school counselors, mental health professionals, administrators, and caregivers can offer valuable perspectives, the focus remains on creating a production that fosters emotional safety for all participants. Productions should reflect diverse perspectives, ensuring representation, while being mindful to mitigate potentially triggering content. This involves approaching sensitive material thoughtfully, using strategies such as content disclosures, open discussions, and creative adaptations to reduce the risk of distress. By addressing challenging topics with care, productions can foster emotional safety without compromising meaningful storytelling or representation.

It is essential for theatre educators to understand the role triggers can play in shaping the emotional experiences of students and audiences. Triggers are specific elements in a production, such as themes, dialogue, sounds, or visual cues, that can evoke strong emotional or physical reactions, often connected to personal trauma or challenging life experiences (Bryce et al., 2022; Cless & Goff, 2017; Lainson, 2019; Renken et al., 2023). These reactions may present as intense emotions, anxiety, or physical discomfort. Recognizing triggers provides a lens of empathy, shifting the focus from avoiding potential issues to acknowledging that emotional activation may occur. While it is impossible to predict every trigger, being mindful of their potential impact is essential to creating a trauma informed environment.

Educators can use the pre-production process to identify sensitive elements in scripts, provide content disclosures, and facilitate open conversations with students, caregivers, and production teams before auditions begin. This trauma-informed approach enables educators to engage thoughtfully with complex material, fostering a supportive environment where students feel safe, respected, and empowered to explore challenging content with confidence and care. By mitigating foreseeable triggers and understanding that unexpected ones may arise, theatre educators cultivate a compassionate space that aligns with trauma-informed principles, supporting both the artistic process and the emotional well-being of all involved.

Preparing Audiences for Potentially Traumatic Themes

Caring for your audience begins in the pre-production phase and should be an integral part of the overall proposal. From the earliest stages, it is important to plan for how you will communicate potentially traumatic themes in a way that ensures a safe and informed experience for all. This preparation

includes developing content disclosures for promotional materials. Importantly, a content disclosure is not intended to reveal the story or eliminate all possible triggers, but rather to empower the audience by giving them the information they need to decide how and to what extent they want to engage with the production.

Tiered Content Disclosure for "The Yellow Boat" Production

Tiered content disclosures offer a balanced approach to informing students, caregivers, administrators, and audiences about the content of performances while respecting the preferences of individuals who prefer to remain unaware of certain details. For a popular 9–12 grade play like "The Yellow Boat," comprehensive disclosures can be made available at the time of auditions, ensuring that all participants and their caregivers are fully informed about potential content concerns.

Tier 1: To Students and Caregivers
Dear Students and Parents,

We are excited to announce auditions for our upcoming production of "The Yellow Boat." As we prepare to embark on this meaningful journey together, we want to ensure that everyone is informed about the content of the play and the emotional themes it explores.

"The Yellow Boat," written by David Saar, is a poignant and powerful story based on the real-life experiences of the author's son, Benjamin, who was born with congenital hemophilia and later contracted HIV through a blood transfusion. The play contains themes of illness, loss, and the impact of a child's death on a family. It is a heartfelt exploration of love, creativity, and resilience in the face of difficult circumstances.

Potentially Upsetting Content:

1. *Illness and Medical Procedures: The play depicts various medical procedures, hospital settings, and the physical and emotional challenges of living with a serious illness.*
2. *HIV/AIDS: The storyline includes discussions and representations of HIV/AIDS, which may be sensitive for some individuals.*
3. *Death and Grief: The play addresses the death of a young child and the profound grief experienced by his family and friends.*
4. *Emotional Intensity: The narrative contains scenes of intense emotional dialogue and expression, which may be triggering for those with similar personal experiences.*

Support and Resources:

We understand that these themes may be difficult for some students and their families. We are committed to providing a supportive environment throughout the audition process and the production. Our staff and counselors will be available to offer support and resources for those who may need them.

Open Communication:

We encourage open communication between students, parents, and the production team. If you have any concerns or need additional support, please do not hesitate to reach out to us. Our goal is to ensure that every participant feels safe, supported, and prepared to engage with the material in a healthy and constructive way.

Thank you for your attention and understanding. We look forward to creating a meaningful and impactful production together.

Tier 2: General Notice to Audiences

Detailed disclosures can be provided through a link on the school's website, where interested parties can click to access in-depth information about the show's themes, language, and sensitive topics. This link can also be included in QR codes placed strategically in the theatre, on posters and doors, in the playbill, and at the box office. For instance, a general disclosure for "The Yellow Boat" might state:

"Our upcoming production of 'The Yellow Boat' by David Saar explores deep and emotional themes, including illness, grief and loss, and family dynamics. The play tells a moving story based on real-life experiences and may contain content that some viewers find sensitive. We encourage you to prepare accordingly and reach out to us if you need more information or support."

Tier 3: Detailed Notice for Audiences

For audience members seeking more detailed information about the themes and potentially sensitive content in this production, we offer a Tier 3 Content Disclosure. By scanning a QR code or clicking a hyperlink provided with the general Tier 2 statement, audiences will be directed to a comprehensive resource outlining specific content elements of the performance. This page mirrors the detailed disclosures shared with caregivers and students, ensuring transparency and supporting informed consent. Like with the Tier 1 disclosure for Caregivers and students, the goal is to empower audiences to engage with the production at their comfort level, allowing them to decide how much information they wish to explore before attending.

"We are pleased to present 'The Yellow Boat' by David Saar, a heartfelt and poignant play based on the real-life experiences of Benjamin Saar, a young boy born with congenital hemophilia who later contracted HIV through a blood transfusion. This production is a celebration of resilience, creativity, and the power of human

connection, but it also engages with sensitive topics that may be emotionally challenging. To help you make an informed decision about attending, please review the following detailed content disclosures:

Illness and Medical Procedures: The play includes depictions of medical procedures such as blood transfusions and diagnostic tests, as well as scenes set in hospital environments. These portrayals highlight the physical and emotional realities of living with a chronic and life-threatening illness, which may evoke strong reactions in individuals with personal experiences of medical trauma or illness.

HIV/AIDS: Central to the story is Benjamin's experience with HIV/AIDS, addressing the medical, emotional, and social implications of the disease. The play explores themes of stigma, fear, and misunderstanding surrounding HIV/AIDS, as well as the profound impact on Benjamin and his family. These moments may be intense for those who have personal or historical connections to the HIV/AIDS crisis.

Death and Grief: A core element of the narrative is the death of Benjamin, a young child, and the subsequent grieving process of his family and friends. The play portrays their emotional journey with vulnerability and honesty, delving into themes of loss, memory, and healing. These scenes may resonate deeply with audience members who have experienced the loss of a loved one.

Emotional Intensity: Throughout the play, characters express deep emotional vulnerability, including moments of despair, frustration, and overwhelming love. These scenes are portrayed with raw honesty and may be triggering for individuals who have experienced similar emotional circumstances or trauma.

Family Dynamics: The play also explores the dynamics within Benjamin's family as they navigate the challenges of his illness and eventual death. This includes moments of tension, emotional exhaustion, and unconditional support, which may resonate with or challenge audience members' personal experiences.

Themes of Childhood and Creativity: Benjamin's creativity and imagination are central to the story, offering moments of joy and wonder amidst the heavier themes. These elements may provide emotional balance but could also evoke nostalgia or longing for those reflecting on their own childhoods or the experiences of children in their lives.

Additional Support and Resources

We understand that 'The Yellow Boat' explores sensitive and emotional themes that may deeply affect some audience members. To support your well-being, we have provided additional resources in the lobby, including information on counseling services, support groups, and grounding techniques. If you feel overwhelmed or need assistance, please reach out to the director or a booster parent, who are here to help.

Your experience matters to us, and we are committed to ensuring a supportive and respectful theatre environment for everyone. Thank you for engaging thoughtfully with this production."

This extensive list ensures that those who need detailed information can access it easily, while giving others the choice to avoid potential spoilers. By implementing tiered disclosures, theatre programs can cater to diverse preferences, ensuring informed consent without compromising the experience for those who prefer to be surprised.

To ensure cultural responsiveness and inclusivity, make content disclosures accessible to diverse communities by offering translations and considering different cultural perspectives. Consulting with community leaders and cultural experts during pre-production can help address cultural nuances and present themes respectfully. This proactive approach helps all audience members feel valued and included, fostering a more thoughtful and engaged response. By prioritizing audience care early on, productions create a more positive and inclusive experience for everyone.

The pre-production process provides theatre educators with a meaningful opportunity to adapt content in ways that promote emotional safety for everyone involved. Consider collaborating with publishers and playwrights as needed to modify scripts while ensuring compliance with copyright laws. Review the material for potentially distressing content and address concerns early through open discussions with key stakeholders, including production staff, cast, crew, mental health professionals, administrators, and caregivers. Additionally, intentional staging choices, such as using symbolism, abstraction, and choreographed movement instead of overtly portraying traumatic elements, can help reduce the risk of retraumatization while enhancing creative storytelling.

When selecting a show for production, it is essential to consider the norms, values, and intersecting identities present within the community to ensure the performance resonates with audiences. Productions that align with the principles of trauma-informed education that emphasize themes of resilience, empathy, and personal growth can foster meaningful connections with viewers while supporting students' emotional well-being. Additionally, it is crucial to choose shows that align with the educational mission of the school, ensuring they contribute to both artistic expression and academic objectives. Engaging mental health professionals in the selection process further enhances the production's impact by offering insights into how the content can support students' emotional and educational development.

Cultural responsiveness must also guide production choices. Theatre educators should select material that reflects and respects the diverse cultural, historical, and gender identities represented in the community.

Recognizing how cultural norms, histories, and societal contexts influence students' experiences and perceptions is vital to creating an inclusive environment. Collaborating with cultural organizations and seeking input from diverse voices ensures that the production honors the community's diversity and intersectional identities. This intentional approach enriches the theatrical experience, fostering an inclusive space that values and celebrates the unique backgrounds of all participants.

Drafting your director's statement during the pre-production process, rather than rushing to complete it when the program is about to be printed, is essential for clarity and intentionality. A well-crafted director's statement provides transparency about the production's purpose, content, and available support mechanisms. It answers key questions such as, "Why this show? Why now?" helping to ensure that the choice of production is intentional for the specific time, place, and community it serves, rather than being selected simply because it is trendy, edgy, or socially provocative. This thoughtful process allows you as the director to articulate your vision and align the production with trauma-informed practices. It also offers a guiding framework for the creative team while serving as a resource for students, caregivers, and administrators. By fostering a shared understanding of the production's goals and support systems, the director's statement strengthens collaboration and enhances the impact of the theatrical experience for everyone involved.

Engaging Administrative Support Through a Detailed Production Proposal

Securing administrative support early in the pre-production phase is essential for a successful and intentional production. Actively involving administrators in the decision-making process allows them to contribute meaningful insights while gaining a clearer understanding of the production's purpose and value. Early engagement fosters a sense of investment and shared ownership, building a collaborative partnership between the production team and school leadership. This partnership ensures the production aligns with institutional goals and creates a strong foundation for a smooth and intentional process.

Theatre educators can build a compelling case for their chosen show by preparing a detailed production proposal. This proposal provides administrators with a clear overview of the production's educational objectives, artistic significance, and alignment with the school's mission, promoting collaboration and support from the outset. Below are the key elements to include in the proposal to address concerns, highlight educational benefits, and demonstrate trauma-informed practices.

Show Synopsis and Educational Significance

Provide a concise summary of the show's plot and key themes. Emphasize how the production will enrich students' understanding of complex issues, promote personal growth, and foster empathy. Highlight how the material aligns with trauma-informed principles by focusing on themes such as resilience and emotional well-being.

Director's Statement

Include your director's statement, answering essential questions like, "Why this show? Why now?" Articulating your reasons for selecting this production ensures the choice is intentional for the time, place, and audience, rather than based on popularity or trendiness. The statement also provides clarity on the production's purpose and alignment with the school's educational objectives.

Alignment with School Mission and Values

Illustrate how the show supports the school's academic and artistic goals. Emphasize connections to educational themes like empathy, critical thinking, and community engagement. This alignment reassures administrators that the production will contribute meaningfully to both the artistic and academic mission of the institution.

Curricular Integration and Learning Opportunities

Explain how the production can complement classroom learning through cross-curricular connections. Identify opportunities for interactive workshops, collaborative projects, and post-performance discussions to enhance student engagement and foster deeper learning.

Caregiver Involvement and Consent

Detail how caregivers will be informed and involved throughout the production process. Outline communication plans to keep families updated, including opportunities for caregivers to engage with the production through meetings, volunteer roles, or post-performance discussions.

Community Engagement and Partnerships

Showcase how the production can strengthen the school's relationship with the broader community. Highlight opportunities for collaboration with local organizations, cultural institutions, and businesses. Mention potential partnerships, sponsorships, volunteer opportunities, or promotional activities that can increase the production's visibility and impact beyond the school.

Student Support Systems

Detail plans to provide emotional support for students throughout the production. Outline collaborations with school counselors, administrators, and community resources to address any challenges that arise. Include strategies for engaging caregivers to offer additional support, ensuring a holistic approach to student well-being.

Wellness and Safety Protocols

Create a wellness document that lists key contacts, mental health resources, and procedures for addressing conflicts, health concerns, or other issues. Establish clear pathways for students and staff to report concerns, ensuring everyone feels safe and supported throughout the process.

Cultural Sensitivity and Inclusivity

Demonstrate how the production reflects and respects the diverse cultural, historical, and gender identities within the student body and community. Collaborate with local cultural organizations and seek input from diverse voices to ensure the show honors and celebrates the community's diversity. This approach fosters an inclusive environment aligned with the school's commitment to equity and representation.

By including these elements in the proposal, theatre educators can present a compelling case for the production's value and alignment with the school's goals. With administrative support secured, the production team can move forward confidently, guided by trauma-informed practices and a shared vision that benefits students, caregivers, and the broader community.

Production Planning

As theatre educators step into the role of director, they take on the critical responsibility of setting the tone for the entire production process. From the start, they must lead with intentionality, ensuring that every aspect of the production aligns with trauma-informed principles. Whether engaging professionals from the community, working with caregivers, or collaborating with students, the director carefully selects team members who share the production's vision and commitment to trauma-informed practices. Team members should be chosen not merely for availability but for their alignment with the production's values and goals.

Fostering a culture of safety, empowerment, and inclusivity from the outset ensures that every participant's contributions are recognized and respected. Clear communication, empathy, and shared responsibility are

essential for building a collaborative environment. The director guides the team in thoughtful exploration, ensuring that all participants, whether cast, crew, or support staff, feel safe, empowered, and meaningfully involved in the creative process.

Directors must also model the trauma-informed practices they expect from their team. Through consistency, accountability, and mutual respect, they maintain the production's focus on emotional well-being. Open dialogue, regular feedback, and prompt attention to challenges ensure the process remains on track. Encouraging team members to hold the director accountable fosters trust and reinforces a shared commitment to trauma-informed principles.

Clear and effective communication is essential to sustaining a trauma-informed, collaborative environment. Transparent communication promotes shared understanding of goals, expectations, and responsibilities, contributing to a sense of safety and alignment. Regular meetings offer a space to discuss progress, challenges, and ideas openly and without judgment, building trust and engagement. Beyond meetings, communication tools such as email, messaging apps, or project management software help keep everyone informed and involved. An open-door policy, where participants feel comfortable raising concerns or asking questions, reinforces empowerment by valuing voice and choice. Providing clear instructions, deadlines, and feedback minimizes misunderstandings, reduces anxiety, and ensures team members feel confident and supported.

Crafting the rehearsal schedule offers a key opportunity for directors to build a supportive and resilient environment. A well-structured schedule includes a clear beginning, focused practice time, and a structured ending to help students transition smoothly from rehearsal back into their daily lives. Incorporating wellness activities, such as mindfulness exercises, games, or emotional check-ins, helps prevents burnout and ensures students feel emotionally supported throughout the process.

Planning ahead through pre-blocking or pre-staging further streamlines rehearsals by creating a roadmap for movement and choreography. This proactive approach ensures smoother sessions while allowing flexibility to accommodate unexpected events or offer additional support to students. Mapping movements in advance enables directors to troubleshoot challenges, address individual needs, and identify potential triggers within the script. Importantly, pre-blocking provides structure without limiting creativity, offering students a stable framework to build on and explore. This thoughtful preparation gives students confidence, knowing there is a plan in place, while leaving room for adaptation as the emotional and physical demands of the story evolve. Directors can remain open to creative input from students and collaborators while maintaining readiness for the rehearsal process.

Enlisting community partners during the planning stage is essential to support your work, the production team's efforts, and to ensure a commitment to the process from the outset. These partners may include cultural sensitivity specialists, as discussed in Chapter 3, as well as mental health professionals, school services, and other community organizations that can provide vital resources and guidance. Collaborating with these experts early in the process helps embed cultural responsiveness and trauma-informed practices into the production. Their involvement ensures that diverse perspectives are represented, strengthens inclusivity, and fosters an environment of mutual respect and understanding. By securing these partnerships at the beginning, directors not only honor the diverse backgrounds of participants but also build a network of support that enhances the well-being and success of everyone involved.

Wellness must remain a priority throughout the production, as the emotional demands of rehearsals and performances can be significant. Supporting students' well-being not only prevents burnout but also maintains performance quality and nurtures emotional regulation and self-care skills (Chrismon & Carter, 2019, 2023; Chrismon, 2022). Directors should ensure students are aware of available wellness resources within both the school and the broader community, providing clear guidance on how to access them when needed. Integrating wellness activities, such as mindfulness exercises, reflective discussions, or check-ins, into the rehearsal schedule gives students space to recharge emotionally. Thoughtful scheduling promotes resilience, ensuring that students, educators, and crew members feel consistently supported.

By leading with intentionality, clear communication, and trauma-informed practices, theatre educators can create a production process that is both artistically enriching and emotionally supportive. Through careful planning, inclusivity, and a focus on well-being, educators pave the way for meaningful theatrical experiences that empower students and strengthen the broader community.

Audition Preparation

Preparing students for potentially challenging or traumatic themes during the pre-audition phase is a vital component of trauma-informed theatre education. This preparation equips students with the tools to engage safely with difficult material and empowers them to navigate emotional complexities effectively. By implementing intentional strategies, educators foster a deeper understanding of the production's intent and create a nurturing environment that prioritizes students' well-being.

Establishing a sense of ensemble among students during the audition process is essential for building a supportive and cohesive theatre community. Early camaraderie encourages collaboration and mutual respect, enriching students' overall experience. Focusing on ensemble-building helps students feel comfortable expressing themselves and supporting one another, laying the foundation for success both in auditions and throughout the production. Inviting actors to express emotions freely and fostering a safe space for vulnerability helps establish a positive tone for the entire production. Developing peer support networks before auditions further strengthens students' ability to offer emotional support, promoting confidence and resilience throughout the creative journey.

Maintaining open and transparent communication with students about the production's themes and content, especially before auditions, ensures they can make informed decisions about their participation. A content disclosure system, which clearly outlines any potentially distressing material, is essential (Chrismon & Carter, 2023; Johnson & Emunah, 2020). This system includes explicit warnings about potentially triggering content and provides access to the script or related resources in advance, allowing both cast and crew members to assess their comfort level with being involved. Sharing the director's statement offers additional reassurance by explaining the purpose of the production, the relevance of content disclosures, and the planned support systems. This proactive approach prioritizes emotional well-being and empowers students to participate on their own terms.

Workshops or information sessions before auditions further prepare students by introducing the play's content and themes and equipping them with emotional self-regulation and self-care strategies. Providing early access to scripts and hosting pre-reading sessions encourages open discussion and helps identify potential triggers within the material. Involving caregivers and administrators in these sessions fosters transparency and ensures a shared understanding of the production's objectives. Reviewing the director's statement during these workshops provides clarity on the production's purpose, content disclosures, and available support. Additionally, the involvement of mental health professionals equips students with coping strategies, helping them navigate emotional challenges throughout the process.

Cultural responsiveness and diversity are also integral to creating an inclusive audition environment. Theatre educators must be mindful of how cultural norms and historical contexts may influence students' comfort levels and interactions during auditions. Providing a space where students feel free to express their cultural identities promotes confidence and engagement. Fostering an environment that values diversity and cultural responsiveness ensures that all students feel respected, valued, and supported, enriching the audition process and the production as a whole.

Prioritizing student well-being throughout the pre-audition process requires multiple strategies. Educators must ensure students are aware of wellness and self-care resources within the school and in the broader community, providing clear guidance on how to access these supports. Incorporating mindfulness exercises, relaxation techniques, and emotional check-ins into pre-audition activities helps students manage anxiety and maintain focus. Offering access to school counselors or mental health professionals, as needed, ensures students have immediate support if they encounter emotional challenges. Distributing a support document that outlines available resources reinforces the message of care and ensures students feel supported as they navigate the audition process.

By weaving trauma-informed practices, cultural responsiveness, and student well-being into the pre-audition process, theatre educators create an inclusive and empowering environment. Through intentional preparation, transparent communication, and individualized support, educators ensure students feel confident, respected, and emotionally safe as they engage with auditions and prepare for the challenges of the production ahead.

In a trauma-informed theatre space, documenting instances when a member of the production becomes emotionally activated at any point in the process, from pre-audition workshops to post-show follow-ups, is as essential as completing an injury report for a physical incident. This documentation records what occurred, who was involved, the actions taken to support the individual, how they responded, how the situation was resolved in the moment, and any next steps needed outside of the immediate setting. Treating emotional activations with the same care and attention as physical injuries reflects a commitment to the well-being of everyone involved in the production. Just as tracking injuries helps prevent future harm, documenting emotional responses ensures continued awareness of mental health, creating a safe, supportive environment where participants can thrive artistically and personally.

This type of documentation, as seen in the sample documentation form in Table 5.1, also provides essential transparency throughout the production process. Whether concerns arise during auditions, rehearsals, or post-show reflections, having detailed notes ensures that any inquiries from caregivers, administrators, or other stakeholders can be addressed with clarity. A well-documented account reflects the thoughtful steps taken to support the individual and outlines the actions planned for their continued well-being. This practice builds trust within the production community among educators, caregivers, and participants by demonstrating that emotional challenges are treated with the same seriousness as physical concerns. Additionally, tracking patterns or recurring emotional stressors allows theatre educators to make informed adjustments, ensuring the ensemble remains supported and resilient at every stage of the production journey.

Table 5.1 Emotional Activation Documentation Form

Emotional Activation Documentation Form	
Date of Incident:	
Time of Incident:	
Participant Name:	
Role in Production (e.g., Cast, Crew, Director):	
Location (e.g., Audition Room, Rehearsal Hall, Stage):	
Stage of Production (e.g., Pre-Audition, Rehearsal, Performance, Post-Show):	
Description of Incident (What occurred? Who was involved?):	
Actions Taken to Support the Individual:	
Response from the Individual (How did they respond to support?):	
Resolution in the Moment (How was the situation resolved?):	
Next Steps (What follow-up actions are needed?):	
Additional Notes or Observations:	
Documented by (Name of Educator or Staff Member):	
Follow-up Date (if applicable):	

Preparing Caregivers for Potentially Traumatic Themes

Engaging caregivers is essential for creating a nurturing and supportive environment in trauma-informed theatre education. Preparing them for the potential emotional impact of the production ensures they understand and support their child's involvement. Establishing a positive and proactive relationship with caregivers from the earliest stages of the production helps cultivate a well-informed community, fostering students' emotional growth and well-being throughout the process.

Open and transparent communication with caregivers is key. Share detailed information about the production's themes, content, and goals early on through a tier 1 content disclosure, allowing caregivers to fully grasp the scope and intent of the production. Providing the director's statement helps clarify the production's purpose, outlines any content disclosures, and explains the support systems available for potentially traumatic material. This transparency equips caregivers with a deeper understanding of the show and the measures in place to support their child.

Providing caregivers with a comprehensive handbook that includes the production schedule, their role in the process, and practical self-care tips ensures they are well-prepared. Supplementing these efforts with access to trauma-informed resource, such as reading materials, videos, or webinar, further empowers caregivers to understand and navigate the emotional aspects of the production. Consider asking caregivers to sign a consent form, affirming their understanding of the show's content and confirming they have discussed it with their child. Encourage caregivers to reach out with any questions or concerns they may have throughout the production. Prompt responses to their inquiries demonstrate a commitment to meeting their needs and fostering a collaborative partnership that benefits both students and caregivers.

Approaching caregiver engagement with cultural responsiveness and respect for diversity is essential. Acknowledge and honor the diverse cultural backgrounds and perspectives caregivers bring, ensuring that all communication and resources are inclusive and considerate of their cultural contexts. Tailoring workshops and materials to reflect cultural norms and values helps caregivers better understand how to support their child's involvement in the production. Providing translated materials and interpretation services, when needed, ensures that all caregivers can fully engage with the information and feel included throughout the process.

Auditions

The audition process is a pivotal phase in any theatrical production, shaping the ensemble and setting the tone for the journey ahead. Approaching auditions in trauma-informed theatre spaces emphasizes the importance of creating a supportive, inclusive environment that prioritizes the emotional well-being and growth of students. Every aspect of the process, whether through transparent communication or promoting wellness resources, should be thoughtfully crafted to foster a positive experience.

Prioritizing students' emotional safety and well-being is essential throughout the process. A trauma-informed approach focuses not on competition but

on fostering an atmosphere where students feel valued for their unique contributions. Early ensemble-building activities promote camaraderie and reinforce the idea that every role, both onstage and off, is integral to the production. This collaborative spirit nurtures mutual respect and empathy, setting a positive tone for both the auditions and the entire production journey.

It is important to maintain the wellness strategies introduced in the pre-audition phase throughout the auditions. Students should be reminded of the wellness and self-care resources available to them, both within the school and externally, so they can access support as needed. Encouraging peer support networks during auditions provides a system for emotional encouragement and appropriate feedback on technique. Incorporating mindfulness exercises, such as breathing techniques or guided relaxation, can help students manage anxiety and stay focused. By sustaining a focus on holistic wellness, educators create an environment where students can showcase their talents with confidence and emotional security.

Clear, ongoing communication throughout the process helps students feel informed and respected. Keeping students updated about the production's themes, content, and expectations supports their engagement. Expanding the callback process to be more transparent and inclusive further reinforces a sense of fairness. Open callbacks, where all students can witness the process, promote integrity, and reduce feelings of exclusion. Communicating expectations and timelines clearly helps alleviate uncertainties and ensures students feel respected throughout the casting process. Making yourself available to offer feedback to students after auditions, regardless of whether they are cast, further demonstrates that they are valued and deserving of your time and insight.

Through intentional preparation, transparent communication, and a commitment to diversity, the audition process becomes more than just a selection phase. It becomes an opportunity for growth, connection, and empowerment. By prioritizing emotional safety, cultural responsiveness, and student well-being, theatre educators foster an environment where all students feel respected, valued, and supported throughout the audition process and beyond.

Prioritizing Wellness in the Pre-Production Process

In the pre-production phase of a 9–12 grade theatre program, student wellness and self-care must remain a priority as students prepare for auditions, navigate the audition process, and await casting decisions. Theatre educators play a crucial role in fostering a supportive environment that encourages students

to practice self-care strategies to manage the stress and anxiety that often accompany auditions. Providing access to stress management tools, mindfulness exercises, and relaxation techniques equips students with practical ways to maintain their emotional well-being during these high-pressure moments. Open conversations about mental health, along with accessible support resources, further cultivate a sense of community and care within the program.

Balancing emotional well-being with academic responsibilities is equally important. Educators should guide students in managing their theatre commitments alongside their schoolwork, reinforcing the importance of academic success as part of their overall wellness. Promoting empathy and inclusivity throughout the audition process ensures that all students feel valued, regardless of casting outcomes. By addressing emotional, physical, and academic needs, educators foster resilience, confidence, and personal growth. This holistic approach not only supports students during pre-production but also helps create a positive and inclusive culture within the theatre program.

The well-being of theatre educators is just as important as that of their students. Educators manage many responsibilities, from selecting the show and assembling the production team to conducting auditions and making casting decisions. Mindful show selection—considering student interest, feasibility, and educational value—can reduce stress and ensure a rewarding experience for everyone involved. Clear communication and thoughtful delegation during the formation of the production team distribute responsibilities more evenly, easing the workload and promoting collaboration.

Preparing for auditions requires careful planning, including setting realistic timelines and using resources efficiently. Integrating self-care strategies throughout these tasks helps educators manage the demands of the process more effectively. Open communication, transparency, and empathy remain essential throughout auditions and casting, ensuring students feel supported and their expectations are managed. Crafting a realistic rehearsal schedule is also key, providing educators with the time they need to rest, recharge, and maintain a healthy work-life balance.

Establishing healthy boundaries is crucial for educators. It is important to remind ourselves not to take student or caregiver reactions to casting decisions personally, but rather to respond with empathy and professionalism. Regular breaks, clear boundaries, and seeking support from colleagues or mentors are essential practices that help educators maintain resilience throughout the pre-production process. By prioritizing their own well-being, theatre educators create space for personal growth and fulfillment while fostering a positive and supportive environment within the theatre program.

Intentionality and Communication in the Pre-Production Process

The pre-production phase is a critical opportunity to embed trauma-informed practices intentionally. The early stages of production offer the most space for thoughtful reflection, allowing educators to establish practices that prioritize emotional well-being, empathy, and inclusivity. However, research has shown that as productions progress, maintaining these intentional efforts can become more challenging (Chrismon & Carter, 2023) The pressures of tight schedules and increasing logistical demands often overshadow the initial focus on trauma-informed principles. Furthermore, the collaborative nature of theatre introduces complexities, with varying perspectives and priorities emerging throughout the process, potentially diluting the original commitment to these practices. Recognizing these challenges is essential for educators who aim to sustain a trauma-informed approach throughout the entire production.

Intentionality is not a one-time act but an ongoing commitment that requires deliberate actions at every stage of the process. Communication serves as the essential tool to maintain this intentionality, acting as the bridge that connects educators with students, caregivers, administrators, and audiences. In trauma-informed theatre, communication goes beyond basic conversations, it becomes purposeful and empathetic dialogue. Educators openly address potential emotional triggers and provide context for the themes explored in the production, ensuring transparency and understanding among all involved.

This approach emphasizes the deeper significance behind artistic choices, helping participants grasp the intent behind the work. Through clear and open communication, everyone involved, whether students, caregivers, or audiences, feels informed and supported. Additionally, educators make sure participants are aware of the resources and support systems available to them, fostering an environment where students can engage with confidence and emotional safety. Sustaining intentionality and communication throughout the production ensures that trauma-informed practices remain at the heart of the theatrical journey, creating a space where everyone involved feels seen, valued, and supported.

References

Bryce, I., Horwood, N., Cantrell, K., & Gildersleeve, J. (2022). Pulling the trigger: A systematic literature review of trigger warnings as a strategy for reducing traumatization in higher education. *Trauma, Violence, & Abuse*. https://doi.org/15248380221118968

Chrismon, J., & Carter, A. (2019). Teacher and administrator perceptions of traits, characteristics, and instructional practices of effective theater teachers. *Journal of Educational Leadership in Action*, 6(1). https://digitalcommons.lindenwood.edu/ela/vol6/iss1/8

Chrismon, J., & Carter, A. W. (2023). The absence of trauma-informed practices in the high school production process: A qualitative study. *Youth Theatre Journal*, 1–16. https://doi.org/10.1080/08929092.2023.2218719

Chrismon, J. D. (2022). Trauma-informed practices in theatre education. *Pathways to Research in Education*, EDU087, 1–20.

Cless, J. D., & Goff, B. S. N. (2017). Teaching trauma: A model for introducing traumatic materials in the classroom. *Advances in Social Work*, 18(1), 25–38. https://doi.org/10.18060/21177

Johnson, D. R., & Emunah, R. (2020). *Current approaches in drama therapy*. Charles C. Thomas Publisher, Limited.

Lainson, K. (2019). Trauma-informed teaching in a narrative practice training context. *International Journal of Narrative Therapy & Community Work*, 4, 99–105.

Lazarus, J. (2005). Ethical questions in secondary theatre education. *Arts Education Policy Review*, 107(2), 21–25. https://doi.org/10.3200/AEPR.107.2.21-26

Renken, N.D., Schiffer, A. A., & Saucier, D. A. (2023). *Using content disclosures in our courses*. Faulty Focus. https://www.facultyfocus.com/articles/course-design-ideas/using-content-disclosures-in-our-courses/?st=FFdaily;sc=FF230911;utm_term=FF230911&mailingID=5464&utm_source=ActiveCampaign&utm_medium=email&utm_content=Using+Content+Disclosures+in+Our+Courses&utm_campaign=FF230911

Venet, A. S. (2019). Role-clarity and boundaries for trauma-informed teachers. *Educational Considerations*, 44(2). https://doi.org/10.4148/0146-9282.2175

6

During Rehearsal and Run of Production Processes

This chapter provides theatre educators with comprehensive tools and strategies to navigate the emotionally complex and often intense process of rehearsals and performances. It extends beyond simply helping students achieve technical success on stage, focusing instead on the holistic development of their emotional and mental well-being. By integrating trauma-informed practices, educators can create a space where students feel valued, understood, and supported, enabling them to fully engage in the creative process.

The chapter also underscores the importance of recognizing the emotional vulnerability that often accompanies artistic expression. It offers guidance on nurturing resilience in students, empowering them to face challenges both within and beyond the theatre. By fostering an empathetic and collaborative environment, educators can establish a culture of trust, where every participant, regardless of their role, feels safe to explore, take risks, and express themselves authentically. Through these practices, a thriving theatre community emerges, one rooted in mutual care, respect, and shared creative purpose. This approach not only enhances the artistic quality of productions but also enriches the personal growth of everyone involved, equipping students with skills and insights that extend far beyond the stage.

Rehearsals

Effective Ensemble Communication

At the heart of building a positive theatre community is effective ensemble communication. Open dialogue fosters unity, professionalism, and clarity, ensuring that all participants understand their roles and responsibilities. Educators can promote this positive communication by setting clear guidelines, encouraging active listening, and facilitating team-building activities that strengthen connections within the ensemble. Addressing negativity promptly—such as confronting gossip or harmful behavior—is also essential for maintaining a respectful and inclusive atmosphere (Barton, 1994; Busselle, 2021; Busselle & Fazio, 2023; Chrismon & Carter, 2023; Chrismon & Marlin-Hess, 2023; Ewan & Green, 2015; Ewan & Sagovsky, 2019; Gualeni et al., 2017; Lapum et al., 2019; Lippe, 1992; Pace, 2020; Tuisku, 2015; Vorbeck, 2019). When students feel heard and supported, they engage more fully in the creative process, contributing to a vibrant and cohesive theatre environment.

Structured and Predictable Rehearsals

In trauma-informed theatre spaces, predictability and routine are essential offering students, especially those with trauma histories, a stable framework that reduces anxiety and fosters engagement. Familiar routines, such as consistent opening and closing activities, create a sense of security and continuity. However, educators must remain attuned to students' individual needs, adjusting practices when necessary to prevent emotional discomfort (Chrismon, 2022; Schreyer, 2023; Shively, 2022). Transparent communication about schedules and expectations further minimizes surprises, promoting a sense of control and safety within the learning environment.

Establishing a consistent structure for rehearsals builds on this foundation, ensuring that all participants feel supported throughout the creative process (Carello & Butler, 2015; Cavanaugh, 2016; St. John, 2022; Walton-Fisette, 2020). A well-organized schedule, including warm-ups, focused work sessions, breaks, and deroling, creates space for both artistic exploration and reflection. Rituals embedded within these routines enhance predictability, helping students feel grounded and secure. For example, beginning rehearsals with a mindfulness exercise fosters focus, while collaborative activities at the midpoint restore energy within the ensemble. Closing each session with a deroling activity offers emotional support and closure.

Structured rehearsals do not inhibit creativity; instead, they empower participants by clarifying expectations and responsibilities at each stage. When students know what is expected of them and how to prepare, they engage more fully and confidently in the creative process. This intentional framework

supports both individual and group growth, allowing participants to explore their potential, knowing they are guided by a stable, responsive environment.

Building trust with authority figures is another vital component of trauma-informed practice. Students with trauma histories may find it difficult to trust adults, but educators who demonstrate reliability through structured routines and predictable behavior create a sense of safety and dependability. These rituals not only help students regulate their emotions but also empower them by offering a sense of control over their environment. This promotes self-regulation and emotional resilience, equipping students to navigate challenges effectively.

When students feel safe and supported, they are better positioned to absorb new knowledge, take creative risks, and explore their artistic abilities with confidence. This secure environment fosters an inclusive community where every participant feels valued, empowered, and motivated to contribute fully to the ensemble. Through consistent routines, thoughtful rituals, and open communication, educators cultivate a space that balances creative freedom with emotional well-being, ensuring all participants thrive artistically and personally.

Warm-Ups

Warm-up routines play a crucial role in preparing students both mentally and physically for rehearsals and performances. These activities should incorporate grounding techniques, mindfulness practices, and physical exercises that help students connect with their bodies and establish presence on stage. Beyond improving concentration and emotional well-being, warm-ups foster a sense of unity within the ensemble, promoting collaboration and shared focus (Chrismon & Carter, 2023).

Incorporating emotional check-ins at the start of each rehearsal adds another layer of support. A "Red, Yellow, Green" system allows students to communicate their emotional and physical states: "Red" indicates distress, "Yellow" signals moderate stress, and "Green" reflects a calm, balanced state. These check-ins provide a space for open communication, giving educators insight into the needs of the group and enabling them to offer targeted support as required (Busselle & Fazio, 2023; Porges, 2015). When students feel seen and supported, they can engage more fully, knowing they are entering a space that prioritizes both their well-being and creative growth.

Work Session Considerations

Open communication is the foundation of trauma-informed theatre spaces, where transparency and dialogue foster trust, collaboration, and meaningful engagement. Sharing the rationale behind directorial choices during

rehearsals brings students into the creative process, helping them connect with the material and take ownership of their roles. When decision-making is transparent, every participant feels seen and valued, reinforcing the importance of their contributions. Open dialogue and feedback provide opportunities for students to express their thoughts, concerns, and suggestions, creating a space where constructive discussions can thrive. This collaborative approach ensures that all voices are heard, building an inclusive and supportive environment. Understanding the "why" behind creative decisions deepens students' connection to the work, making them active participants in a shared process—an essential principle of trauma-informed theatre.

Building on this foundation of open communication, it is equally important to establish a documented and accessible support system for all participants. Guidelines and protocols must clearly outline expectations and address emotionally charged content throughout the production process, ensuring everyone feels supported. Extending these resources to technicians and stage managers through strategies like deroling helps them manage their emotional responses and engage with the work sustainably. By offering support from pre-audition to post-show, the ensemble creates a culture of empathy and resilience, ensuring that participants at every level are equipped to navigate the challenges of theatre with confidence.

As outlined in Chapter 4, consent, boundaries, and safety are cornerstones of trauma-informed theatre education. Rigorous procedures, such as proper choreography and clear communication, are essential to maintaining well-being throughout the production. Intimacy directors and fight choreographers provide critical expertise, ensuring that challenging scenes are executed safely and artistically. Productions must prioritize the protection of boundaries and adhere to ethical standards to prevent harm or retraumatization. When a boundary violation occurs, a respectful and structured response is necessary (Pace, 2020). The offended party should express discomfort using a self-care cue, while the offender must acknowledge the issue, offer a sincere apology, and commit to future boundary adherence. While the goal is to move forward with a fresh start, repeated violations may require additional intervention, with removal from the production as a potential consequence. Clear documentation and collaboration with administrators, counselors, and caregivers ensure both accountability and ongoing support.

Addressing discomfort voiced by a student or a caregiver requires the same level of care and empathy. When a student expresses discomfort with their assigned role, educators must listen attentively and without judgment, validating their emotions and exploring the issue through open dialogue. Framing these conversations within the context of the director's role as

a creative facilitator rather than a counselor helps clarify expectations and boundaries. Collaboratively identifying solutions and involving the production team as needed ensures that the student feels heard, while maintaining confidentiality fosters trust and psychological safety.

Similarly, caregiver concerns should be handled with sensitivity and open communication. Listening actively and validating their concerns establishes trust from the outset. Reflecting on earlier communications and clarifying roles helps identify potential misunderstandings, while consulting with the production team promotes collaborative solutions that address concerns without assigning blame. Offering emotional support and maintaining confidentiality reinforce trust between the caregiver, student, and production team, ensuring that the community remains cohesive and inclusive. A trauma-informed approach to caregiver engagement promotes a culture where concerns are addressed thoughtfully and proactively.

Deroling and Debriefing

Rooted in psychodrama, drama therapy, and Augusto Boal's *Rainbow of Desire*, a structured deroling process is essential for both cast and crew transitioning out of emotionally demanding content, helping them restore emotional balance and return to a neutral state (Burgoyne et al., 1999). This process integrates physical exercises with mindfulness techniques to reduce lingering emotional intensity. Deep breathing exercises ground participants in the present moment, while progressive muscle relaxation releases physical tension accumulated during performance. Guided visualizations further assist in mentally disengaging from roles, promoting emotional recalibration. Reflection through journaling or group discussions provides closure, offering participants space to process their experiences in a supportive environment.

For example, to support emotional separation from roles, cast members can gather in a circle at the end of rehearsal and, in unison, say, "I am not my character, and my character is not me."

This simple but powerful ritual helps participants create a mental boundary between themselves and the characters they portray, reinforcing emotional detachment (Bailey & Dickinson, 2016; Busselle & Fazio, 2023). Similarly, crew members may circle up and share one task they are proud of from that rehearsal, followed by a plan for what they will do after rehearsal to bridge smoothly into their personal time. These practices foster intentional reflection and create a sense of closure for both cast and crew.

We advocate that deroling practices be integrated at the end of every rehearsal and performance for everyone, cast and crew alike, regardless of their role in the production. Consistently practicing these techniques helps

> **Jimmy's Group Deroling Script**
>
> *"Stand with your feet hip width apart, knees slightly bent, arms by your sides, eyes and mouths closed, think of a string at the top of your head pulling you up just an inch or two taller.*
>
> *Big breath in . . .Big breath out*
>
> *Big breath in . . .Big breath out*
>
> *Repeat after me:*
> *I am (say your name as the actor).*
> *Tonight, I played (say your character's name).*
> *I am not my character.*
> *My character is not me.*
> *I will leave my character in this space until we meet again.*
> *I may work on my lines and character development outside of this space.*
> *But I am not my character.*
> *And my character is not me.*
>
> *Big breath in . . .Big breath out*
>
> *Big breath in . . .Big breath out*
>
> *Open your eyes."*
>
> *Around the circle sharing (favorite feel-good song, favorite comfort food, what are you doing tonight when you get home for you, before you leave tell two actors what you enjoyed about their work this evening, share something you are proud of about your work as an actor this evening, have a dance party, etc.).*

participants develop "muscle memory" for emotionally transitioning out of demanding situations. This routine equips them with the skills needed to disengage with greater ease when faced with particularly challenging content, ensuring they feel emotionally supported and ready to re-enter their personal lives.

Incorporating debrief forms provides an additional layer of emotional support and accessibility. These forms offer a private space for participants to share their thoughts, emotions, and concerns. Multiple submission options such as email links, QR codes, or anonymous paper submissions ensure all participants can engage comfortably. Forms allow students to raise interpersonal concerns, reflect on their well-being, and identify challenges they may have encountered during rehearsal. Educators should

emphasize that completing these forms is voluntary and confidential, encouraging open and honest feedback. Additionally, reminding students of the educator's role as a mandated reporter reinforces a commitment to safety and trust.

Sample Rehearsal Debrief Form

Please use this form for personal debriefing and processing thoughts, feelings, and experiences following rehearsals. You may provide your name or remain anonymous. However, if you want the director to follow up with you personally about an item, please fill in your name.

All questions are optional. This is not evaluative in nature; it is informative and gives you agency and autonomy in the production process. It is for you. This information will only be viewed by the director.

First Name: _____

Last Name: _____

Please identify in which area you work in this production:
☐ Adult leadership
☐ Student leadership
☐ Cast
☐ Crew
☐ External Support
☐ Other: _____

Use the scale provided to answer the question below.
I feel like I am in a healthy space mentally and emotionally leaving rehearsal.
☐ Strongly Disagree
☐ Somewhat Disagree
☐ Neutral
☐ Somewhat Agree
☐ Strongly Agree

Do you have anything further to say about your mental and emotional well-being in rehearsal?
☐ Use the scale provided to answer the question below.
☐ I feel like I am in a healthy space physically leaving rehearsal.
☐ Strongly Disagree
☐ Somewhat Disagree
☐ Neutral
☐ Somewhat Agree
☐ Strongly Agree

Do you have anything further to say about your physical well-being during rehearsal?

Use the scale provided to answer the question below.
My boundaries and consent were respected in rehearsal.
☐ Strongly Disagree
☐ Somewhat Disagree
☐ Neutral
☐ Somewhat Agree
☐ Strongly Agree

The boundary and consent practices are helpful for me to feel safe in the rehearsal process.
☐ Strongly Disagree
☐ Somewhat Disagree
☐ Neutral
☐ Somewhat Agree
☐ Strongly Agree

Do you have anything further to say about boundary and consent practices in rehearsal?

Use the scale provided to answer the question below.
I felt like a collaborator in the rehearsal process today.
☐ Strongly Disagree
☐ Somewhat Disagree
☐ Neutral
☐ Somewhat Agree
☐ Strongly Agree

Do you have anything further to say about collaboration in rehearsals?
Use the scale provided to answer the question below.

The DEROLING process was effective in helping me feel grounded at the end of this rehearsal.
☐ Strongly Disagree
☐ Somewhat Disagree
☐ Neutral
☐ Somewhat Agree
☐ Strongly Agree

> Do you have anything further to say about the DEROLING process?
> Use the scale provided to answer the question below.
> I feel like I need further support after this rehearsal.
> ☐ Strongly Disagree
> ☐ Somewhat Disagree
> ☐ Neutral
> ☐ Somewhat Agree
> ☐ Strongly Agree
>
> What further support do you think you need in this process?
>
> Is there a directing/collaboration concern you would like to discuss and address?
>
> Is there an intimacy choreography concern you would like to discuss and address?
>
> Is there a fight choreography/violence concern you would like to discuss and address?
>
> Is there a movement/dance concern you would like to discuss and address?
>
> Are there any interpersonal concerns you would like to discuss and address?
>
> Is there a technical (costuming, set, lighting, sound) concern you would like to discuss and address?
>
> Is there a dramaturgical concern you would like to discuss and address?
>
> Is there anything else you would like to share?
>
> Thank you so much for submitting a response.
> Your response has been recorded.

The combination of structured warm-ups, emotional check-ins, deroling practices, and open communication ensures a trauma-informed rehearsal process that prioritizes participants' well-being. When rehearsals are intentionally designed with both creative freedom and emotional support in mind, students feel empowered to explore their potential while maintaining their

mental health. Consistent routines, thoughtful rituals, and clear communication foster a positive theatre community where students feel safe, respected, and motivated to engage fully. This intentional approach creates a meaningful and rewarding theatre experience, ensuring that all participants thrive both artistically and emotionally.

Adapting Acting Methods for Young Performers

Traditional acting methods often emphasize subjective, intuitive processes that rely heavily on emotional recall drawing from personal experiences to enhance authenticity on stage (Burgoyne, Poulin, & Rearden, 1999; Tuisku, 2015). While adult actors may navigate these methods effectively, young performers have different developmental and emotional needs, requiring more adaptable approaches (Shively, 2022). Asking students to engage with personal trauma for the sake of performance is not only negligent but can be harmful if the proper support systems are not in place.

A trauma-informed approach prioritizes emotional safety by steering away from techniques that demand deep emotional introspection. Methods such as Stanislavski's emotional recall, Strasberg's affective memory, and Hagen's substitution can unintentionally trigger distress, leaving students without the tools to manage activated states. If educators are not prepared with trauma-informed practices or mental health support, this approach puts students at unnecessary risk. Pushing young performers to rely on their trauma not only undermines their well-being but also reflects poor teaching and directing. It is the responsibility of educators to adapt techniques to meet students where they are emotionally, rather than placing the burden solely on them to deliver authenticity.

Embodied acting techniques, or "working from the outside in," offer a safer alternative by emphasizing physical exploration as a means of character development. These methods shift the focus from emotional recall to movement, using the body as the primary tool for performance. Techniques from practitioners such as Laban, LeCoq, Viewpoints, Meisner, Adler, and Stanislavski's Method of Physical Actions provide tools for students to build characters without drawing from personal trauma (Tuisku, 2015). These approaches, as distinguished in Table 6.1, align with trauma-informed principles by reducing the need for emotional excavation and offering students a sense of control and agency in their creative process.

The long-term psychological impact of engaging with emotionally charged or traumatic material is still under-researched, underscoring the

Table 6.1 Traditional Acting Methods and Embodied Acting Methods

Traditional Acting Methods	Embodied Acting Methods
Traditional acting methods involve actors fully immersing themselves in their characters, authentically experiencing the emotions required for each scene, which can lead to psychological and behavioral changes during the portrayal.	Embodiment refers to the physical manifestation of an abstract notion, characteristic, or emotion. In light of this definition, any emotional or psychological state experienced by an actor must be outwardly demonstrated through their physicality, thereby giving rise to the formation of a character.
• Constantin Stanislavski's System, The Method, & Emotional Recall • Lee Strasberg's Method Acting, Affective Memory, & Sense Memory • Uta Hagen's Substitution and Transference • Sanford Meisner's Technique • Ivana Chubbuck's Technique	• Rudolph Laban's Efforts and Movement Analysis • Jacques Lecoq • Alba Emoting • Ann Bogart's Viewpoints • Tadashi Suzuki • Jerzy Grotowski's Physical Theatre • Sanford Meisner's Technique • Stella Adler • Michael Chekov's Psychological Gesture • Constantin Stanislavski's Method of Physical Action • Meyerhold's Biomechanics • Feldenkrais Method • Richard Schechner's Rasa Boxes

need for careful consideration when working with minors in creative settings (Shively, 2022). While theatre educators are not mental health professionals, they have a responsibility to recognize when students encounter unprocessed emotions during the creative process and to encourage them to seek support from trained professionals (Van der Kolk, 2015). Establishing clear distinctions between actors and their characters further supports emotional safety by helping students maintain their personal identity throughout their performances.

Theatre spaces often encourage performers to push past personal boundaries, with vulnerability being celebrated as a marker of artistic success.

However, these expectations can discourage students from maintaining healthy limits (Shawyer & Shively, 2019). Trauma-informed spaces must integrate consent-based practices, empowering young performers to set boundaries and communicate openly about their emotional needs. Educators should reinforce these practices throughout rehearsals and performances, helping students develop self-respect and confidence while preserving their well-being on and off stage (Chrismon & Marlin-Hess, 2023).

Maintaining a clear distinction between the actor and the character they portray is crucial for ensuring emotional safety and safeguarding performers' well-being. This practice allows students to engage deeply with their craft without blurring the lines between their own identities and the roles they play. For example, consistently referring to actors by their real names during rehearsals and discussions, while addressing characters by their role names, reinforces this separation. Consider a scene in which a student named Alex is playing the antagonist in a play. Rather than saying, "Alex, you are so cruel in this scene," the director might say, "Your character, Victor, comes across as very manipulative here." This approach helps Alex maintain a healthy distance from the traits of the character, preventing any unintended internalization of negative behaviors or emotions.

By embracing embodied methods and trauma-informed principles, educators create a supportive environment where young performers can explore their creativity without compromising their mental health. These approaches foster artistic growth, resilience, and self-awareness, equipping students with the tools to navigate the challenges of performance while prioritizing their well-being.

Run of the Show

The responsibilities of a theatre educator evolve significantly once the show begins. During performances, their focus shifts to sustaining the production's quality while fostering the emotional well-being of the cast and crew. This includes maintaining consistency, providing constructive feedback, guiding problem-solving, and celebrating successes. A trauma-informed approach enriches this role by prioritizing emotional safety, consent, and well-being, encouraging open communication, respecting boundaries, and using mindfulness techniques. These practices cultivate an environment where personal growth, cultural responsiveness, and safety are paramount, reinforcing empathy throughout the creative process.

While the theatre educator steps back as students assume greater responsibility, emotional safety remains a priority. Educators provide support by

guiding student leaders, maintaining trauma-aware practices, and embedding trust, resilience, and inclusivity. Even in this more hands-off phase, the educator plays a critical role in helping students navigate challenges with confidence and compassion.

Promoting Safety, Unity, and Emotional Well-Being Through Pre-Show and Post-Show Rituals and Routines

In trauma-informed theatre spaces, pre-show rituals and post-show routines are intentional practices designed to foster emotional safety, unity, and well-being for everyone involved including cast, crew, and audience members alike. These practices provide structure, helping participants navigate the emotional demands of the creative process while building a culture of trust, care, and resilience. When integrated into the production, these rituals ensure participants feel prepared, supported, and safe. Through consistent use, theatre educators create an environment where personal boundaries are respected, emotional expression is welcomed, and well-being is prioritized for all.

Pre-show rituals are essential in preparing participants emotionally, mentally, and physically for the challenges of a performance. In trauma-informed spaces, these practices extend beyond simply focusing energy, they create an environment where participants feel grounded, connected, and secure. Mindfulness exercises, such as breathwork, visualization, or body scanning, are particularly helpful in guiding participants to center themselves and regulate emotional responses. These strategies encourage students to become more aware of their emotional states and equip them with tools to manage anxiety or stress that may arise before or during a performance. Including all members of the production team, including actors, tech students, and backstage crew, fosters an inclusive space where each person's contribution is recognized and valued, reinforcing the idea that everyone plays an essential role in the success of the production.

The integration of trauma-informed practices into pre-show rituals promotes both individual well-being and group cohesion. Grounding exercises, such as intentional breathing or focusing on physical sensations like the feel of the floor beneath one's feet, are particularly beneficial for participants with trauma histories. These exercises help individuals remain present, reduce emotional overwhelm, and prevent dissociation, which can occur when stress levels escalate. When participants engage in these practices, they feel more prepared to meet the emotional and mental demands of their roles, maintaining a sense of personal safety and autonomy throughout the performance.

This intentional preparation not only strengthens the quality of the performance but also creates a healthier, more connected ensemble.

Equally critical to the trauma-informed process are post-show routines, which provide emotional closure and ensure participants transition smoothly out of their roles. One of the most essential components of these routines is deroling, a practice you will continue to engage in after every performance, just as you did during rehearsals. For actors, deroling may involve symbolic gestures, such as removing a piece of their costume or makeup, reciting a specific line to release the character, or engaging in grounding movements like stretching or shaking off tension. Consistently practicing deroling ensures that each performance ends with an intentional separation from the characters or tasks embodied on stage, preventing emotional entanglement and supporting the well-being of everyone involved.

Tech students and backstage crew also benefit from deroling practices, as their roles often require sustained focus and emotional investment. Their routines may involve organizing equipment, resetting the stage, or participating in reflective conversations with teammates, which not only foster teamwork but also provide opportunities for closure. These transitions create a sense of accomplishment and ensure every participant can step away from the performance with clarity and a sense of completion. Incorporating deroling into post-show routines is particularly important during the high-pressure environment of a production run, where the focus can easily shift toward technical demands at the expense of emotional care.

To ensure trauma-informed practices remain consistent throughout the production, theatre educators can delegate leadership by appointing a production deputy or show captain—a student leader responsible for guiding warm-ups, deroling, and other rituals. This shared responsibility not only ensures that these practices are followed but also empowers students to internalize and practice trauma-informed care themselves. Teaching students how to implement these techniques fosters emotional resilience and provides them with self-care skills they can carry into future productions.

By integrating intentional pre-show and post-show rituals, trauma-informed theatre spaces prioritize the well-being of all participants while fostering unity and collaboration. These practices strengthen the ensemble, enhance individual well-being, and create an environment where artistic expression and personal care are deeply connected. They also help students prepare for the emotional transition that follows a production, often known as the post-show blues. Through proactive conversations about closure and celebratory rituals, students are given the tools to reflect on and process their experiences in a positive way. Involving caregivers in these moments further

strengthens the sense of community and shared accomplishment, reinforcing the bonds built throughout the production. As students embrace these strategies, they cultivate emotional tools that extend beyond the stage, equipping them for future challenges. In this way, theatre becomes more than just a creative outlet—it evolves into a space for meaningful connection, personal growth, and healing.

Supporting an Overwhelmed Ensemble Member

Preparing students to manage emotionally challenging moments during a production involves educating the entire ensemble about potential stressors they may encounter and emphasizing the importance of recognizing and addressing these challenges both for themselves and their peers. The goal is not for students to take on the role of providing support themselves but rather to empower them with the knowledge of how and when to engage a supportive adult on behalf of a peer in need. Equipping students with emotional preparedness techniques, such as mindfulness exercises, deep breathing, and grounding strategies, provides them with practical tools to navigate difficult situations effectively. Encouraging regular check-ins on personal boundaries and self-care practices, alongside fostering strong communication skills, helps students learn how to offer and receive support within the ensemble. This creates an environment where participants feel safe, respected, and comfortable seeking help, promoting a culture of care, empathy, and inclusivity throughout the production process.

During a performance, prioritizing the well-being of an overwhelmed ensemble member is essential to maintaining a safe and supportive environment. Immediate strategies might include offering the impacted individual access to a quiet, private space to regroup and process their emotions. Designating a trusted support person, such as a school counselor or caregiver, to be with the student as they regulate ensures the ensemble member receives appropriate care while their boundaries are respected. It is equally important to empower the individual to decide whether to continue with the performance or step out temporarily. This autonomy fosters trust and helps the student feel safe in making decisions based on their needs at that moment.

For student actors, having an understudy prepared ensures continuity in the performance and alleviates pressure on the student, allowing them to prioritize their well-being without guilt. Theatre educators must never use a student's decision to step out or continue against them, as doing so could undermine trust and discourage students from prioritizing their mental and emotional health in the future. Instead, it is crucial to affirm that choosing to step back when necessary is a sign of self-awareness. Respecting these

decisions reinforces the trauma-informed principles of safety, autonomy, and care, ensuring that the theatre space remains a supportive environment where personal well-being and artistic expression coexist.

Creating a calm, supportive backstage environment is essential for managing stress and fostering well-being throughout the production process. A backstage area that feels safe, organized, and intentionally designed can make a significant difference in how students experience the demands of live performance. Providing designated relaxation spaces, such as a quiet corner with soft lighting, cushions, or mindfulness tools, offers participants a place to decompress and recharge as needed. These spaces signal that it is acceptable to step away temporarily for self-regulation without judgment, reinforcing a culture of care and understanding.

Encouraging peer support within the ensemble strengthens bonds and promotes a collaborative atmosphere where students feel valued and supported. Peer-to-peer check-ins help create a sense of shared responsibility for well-being, reminding students that they are not alone in managing stress. Integrating stress management techniques, such as progressive muscle relaxation, breathing exercises, or visualization practices, into backstage routines ensures students have practical tools to manage emotions in real-time. Furthermore, theatre educators can establish systems for students to signal when they need support, such as through non-verbal cues or a designated point person, ensuring every participant feels empowered to ask for help at any point in time.

Clear expectations for backstage behavior also contribute to a calm environment. Setting norms around communication, noise levels, and personal space minimizes unnecessary stress and creates predictability, which can be particularly beneficial for individuals prone to anxiety. Acknowledging the emotional challenges of being a part of a production, both individually and collectively, fosters empathy within the ensemble and encourages students to support each other with kindness and respect. By intentionally shaping the backstage environment to prioritize well-being, theatre educators create a space where participants can thrive, feel safe, and engage fully in the creative process.

Making yourself available for a quick post-show check-in with students is essential so they know where to find you and when, should they need additional support with deroling or transitioning out of character. These brief, intentional check-ins ensure that students feel heard and validated, helping to release lingering emotions before the next performance. Access to professional support or designated adults remains vital for those who need further assistance, while regular peer check-ins throughout the production run help maintain connection and prevent anyone from feeling isolated.

Documenting any emotionally challenging moments or patterns that arise during these check-ins allows you to adjust your approach and provide targeted support where needed, ensuring participants feel genuinely cared for throughout the production. These practices foster empathy, resilience, and community, transforming the theatre space into more than just a venue for artistic expression, it becomes a place rooted in trust, mutual care, and meaningful support.

To make the process even smoother, theatre educators can use structured formats like "circle shares," where each participant takes a turn speaking briefly, or they can offer anonymous written reflections if students feel more comfortable expressing themselves privately. These quick debriefs ensure students feel heard and validated while preventing emotions from lingering unresolved between performances. Access to professional support or designated adults remains crucial for those who may need additional help, and regular peer check-ins throughout the production run help maintain connection and prevent anyone from feeling isolated.

Documenting emotionally challenging moments or patterns during these debriefs allows theatre educators to adjust their approach and provide targeted support, ensuring that participants feel cared for throughout the production. By integrating short, intentional debriefing sessions into the routine, educators create a trauma-informed environment that prioritizes the emotional well-being of all involved. These practices foster empathy, resilience, and care, making the theatre space not only a place for artistic expression but also a community rooted in trust and mutual support.

TIPPS

Dialectical Behavior Therapy (DBT) is a structured approach designed to help individuals regulate intense emotions, making it valuable for theatre educators working with students struggling with emotional regulation. DBT includes four key elements: individual therapy, skills training, phone coaching, and therapist consultation (Psychology Today, 2024). Originally developed for severe mental health conditions, DBT techniques, such as mindfulness and distress tolerance, can be adapted to create trauma-informed rehearsals, performances, and classrooms that promote emotional safety without venturing into therapy.

Although theatre educators are not therapists, they can apply DBT techniques as practical tools to support students experiencing emotional dysregulation, such as panic attacks or heightened stress. DBT's skills training

element is particularly relevant, offering strategies to manage negative emotions, foster positive experiences, and stay grounded in the present.

The TIPPS method (Time and Space, Intense Exercise, Paced Breathing, Progressive Muscle Relaxation, Sensation Change) offers theatre educators grounding techniques they can adapt to help students quickly stabilize their emotional state when needed (AMHC, 2024; Counseling Center Group, 2024; Dialectical Behavior Therapy, 2024). These approaches act as immediate "triage" support, de-escalating intense emotions and guiding students toward a sense of calm before they can be referred to further support if necessary. By using these strategies, some of which are provided in Table 6.2, theatre educators foster a safer, more supportive learning environment without crossing into therapeutic practice.

Time and Space

Encouraging students to take time and physical space from a triggering situation is essential in a trauma-informed 9–12 grade theatre classroom. When a student feels overwhelmed, guiding them to step away from the source of distress can create the distance they need to regain composure (AMHC, 2024). For instance, suggesting a short walk down the hall, stepping outside briefly, or moving to a quieter spot within the school can help them shift focus away from the emotional trigger. Alternatively, redirecting the student to a different task such as organizing props, painting a set piece, or assisting backstage gives them a constructive way to manage their emotions while remaining engaged in the production. These actions not only offer students the space to calm down but also empower them to choose how they handle their emotional responses. By building in options for physical space, theatre educators give students a low-pressure, practical way to de-escalate, fostering a safe and supportive learning environment.

Intense Exercise

Intense exercise is a quick, effective tool for helping 9–12 grade students manage overwhelming emotions, especially in a high-energy setting like a theatre class or rehearsal. Short bursts of physical activity, such as jumping jacks, running in place, or dancing, enable students to release pent-up energy and reset their emotional state (AMHC, 2024; Counseling Center Group, 2024; Dialectical Behavior Therapy, 2024). This technique helps by increasing heart rate and releasing endorphins, the body's natural mood enhancers, which improve distress tolerance and help regulate emotions. While intense exercise is not a long-term solution, it can provide immediate relief during high stress. Educators should ensure activities are safe and appropriate for each student's physical capabilities and that the

student consents to the exercise, maintaining a supportive and inclusive environment.

Paced Breath

Paced breathing is a simple, powerful technique for managing intense emotions, particularly in moments of stress or anxiety that can arise in 9–12 grade theatre settings. Teaching students to slow their breath deliberately can better calm both mind and body. When students feel overwhelmed, they often begin breathing rapidly and shallowly, which can heighten feelings of panic or anxiety. Techniques like "box breathing" where you are inhaling for a count of four, holding for four, exhaling for four, and holding again can interrupt this cycle by activating the body's relaxation response (AMHC, 2024; Counseling Center Group, 2024; Dialectical Behavior Therapy, 2024). Incorporating paced breathing as a grounding tool in the theatre classroom equips students with an accessible strategy to center themselves during intense moments. Paced breathing allows students to regain focus and control, becoming an invaluable addition to trauma-informed teaching practices.

Progressive Muscle Relaxation

Progressive Muscle Relaxation is a practical method for reducing stress by intentionally tightening and releasing specific muscle groups, creating physical and emotional relaxation (Counseling Center Group, 2024; Dialectical Behavior Therapy, 2024). To practice Progressive Muscle Relaxation, students can sit or lie comfortably and start by tensing the muscles in their feet for 5–10 seconds, then releasing them while focusing on the sensation of relaxation. They can then move progressively through other muscle groups, such as their legs, arms, and neck. This technique helps ease both physical tension and emotional stress, making it especially beneficial for students experiencing anxiety or emotional intensity. Theatre educators who incorporate Progressive Muscle Relaxation into their routines offer students an accessible way to reduce stress, providing a calmer, more focused learning environment that supports emotional well-being.

Sensation Change

Sensation change can be a highly effective way to manage intense emotions in the theatre classroom by altering the body's sensory input (AMHC, 2024; Counseling Center Group, 2024; Dialectical Behavior Therapy, 2024). One approach is to use temperature changes—such as holding an ice cube or splashing cold water on the face—which can activate the body's dive reflex to slow heart rate and calm breathing. Alternatively, holding a warm object like a heating pad or warm cup can provide comfort and help relax tense

muscles. Other sensation changes, such as holding textured items like stress balls or using sour candies, help shift focus from emotional intensity to the immediate physical experience. Theatre educators can offer students immediate relief by using these simple, sensory-based grounding techniques in moments of distress, allowing them to regain focus and calm. These techniques are not therapeutic interventions but practical tools for educators to help students regulate emotions, supporting a balanced, trauma-informed classroom environment.

Table 6.2 TIPPS Strategies for Grounding

Time and Space	5,4,3,2,1: Before starting the exercise try taking a few slow, deep breaths then identify: • Five things you can see: Share five things you can see around you. You can look for small details, like the wood grain on a desk or the shape of your fingernails. • Four things you can touch: Share four things you can touch around you. You can touch things like a pillow, the ground under your feet, or your hair. • Three things you can hear: Share three things you can hear. You can listen for external sounds like distant traffic, voices in another room, or faint music. • Two things you can smell: Share two things you can smell. You can smell something like food, a candle, or the clean scent of your clothes. • One thing you can taste: Acknowledge one thing you can taste. You can taste something like gum, coffee, or a mint.
Time and Space	• Stomp on some text (works great for memorized text work to shake something loose) • Take a walk, listen to music • Dance break (try a song we know well, try a brand-new song) • Cartwheels • Following the leader (age group dependent) • Pushups against a wall • Reaching up and down, stacking (careful of height here, falling is possible if focus is off) • Cross body stretching • Yoga • "Shake it off" across the body

Paced Breath	- Humming and singing - "Can we take three deep breaths together?" - 4-7-8 - Inhale quietly through your nose for a count of four - Hold your breath for a count of seven - Exhale completely through your mouth, making a "whoosh" sound, for a count of eight - Repeat the cycle at least three more times - Color Breath - Inhale and imagine a color that represents how you want to feel - As you inhale, imagine the color entering your body and spreading throughout - As you exhale, imagine a color that represents stress leaving your body - Repeat for several minutes - Breathe in a flower, breathe out a candle - Blow bubbles (literally, get a bubble wand) - Squeeze a stress ball to a breath pattern
Progressive Muscle Relaxation	- Tense and release - Focus on areas of tension - Breathe and squeeze - Work through the body - Stretch and relax - Body scan - Visualize tension melting away
Sensation Change	- Hold cold water in your mouth for 30 seconds - Ice compress on neck or wrists - Hot pack on kidneys/lower back - Cold snack/crunchy snack (apples are great for this) - Run cold water on wrists - Sour candies - Hershey's Kiss - Unwrap: Pay attention to the feel of the foil and the weight of the candy. - Smell: Inhale the scent of the chocolate and notice any other layers of scent. - Look: Examine the chocolate's appearance, including its color, shape, and size. - Taste: Place the chocolate in your mouth and let it melt slowly. Notice the different flavors and textures as it coats your tongue. Try to hold the chocolate on your

	tongue without chewing it. Redirect your thoughts if they drift elsewhere. o Swallow: Feel the sensation of swallowing the chocolate and any lingering taste. o Reflect: Notice any thoughts or emotions you're feeling, and consider if you're able to be satisfied with just one.

Adapted from "The Glimmer Guide" by the Association of Mental Health Coordinators.

Progressive Muscle Relaxation Script

Introduction

"Today, we will practice Progressive Muscle Relaxation, a technique designed to help release tension in your body and promote relaxation. Muscle tension is often linked to stress, anxiety, and fear as part of the body's natural response to perceived danger. Even when situations may not truly be threatening, our bodies can react in similar ways, causing muscles to tighten. This tension can appear subtly, such as clenching your jaw, tensing your shoulders, feeling tightness in your back or neck, or experiencing tension headaches. This practice teaches us how to notice and release this tension."

"Before we begin, a few reminders:
- If you have physical injuries or conditions, consult a doctor before trying this technique.
- Minimize distractions by turning off electronic devices and creating a calm environment with soft lighting.

Let us begin."

Preparation

"First, make yourself comfortable. Sit back in your chair, letting your hands rest in your lap or by your sides. Close your eyes or lower your gaze if you feel comfortable doing so. Begin by taking a slow, deep breath in . . . and out. Let your breathing settle into a steady, natural rhythm. Now, as we move through the exercise, we will focus on one muscle group at a time. For each group, you will tense the muscles for about five seconds, just enough to feel the tension without causing pain, and then relax for ten seconds. If it helps, silently say the word 'relax' as you release the tension."

Relaxation Sequence

"Let us begin at the top of your body and work our way down.
1. **Right Hand and Forearm:** Make a fist with your right hand. Squeeze tightly . . . hold for 5 . . . 4 . . . 3 . . . 2 . . . 1. Now release and relax. Feel the tension melting away.
2. **Right Upper Arm":** Bend your right arm, bringing your forearm toward your shoulder to flex your bicep. Hold for 5 . . . 4 . . . 3 . . . 2 . . . 1. Now release and let it go.
3. **Left Hand and Forearm:** Make a fist with your left hand. Squeeze tightly . . . hold for 5 . . . 4 . . . 3 . . . 2 . . . 1. Now relax. Let it soften.
4. **Left Upper Arm:** Flex your left arm, bringing your forearm toward your shoulder. Hold for 5 . . . 4 . . . 3 . . . 2 . . . 1. Release.
5. **Forehead:** Raise your eyebrows as high as you can, as if in surprise. Hold for 5 . . . 4 . . . 3 . . . 2 . . . 1. Now relax, letting your forehead smooth.
6. **Eyes and Cheeks:** Squeeze your eyes shut tightly. Hold for 5 . . . 4 . . . 3 . . . 2 . . . 1. Now release. Let the tension fade.
7. **Mouth and Jaw:** Open your mouth wide, as if in a big yawn. Hold for 5 . . . 4 . . . 3 . . . 2 . . . 1. Relax, letting your jaw go slack.
8. **Neck:** Gently tilt your head back, as if looking up at the ceiling. Hold for 5 . . . 4 . . . 3 . . . 2 . . . 1. Return to a neutral position and relax.
9. **Shoulders:** Bring your shoulders up toward your ears, as if in a shrug. Hold for 5 . . . 4 . . . 3 . . . 2 . . . 1. Now release them completely.
10. **Shoulder Blades and Back:** Push your shoulder blades together, expanding your chest. Hold for 5 . . . 4 . . . 3 . . . 2 . . . 1. Relax and let your back soften.
11. **Chest and Stomach:** Take a deep breath in, filling your lungs fully. Hold for 5 . . . 4 . . . 3 . . . 2 . . . 1. Exhale slowly and relax.
12. **Hips and Buttocks:** Squeeze your buttocks tightly. Hold for 5 . . . 4 . . . 3 . . . 2 . . . 1. Release the tension.
13. **Right Upper Leg:** Tighten your right thigh. Hold for 5 . . . 4 . . . 3 . . . 2 . . . 1. Relax.
14. **Right Lower Leg:** Pull your toes toward you to stretch your calf. Hold for 5 . . . 4 . . . 3 . . . 2 . . . 1. Relax your leg.
15. **Right Foot:** Curl your toes downward. Hold for 5 . . . 4 . . . 3 . . . 2 . . . 1. Release.
16. **Left Upper Leg:** Tighten your left thigh. Hold for 5 . . . 4 . . . 3 . . . 2 . . . 1. Relax.
17. **Left Lower Leg:** Pull your toes toward you to stretch your calf. Hold for 5 . . . 4 . . . 3 . . . 2 . . . 1. Relax.
18. **Left Foot:** Curl your toes downward. Hold for 5 . . . 4 . . . 3 . . . 2 . . . 1. Release."

> **Conclusion**
> "Take a moment now to notice how your body feels. Scan your body from head to toe, observing the sense of relaxation and ease. Breathe deeply, allowing yourself to fully enjoy this state of calm. With regular practice, Progressive Muscle Relaxation can help you identify and release tension more easily. Thank you for taking this time for yourself today. When ready, gently open your eyes and return to the present moment."
> Adapted from "Progressive Muscle Relaxation" by Centre for Clinical Interventions and "Progressive Muscle Relaxation Transcript" by The US Department of Veterans Affairs.

Audience Engagement, Transparency, and Emotional Safety

In trauma-informed theatre spaces, the emotional well-being of audience members is thoughtfully considered. Productions exploring sensitive themes or emotionally charged material integrate content disclosures throughout various touchpoints, including the ticket purchasing process, playbills, pre-show announcements, and dramaturgy displays, ensuring transparency. These disclosures empower audience members to make informed choices about their participation, respecting personal boundaries and granting them autonomy over their experience (Renken et al., 2022). Content disclosures do not ruin your shows—promise. Reading them is entirely up to the individual who may need them, and they do not spoil surprises but instead allow audience members to prepare for content that might be difficult to experience without prior preparation.

It is essential that pre-show announcements provide these disclosures with enough time for audience members to process the information and make decisions about whether to stay for the performance. Announcing sensitive content immediately before the lights dim or the show begins does not give individuals adequate opportunity to act on the information. A more thoughtful approach might involve repeating the content disclosure every 10–15 minutes after the house opens, ensuring all attendees have the chance to hear it before the performance begins.

Additionally, pre-show announcements should highlight available resources for audience members who may need support during the production. It's important to avoid directing individuals to student house managers, as they are neither equipped nor trained to provide appropriate emotional support. Instead, provide information about designated support

personnel, such as the director, on-site mental health professionals, or quiet spaces within the venue, ensuring both the audience's and students' well-being are respected. This approach aligns with trauma-informed principles by prioritizing safety, autonomy, and care for everyone involved in the theatre experience.

Bows at the end of a production play a vital role in ensuring emotional safety for both actors and the audience. By bowing as themselves rather than in character, students initiate the process of deroling, signaling that they have stepped out of the roles they embodied on stage. For example, instead of bowing with the posture or gestures of their character, slouched villain or regal monarch, they stand upright, smiling naturally, and bow as the student they are. This intentional transition helps actors mentally and emotionally separate from their characters while also allowing the audience to distinguish the performer from the role, providing essential closure, especially after emotionally intense performances. Bows mark a clear end to the story, reinforcing transparency and helping everyone process the experience more fully.

Post-show activities, such as talkbacks or meet-and-greet sessions with the cast, provide audience members with an opportunity to engage more deeply with the production. These interactions can serve as a form of deroling for the audience (Burgoyne, 1999; Busselle, 2017), helping them transition from the emotional experience of the performance. They foster meaningful connections between performers and viewers, humanizing the performer and offering closure for both sides. Making participation optional allows individuals to engage at their own pace, supporting emotional safety and respecting personal boundaries. To further this goal, talkbacks can be scheduled to begin 15 minutes after the final curtain, giving those who prefer not to participate the opportunity to leave without pressure. This approach avoids the impression that audience members are required to stay and discuss the show, emphasizing instead that these activities are intended to support learning and self-regulation.

Designating quiet spaces within the venue provides audience members with a retreat if they become overwhelmed. This aligns with trauma-informed principles by giving patrons the autonomy to manage their emotions without fear of judgment. The presence of mental health professionals or trained volunteers on-site enhances this supportive environment, ensuring audience members have access to help if they experience distress during or after the performance. The TIPPS strategies discussed earlier for students can also be utilized effectively for activated audience members providing further support in grounding. These thoughtful approaches foster an atmosphere of care, empowering both participants and viewers to navigate the emotional journey of theatre safely and comfortably. To further support transparency,

this information can be included in programs and shared as part of the pre-show content disclosures.

Acknowledging that individuals engage with content in diverse ways reinforces the trauma-informed principle of individualized care. Responding to overwhelmed audience members with empathy and sensitivity fosters an environment where everyone, whether on stage or in the audience, feels safe, respected, and supported. This approach enhances the theatre experience by ensuring that participants' emotional needs are prioritized. It also aligns with the core objectives of trauma-informed practice: to create spaces that emphasize emotional safety, nurture meaningful connections, and leverage the power of art as a catalyst for healing and personal growth (Cless & Goff, 2017; Crosby et al., 2018).

Centering Self-Care During Rehearsals and Productions

For theatre educators and students alike, prioritizing self-care throughout rehearsals and the run of the show is essential to maintaining well-being and fostering resilience during the demands of a production (Miller & Flint-Stipp, 2019; Walton-Fisette, 2020). Integrating self-care strategies into the daily rehearsal process helps prevent burnout and promotes emotional balance for both educators and students. One effective approach is beginning and ending each rehearsal with short mindfulness exercises or deep breathing techniques, which can help participants center themselves and release tension. Encouraging regular check-ins whether through brief group reflections or private journaling allows both students and educators to monitor their mental and emotional state, promoting self-awareness and emotional regulation.

Creating a calm and organized rehearsal environment also supports self-care. Establishing predictable schedules, ensuring breaks are built into rehearsals, and encouraging healthy boundaries between theatre commitments and personal responsibilities are critical strategies for stress management. Educators can model these boundaries by adhering to start and end times and encouraging students to leave the rehearsal space promptly to rest and recharge. Teaching time management skills throughout the production helps students balance academic, personal, and theatre obligations more effectively, reducing the risk of stress and overwhelm. Additionally, embedding physical activities such as light stretching or movement-based relaxation exercises during warm-ups or breaks promotes both physical and emotional well-being.

Peer support within the ensemble plays a significant role in sustaining self-care practices during a production. Forming peer support groups or assigning accountability partners encourages students to check in on one another regularly, fostering a sense of community and shared responsibility for well-being. Educators can promote positive self-talk and normalize help-seeking behavior, ensuring that students feel comfortable reaching out to peers, mentors, or mental health professionals when they need support (Miller & Flint-Stipp, 2019). Incorporating reflective activities like journaling or group discussions into the rehearsal routine also offers students opportunities for self-reflection, promoting personal growth and emotional regulation.

Educators should also take care of their own well-being throughout the production process to model healthy behaviors for their students. Delegating tasks to student leaders and parent volunteers allows educators to focus on their self-care. Techniques like deroling, such as calling a friend or listening to music on the way home, help educators decompress and leave the demands of the production at the theatre. Providing snacks and water during rehearsals, encouraging regular breaks, and fostering a culture of openness around mental health ensures that the entire production team, students and educators alike, can maintain their well-being throughout the show's run. By weaving these strategies into rehearsals and performances, theatre educators and students create a culture that balances artistic expression with intentional care, fostering both resilience and community within the ensemble (Walton Fisette, 2020).

It All Goes Back to Intentionality

Intentionality is not just an extra step; it is the heartbeat of trauma-informed theatre. It involves actively planning and prioritizing the emotional well-being of everyone involved, recognizing it as a core element of the creative process rather than an afterthought. Weaving trauma-informed practices into every stage of production helps prevent small challenges from becoming larger issues, establishes consistency and trust within the ensemble, and empowers students to take ownership of their well-being. This intentional focus on care builds resilience and promotes personal growth, enabling participants to thrive both artistically and emotionally (Miller & Flint-Stipp, 2019).

As the technical demands of the production take center stage, intentionality becomes even more critical. The final weeks before opening night are often marked by long hours, increased stress, and the pressure to perfect every

element. This is when trauma-informed practices such as regular check-ins, self-care routines, and peer support become indispensable. These practices are not obstacles to completing the show; they are essential tools for keeping the ensemble connected, engaged, and resilient. The urgency of meeting production deadlines must not overshadow the well-being of those involved. By prioritizing care during high-pressure moments, theatre educators create a safer, more supportive space where creativity can flourish. When intentionality becomes a guiding principle, students are empowered to express themselves fully, free from fear or burnout, and theatre becomes not just a performance but a space for meaningful growth and healing (Walton-Fisette, 2020).

Educators who deliberately model positive self-care behaviors and integrate trauma-informed practices throughout the process teach students to do the same. As a result, students become more than just participants in a production; they develop lifelong emotional skills and healthy habits. This intentional environment fosters empathy, trust, and teamwork, allowing students to grow both as artists and individuals. When intentionality becomes a core value in theatre spaces, it builds a community that promotes emotional resilience and unlocks the potential for powerful artistic expression. In this space, where self-care and creativity coexist, students thrive. Theatre is no longer just a place to put on a show; it transforms into a culture that nurtures growth, fosters connection, and ensures that every performance offers an opportunity for healing, empowerment, and personal transformation.

References

Association of Mental Health Coordinators. (2024). AMHC. https://www.associationmhc.com/

Bailey, S., & Dickinson, P. (2016). The importance of safely de-roling. *Methods: A Journal of Acting Pedagogy*, 2.

Barton, R. (1994). Therapy and actor training. *Theatre Topics*, 4(2), 105–118. https://doi.org/10.1353/tt.2010.0081

Burgoyne, S., Poulin, K., & Rearden, A. (1999). The impact of acting on student actors: Boundary blurring, growth, and emotional distress. *Theatre Topics*, 9(2), 157–179. https://doi.org/10.1353/tt.1999.0011

Busselle, K. (2017). When the problem is personal: Working on Naomi Iizuka's Good Kids as a sexual assault survivor. *Fight Master: The Journal of the Society of American Fight Masters*, 39(2), 9–13.

Busselle, K. (2021). De-roling and debriefing: Essential aftercare for educational theatre. *Theatre Topics*, *31*(2), 129–135. https://doi.org/10.1353/tt.2021.0028

Busselle, K., & Fazio, H. (2023). Windows into revolutionary recovery: Check-ins, de-roling, and debriefing practices for rehearsal and performance. *Theatre/Practice: The Online Journal of the Practice/Production Symposium of the Mid America Theatre Conference*, *12*. https://www.theatrepractice.us/pdfs/Busselle-and-Fazio-Revolutionary-Recovery.pdf

Carello, J., & Butler, L. D. (2015). Practicing what we teach: Trauma-informed educational practice. *Journal of Teaching in Social Work*, *35*(3), 262–278. https://doi.org/10.1080/08841233.2015.1030059

Cavanaugh, B. (2016). Trauma-informed classrooms and schools. *Beyond Behavior*, *25*(2), 41–46. https://doi.org/10.1177/107429561602500206

Centre for Clinical Interventions. (n.d.). *Muscle tension*. https://www.cci.health.wa.gov.au/-/media/CCI/Mental-Health-Professionals/Panic/Panic---Information-Sheets/Panic-Information-Sheet---05---Progressive-Muscle-Relaxation.pdf

Chrismon, J. D. (2022). Trauma-informed practices in theatre education. *Pathways to Research in Education*, EDU087, 1–20.

Chrismon, J. D., & Carter, A. W. (2023). The absence of trauma-informed practices in the high school production process: A qualitative study. *Youth Theatre Journal*, 1–16. https://doi.org/10.1080/08929092.2023.2218719

Chrismon, J. D., & Marlin-Hess, M. (2023). Intimacy direction best practices for school theatre. *Drama Research*, *14*(1).

Cless, J. D., & Goff, B. S. N. (2017). Teaching trauma: A model for introducing traumatic materials in the classroom. *Advances in Social Work*, *18*(1), 25–38. https://doi.org/10.18060/21177

Counseling Center Group. (2024). *DBT Skill Intense Exercise | Transform your life today*. The Counseling Center Group. https://counselingcentergroup.com/dbt-skill-intense-exercise/.

Crosby, S. D., Howell, P., & Thomas, S. (2018). Social justice education through trauma-informed teaching. *Middle School Journal*, *49*(4), 15–23. https://doi.org/10.1080/00940771.2018.1488470

Dialectical Behavior Therapy. (2024). *TIPP: DBT skills, worksheets, videos, exercises*. https://dialecticalbehaviortherapy.com/distress-tolerance/tipp/

Ewan, V., & Green, D. (2015). *Actor movement: Expression of the physical being a movement handbook for actors*. Bloomsbury Publishing, Methuen Drama.

Ewan, V., & Sagovsky, K. (2019). *Laban's efforts in action: A movement handbook for actors*. Bloomsbury Publishing, Methuen Drama.

Gualeni, S., Vella, D., & Harrington, J. (2017). De-roling from experiences and identities in virtual worlds. *Journal of Virtual Worlds Research, 10*(2).

Lapum, M., Kennedy, K., Turcotte, C., & Gregory, H. (2019). Sole expression: A trauma-informed dance intervention. *Journal of Aggression, Maltreatment & Trauma, 25*(5), 566–580. https://doi.org/10.1080/10926771.2018.1544182

Lippe, W. (1992). Stanislavski's affective memory as a therapeutic tool. *Journal of Group Psychotherapy, Psychodrama & Sociometry, 45*(3).

Miller, K., & Flint-Stipp, K. (2019). Preservice teacher burnout: Secondary trauma and self-care issues in teacher education. *Issues in Teacher Education, 28*(2), 28–45.

Pace, C. (2020). *Staging sex: Best practices, tools, and techniques for theatrical intimacy* (1st ed.). Routledge.

Porges, S. (2015). Play as a neural exercise: Insights from the Polyvagal Theory. In Debra Pearce-McCall (Ed.), *The Power of Play for Mind Brain Health*, 3–7. https://mindgains.org/bonus/GAINS-The-Power-of-Play-for-Mind-Brain-Health.pdf

Psychology Today. (2024). Dialectical behavior therapy. https://www.psychologytoday.com/us/therapy-types/dialectical-behavior-therapy

Renken, N. D., Schiffer, A. A., & Saucier, D. A. (2023). Using content disclosures in our courses. *Faulty Focus*. https://www.facultyfocus.com/articles/course-design-ideas/using-content-disclosures-in-our-courses/?st=FFdaily;sc=FF230911;utm_term=FF230911&mailingID=5464&utm_source=ActiveCampaign&utm_medium=email&utm_content=Using+Content+Disclosures+in+Our+Courses&utm_campaign=FF230911

Schreyer, S. R. (2023). Promoting psychophysiological play: Applying principles of polyvagal theory in the rehearsal room. *Journal of Consent-Based Performance, 2*(1).

Shawyer, S., & Shively, K. (2019). Education in theatrical intimacy as ethical practice for university theatre. *Journal of Dramatic Theory and Criticism, 34*(1), 87–104. https://doi.org/10.1353/dtc.2019.0025

Shively, K. (2022). Using principles of theatrical intimacy to shape consent-based spaces for minors. *Journal of Consent Based Practice*, Spring, 74–80.

St. John, A. (2022). Thought bubble theatre festival: Applying and developing consent-based practices with pre-professional actors. *Journal of Consent-Based Performance, 1*(2), 111–136. https://doi.org/10.46787/jcbp.v1i2.2872

Tuisku, H. (2015). Exploring bodily reactions: Embodied pedagogy as an alternative for conventional paradigms of acting in youth theatre education. *Youth Theatre Journal, 29*(1), 15–30. https://doi.org/10.1080/08929092.2015.1006713

US Department of Veterans Affairs. (2019). PTSD Coach Online. https://www.ptsd.va.gov/apps/ptsdcoachonline/tools/relax-your-body/pages/files/progressive-muscle-relaxation-transcript.pdf.

Van der Kolk, B. (2015). *The body keeps the score: brain, mind, and body in the healing of trauma* (Reprint). Penguin Publishing Group.

Vorbeck, C. (2019). New directions in teaching theatre arts. A. Fliotsos & G.S. Medford (Eds.). Cham: Palgrave Macmillan (pp. xix + 310 + 7 illus.). *Theatre Research International*, 44(2), 221–222. https://doi.org/10.1017/S0307883319000208

Walton-Fisette, J. L. (2020). Fostering resilient learners by implementing trauma-informed and socially just practices. *Journal of Physical Education, Recreation & Dance*, 91(9), 8–15. https://doi.org/10.1080/07303084.2020.1811620.

7

Post-Production Processes

As the curtain falls for the last time and the production ends, as theatre educators we often feel drained, carrying the weight of guiding students, managing performances, and keeping everything on track. However, these final moments, though exhausting, are also some of the most meaningful. They offer vital opportunities for growth, healing, and connection, not just for students but for educators as well. How the production is wrapped up can leave a lasting impact, fostering personal development and emotional well-being. Educators must recognize the power of intentional closure, taking deliberate steps to nurture both their students' growth and their own resilience.

Closing rituals, reflection, and post-mortems are not just formalities; they are essential moments for emotional processing and personal growth. Leaning into these practices, even when energy is low or another production's beginning is approaching, allows educators to help students navigate challenges like post-production blues while modeling the importance of self-care. Acknowledging accomplishments, celebrating successes, and fostering meaningful closure strengthens bonds within the theatre community and ensures a smooth transition to future endeavors. This chapter calls on theatre educators to approach the post-production phase with purpose, knowing that their care and intentionality will shape the experience and inspire students long after the house lights dim.

Reflection and Debriefing Techniques

Reflection and debriefing are essential non-therapeutic practices for theatre educators, offering students opportunities to explore their experiences, emotions, and personal growth. When implemented with care, these practices create space for both individual introspection and group collaboration. Reflection encourages personal awareness, while debriefing facilitates structured conversations among participants. In trauma-informed theatre spaces, these processes allow students to engage with their experiences meaningfully without crossing into therapeutic territory (On the Stage, n.d.; Roberts, 2023; Roznowski & Domer, 2009).

Reflection might take place after the final performance, with students journaling about their experiences throughout the production. They could explore how various stages such as auditions, rehearsals, or performances shaped their artistic journey. A student may realize that stepping into a difficult role expanded their comfort zone, or that working with peers helped them develop stronger teamwork skills. Reflection might also involve creative activities like drawing or storytelling, allowing students to express their thoughts symbolically. These moments provide students with a safe space to engage with their emotions without the expectation of resolving complex feelings.

Debriefing often occurs through structured conversations following significant events, such as strike, where cast and crew share their insights. A theatre educator might open the discussion by asking participants about the most rewarding aspects of the process or the challenges they encountered. A student might reflect on overcoming stage fright, while another may express gratitude for peer support during a demanding tech week. One-on-one debriefing sessions can provide students with focused feedback, inviting them to explore questions like, "What part of the production are you most proud of?" or "How do you think you grew as an artist?" These discussions foster open communication, provide closure, and guide students toward future growth.

However, both reflection and debriefing must stay within the boundaries of theatre education. Theatre educators should avoid facilitating emotional processing, especially when trauma-related issues arise (Chrismon & Carter, 2023; Venet, 2019). Opening a conversation that leads to emotional labor without the skills to help a student close it can create harm. If an educator suspects that deeper emotional processing may occur, or if they feel additional support is needed, a mental health professional should be invited to lead the session. Educators are not trained to manage therapeutic conversations and

ensuring that these sessions remain non-clinical protects the well-being of both students and staff.

By maintaining these boundaries, theatre educators create a safe environment where students can reflect meaningfully and connect with their experiences without the expectation of therapeutic resolution. Reflection and debriefing promote personal growth and strengthen community bonds, preparing students for future artistic challenges. These practices empower students to develop self-awareness while ensuring that both their emotional well-being and artistic growth remain supported within the scope of theatre education

Post-Production Blues and Emotional Support

Post-performance depression, often called "post-production blues," is a well-documented phenomenon that affects many individuals in theatre, particularly actors and production crews, after a show concludes (Robson & Gillies, 1987). The emotional intensity of a production, combined with the deep bonds formed among cast and crew, can make the sudden absence of rehearsals and performances feel like a significant loss. Those experiencing post-production blues often report feelings of sadness, emptiness, and disconnection, which can linger for days or even weeks. These emotions are not simply fleeting disappointments but can resemble symptoms of clinical depression, making it essential for theatre educators to recognize and address the depth of this emotional response. By using trauma-informed practices, educators can provide the empathy and support students need to navigate these challenging moments.

Theatre educators play a key role in helping students transition out of a production by normalizing and validating their emotions. Acknowledging that it is entirely common to feel a sense of loss or sadness after a production ends can ease students' concerns and foster emotional acceptance. Trauma-informed practices encourage educators to create spaces where students can reflect on their achievements, helping them recognize personal growth and artistic progress throughout the process. Celebrating these accomplishments, whether through post-show gatherings or awards ceremonies, offers closure and reinforces a sense of completion. Setting future goals or discussing upcoming projects helps students maintain focus, shifting their energy toward new opportunities and keeping their enthusiasm alive.

Maintaining open communication is crucial to ensuring students feel supported and connected during this transition. Encouraging discussions about

the production, offering creative outlets for self-expression, and providing mentorship allow students to engage with their emotions constructively. Program-specific rituals such as reflection circles, show viewing parties, or poster signings can help students mark the end of one production while embracing what lies ahead. Offering students resources for self-care, including strategies like exercise, mindfulness, and journaling, reinforces healthy coping mechanisms. Promoting these practices supports students' well-being and teaches them how to care for themselves beyond the theatre. Additionally, guiding students back into a routine that emphasizes rest, proper nutrition, and time with loved ones fosters stability during this emotional transition.

By leaning into trauma-informed strategies, theatre educators ensure students feel seen, supported, and prepared to move forward. These approaches not only address the emotional complexities of post-production blues but also foster resilience, empowering students to embrace change and growth. Educators who prioritize connection, reflection, and self-care help students transition smoothly into future endeavors, leaving them with the confidence and tools needed to navigate the highs and lows of future theatrical journeys.

Post-Mortems: Creating Constructive Closure

Post-mortem discussions offer theatre educators and students a chance to reflect on a production's successes, challenges, and lessons learned (Busselle, 2021; Busselle & Fazio, 2023). Although post-mortems and debriefings both promote reflection, they serve distinct purposes. While debriefings focus on immediate experiences, logistical feedback, and emotional well-being shortly after an event, post-mortems offer a more comprehensive review. The goal of a post-mortem is to generate actionable insights, provide closure, and inform future productions. These discussions help theatre educators assess the production as a whole and develop long-term improvements for the program (Hishon, n.d.).

To conduct an effective post-mortem, theatre educators can use the Agile Retrospectives model to maintain structure and ensure productive conversations. This approach divides the discussion into focused sections, such as identifying what went well, what could have been improved, and what adjustments can be made in the future (Francino, 2021). By breaking the discussion into specific areas like communication, technical execution, and cast dynamics, educators can keep participants engaged and focused. A prompt such as, "What worked well during tech week?" encourages students to

reflect on successes, while a question like, "What unexpected challenges did we encounter, and how did we respond?" helps them analyze areas for growth. Providing guiding questions in advance gives students time to reflect and formulate meaningful contributions.

Throughout the post-mortem, creating a supportive atmosphere is essential to fostering open dialogue. Theatre educators should begin by highlighting positive aspects of the production, encouraging students to share what they found rewarding. Starting with successes helps participants feel recognized and valued, which increases engagement before moving on to more constructive feedback. Managing emotions with empathy is particularly important when addressing challenges. Feedback should focus on actions and decisions, not personal attributes, and the conversation should emphasize problem-solving rather than blame. If conflicts arise, educators should address them promptly, using collaborative strategies to reach resolution.

A well-facilitated post-mortem goes beyond critique, offering students and educators insights that contribute to continuous improvement (On the Stage, n.d.). Documenting key takeaways ensures that lessons learned are not forgotten. Educators can compile these insights into a summary that becomes a reference for future productions, fostering a culture of learning and growth within the theatre program. Regular follow-ups after the post-mortem, such as checking in on whether identified improvements have been implemented, reinforce the importance of reflection and demonstrate a commitment to meaningful change.

Three Examples of Post-Mortems

Agile Retrospectives Model

- What worked well for us?
- What did not work well for us?
- What actions can we take to improve our process going forward?

Graffiti Wall
Affix large sheets of paper to a wall as a visual and textual response platform, with separate sheets representing different phases of the process: *Pre-Production, Rehearsals and Run of the Show, and Post-Production.* This set-up allows cast and crew members to reflect on and engage with each stage of the production experience. Provide participants with markers and invite them to draw symbols, create sketches, or write words that capture their thoughts, impressions and insights throughout the process.

Possible Reflection Questions
- What took place during each phase? (What did you observe, feel, or hear?)
- What insights did you gain from the group's feedback?
- What moments felt significant or challenging during the production process?
- How did you perceive your own and the group's progression from start to finish?
- Are there specific areas or elements you would like to explore further as a group?

How to Conduct an In-Depth Post-Mortem for School Theatre Programs

A. **Schedule a Final Meeting with the Entire Company (Include in Rehearsal Schedule):** Plan a celebratory meeting for the entire cast and crew to reflect on the production. Encourage self-evaluation with questions like:

 o Did we meet our creative objectives?
 o What are we especially proud of?
 o What might we do differently to better achieve our goals?

B. **Incorporate Community Feedback:** Share congratulatory messages and audience feedback to create a positive atmosphere. Celebrate accomplishments together, providing a sense of closure and pride for the entire team.
C. **Emphasize the Educational Impact:** Highlight the production's alignment with educational goals, including mission objectives, curricular connections, and student participation. Emphasize partnerships and learning opportunities that emerged during the process.
D. **Express Gratitude:** Thank everyone involved, from production leaders and crew members to volunteers, caregivers, sponsors, and administrators, acknowledging their contributions to the production's success.
E. **Discuss Operational Goals:** Reflect on operational aspects like audience engagement, social media, sales, time management, partnerships, and task delegation. Evaluate how these goals contributed to the production's overall success.
F. **Foster a Growth Mindset and Reflection:** Encourage individual reflections on personal experiences and contributions. Consider creative activities, like awards, improv games, or creative writing, to support self-reflection and celebrate growth.

> G. **Use Reflective Questions:** Guide students through a meaningful reflection on all aspects of the production—from process and selection to casting, rehearsals, and their overall experience. Encourage honesty, self-awareness, and constructive feedback, modeling these values throughout.
> H. **Celebrate Achievements and Learn from Challenges:** Acknowledge successes and identify areas for improvement. Foster a growth mindset by focusing on learning from challenges and recognizing growth opportunities.
>
> *Create an online form for individuals who prefer to share feedback privately rather than speaking openly, allowing them to contribute their insights comfortably and anonymously if desired.*
>
> * Adapted from "The Theatre Postmortem Demystified" by On the Stage and "Coming to an End: Reflecting on Your Process" by Kerry Hishon at Theatrefolk.

Ongoing Support in the Post-Production Process

After staging a production with traumatic themes, providing ongoing support for students is essential, even when access to the full group becomes limited post-production (Chrismon & Carter, 2023; Schreyer, 2023; Shively, 2022; St. John, 2022). In the absence of the structured environment offered by rehearsals and performances, theatre educators must find creative ways to maintain connection and support. Regular individual check-ins through emails, phone calls, or one-on-one meetings offer students the chance to share lingering emotions or challenges in a more personal setting. Group discussions can still take place, but with lower participation expected, educators might need to adjust these to smaller gatherings or virtual formats that fit students' schedules.

Using surveys or anonymous feedback tools allows students to express thoughts they may not feel comfortable sharing openly, while also helping educators identify any unresolved issues. Educators can promote reflective practices by encouraging students to journal their post-production experiences or engage in creative outlets like drawing or storytelling. If follow-up conversations are needed, these reflective activities can serve as entry points for deeper dialogue. Inviting guest experts for post-production discussions, even in smaller settings, can provide additional emotional support and resources when full-cast gatherings are no longer feasible (Anderson et al., 2022).

Maintaining a sense of community during the post-production phase can be challenging, but intentional efforts to stay connected foster emotional well-being and empathy among students. Educators can schedule informal meetups, such as cast reunions, or create online spaces where students can reconnect and reflect on their experiences together. Even simple gestures, like sending out a group message or organizing a small awards event, can reinforce a sense of closure and belonging. Self-care practices remain important during this time, so educators should encourage students to prioritize rest, healthy routines, and personal reflection.

When conflicts or unresolved issues surface, educators should respond with empathy and transparency, offering mediation or small-group dialogues where needed. Although the production has ended, maintaining open communication ensures that students feel supported as they navigate their emotions. Providing access to counseling services or additional resources reinforces students' well-being and ensures they know where to turn if they need further support. These strategies help theatre educators transform the post-production phase into a meaningful continuation of the theatre experience, fostering resilience, growth, and connection even as the formal production ends.

Personal Reflection and Self-Care for Theatre Educators

The role of a theatre educator goes beyond directing performances; it involves emotional investment, dedication, and a deep connection to each production. While celebrating the accomplishments of students is essential, educators must also take time to reflect on their own experiences. Personal reflection helps educators recognize their efforts, confront challenges, and grow in their teaching practice (Lazarus, 2005). Without this intentional pause, valuable lessons may be missed, and unresolved emotions can carry into the next project, hindering personal growth. Journaling or engaging in artistic activities can provide clarity about successes, challenges, and connections that shaped the experience, while tracking insights over time aids in planning future productions. Some educators might seek renewal through quiet reflection or artistic pursuits to reconnect with their passion for theatre.

Setting goals for future productions, such as improving student collaboration or refining rehearsal structures, is another key aspect of reflection. Equally important is reflecting on self-care, ensuring that routines between productions, such as scheduling time off or engaging in hobbies, allow for recharging. This reflection not only enhances personal well-being but also models healthy practices for students, promoting self-awareness and continuous learning. Through intentional reflection,

theatre educators build resilience and maintain the sustainability of their teaching practice.

In addition to reflection, prioritizing self-care after a production is vital for preventing burnout and sustaining the passion needed for future work. We have discussed that self-care is not just pampering. However, after the emotional highs and lows of a production, a little pampering is certainly earned. Small indulgences—whether enjoying a special meal, taking a day off, or spending time with friends—offer much-needed restoration. These moments are more than a reward; they provide a way to reconnect with yourself after weeks or months of pouring energy into others. When theatre educators care for themselves, they create a foundation for a sustainable, thriving program ready for the next creative journey.

It Still Goes Back to Intentionality

Sustaining intentionality with the strategies outlined in this chapter is perhaps the greatest challenge for theatre educators. We have found that as the post-production phase unfolds, maintaining a trauma-informed approach becomes increasingly difficult. Many educators quickly shift their focus to planning, preparing, and casting for the next production, leaving little time for meaningful reflection and debriefing from the previous one. In this rush to move forward, critical insights and lessons often go unexamined. Additionally, once students complete their roles, they disperse in various directions, making it harder to reassemble and engage them in discussions or celebrations. Theatre educators also tend to neglect their own self-care and reflection, which undermines the continuity of trauma-informed practices within the educational framework (Chrismon & Carter, 2023). By resisting the urge to rush ahead, theatre educators can honor the impact of each production, fostering meaningful growth that students carry with them throughout their lives. We urge educators to slow down, reflect intentionally, and care for themselves, knowing that these practices are essential for sustaining trauma-informed education and building compassionate, confident artists for the future.

References

Anderson, K. M., Haynes, J. D., Ilesanmi, I., & Conner, N. E. (2022). Teacher professional development on trauma-informed care: Tapping into students'

inner emotional worlds. *Journal of Education for Students Placed at Risk (JESPAR), 27*(1), 59–79. https://doi.org/10.1080/10824669.2021.1977132

Busselle, K. (2021). De-roling and debriefing: Essential aftercare for educational theatre. *Theatre Topics, 31*(2), 129–135. https://doi.org/10.1353/tt.2021.0028

Busselle, K., & Fazio, H. (2023). Windows into revolutionary recovery: Check-ins, de-roling, and debriefing practices for rehearsal and performance. *Theatre/Practice: The Online Journal of the Practice/Production Symposium of the Mid America Theatre Conference,* 12. https://www.theatrepractice.us/pdfs/Busselle-and-Fazio-Revolutionary-Recovery.pdf

Chrismon, J., & Carter, A. W. (2023). The absence of trauma-informed practices in the high school production process: A qualitative study. *Youth Theatre Journal,* 1–16. https://doi.org/10.1080/08929092.2023.2218719

Francino, Y. (2021). Agile retrospective. Tech Target. https://www.techtarget.com/searchsoftwarequality/definition/Agile-retrospective

Hishon, K. (n.d.). *Coming to the end: Reflecting on your process.* Theatrefolk. https://www.theatrefolk.com/blog/coming-end-reflecting-process

Lazarus, J. (2005). Ethical questions in secondary theatre education. *Arts Education Policy Review, 107*(2), 21–25. https://doi.org/10.3200/AEPR.107.2.21-26

On the Stage. (n.d.). *Planning your theatre post-mortem process.* On the Stage. https://onthestage.com/blog/planning-your-theatre-post-mortem-process/

Roberts, L. (2023). *Post-Mortem: 5 wonderful ways to reflect.* Pioneer Drama. https://www.pioneerdrama.com/Newsletter/Articles/Post-Mortem.asp

Robson, B. E., & Gillies, Eleanore. (1987). Post-performance depression in arts students. *Medical Problems of Performing Artists, 2*(4), 137–141.

Roznowski, R., & Domer, Kirk. (2009). *Collaboration in theatre a practical guide for designers and directors.* Palgrave Macmillan.

Schreyer, S. R. (2023). Promoting psychophysiological play: Applying principles of polyvagal theory in the rehearsal room. *Journal of Consent-Based Performance, 2*(1).

Shively, K. (2022). Using principles of theatrical intimacy to shape consent-based spaces for minors. *Journal of Consent Based Practice,* Spring, 74–80.

St. John, A. (2022). Thought bubble theatre festival: Applying and developing consent-based practices with pre-professional actors. *Journal of Consent-Based Performance, 1*(2), 111–136. https://doi.org/10.46787/jcbp.v1i2.2872

Venet, A. S. (2019). Role-clarity and boundaries for trauma-informed teachers. *Educational Considerations, 44*(2). https://doi.org/10.4148/0146-9282.2175

8

Trauma-Informed Practices in the Theatre Classroom

Introducing trauma-informed practices into the 9–12 grade theatre classroom is essential for fostering a supportive and effective learning environment. Trauma can significantly impact students' ability to learn and regulate their emotions (Brunzell, Stokes, & Waters, 2016). Students who have experienced trauma can often struggle with behavioral and emotional regulation and building meaningful relationships, factors which can limit their academic success. As theatre educators, we have a unique opportunity to support our students by fostering a stable and nurturing classroom environment, which may often serve as the most consistent and reliable space in a trauma-affected student's life (Perry, 2006).

As discussed extensively in Part 1, trauma-informed practice in the theatre classroom is anchored in the "4 R's": realizing the impact of trauma, recognizing its signs, responding with supportive strategies, and resisting re-traumatization. Trauma-informed practices also uphold six core principles: safety, trust, peer support, collaboration, empowerment, and cultural responsiveness. Together, these principles create an environment that prioritizes students' emotional well-being. Part 1 further emphasizes that educators should be mindful of their own self-care and consider the impact of their identities—and those of their students—on classroom dynamics. Additionally, the need to address legal and ethical considerations specific to each school and state, with a focus on consent and boundaries, is essential for fostering respectful and inclusive spaces. These practices not only protect students and educators but also enrich engagement and creativity in the theatre classroom.

Theatre classes, with their emphasis on creative storytelling, teamwork, and emotional exploration, provide students with a unique space to express themselves, build confidence, and develop vital communication and empathy skills. The strategies covered in earlier chapters, which focus on production techniques, are equally relevant in classroom settings, underscoring the importance of consistent trauma-informed practices across all facets of theatre education. For educators who integrate production elements into their teaching, revisiting the production-focused chapters can offer additional guidance and insights. These practices not only enhance the creative experience, but also establish a strong foundation for effective classroom management.

We believe that the foundation of effective classroom management lies in building strong, supportive relationships with students, a principle that is consistently supported in trauma-informed research. Studies have shown that positive teacher-student relationships, characterized by trust, empathy, and mutual respect, are essential in creating an environment where students feel safe, engaged, and ready to learn (Rimm-Kaufman, 2015; Hamre & Pianta, 2001). These connections help students develop resilience and emotional regulation, particularly those with trauma histories, by providing a stable anchor in the classroom. Research further suggests that students who experience strong, positive relationships with their educators are more likely to exhibit self-regulation, cooperation, and academic engagement, and are less likely to engage in disruptive behaviors (Curby, Rimm-Kaufman, & Ponitz, 2009; Birch & Ladd, 1997). With this foundation in mind, we invite you to view the remainder of this chapter as a guide to operationalizing "relationships" in practical ways, offering strategies to foster meaningful connections that support both classroom management and students' overall well-being.

The Adolescent Brain

In order to talk about relationships with our students, we must talk about the adolescent brain. Adolescence is a crucial time for brain development, with the prefrontal cortex, the area involved in planning, decision-making, impulse control, and emotional regulation, not reaching full maturity until the mid-to-late 20s (NIMH, 2024). We often use the term "Jell-O-brain" to describe this stage of development, a respectful and lighthearted way to convey that certain parts of the brain are still solidifying, much like Jell-O setting in the fridge. Just as Jell-O needs time to set, the adolescent brain also requires time to fully develop. This does not imply there is anything "wrong" with the adolescent brain for needing time to mature, nor does it mean that teens are at

fault for not yet having a fully developed brain. Instead, it simply highlights the natural phase of growth they are experiencing.

Researchers have shown that trauma can physically alter the brain's structure during this formative period, when the "Jell-O" is still setting and thus more vulnerable to external influences. Trauma can impact the development of the prefrontal cortex and other areas, leading to heightened sensitivity to stress, increased anxiety, and challenges with emotional regulation (Teicher et al., 2016; McCrory, Gerin, & Viding, 2017). These changes can complicate adolescents' ability to manage impulse control, plan effectively, and respond calmly to stressors. Understanding these potential impacts underscores the importance of trauma-informed practices in the classroom, which provide essential support for emotional and cognitive development. Trauma-informed approaches help create a stable environment that respects and supports each student's growth, fostering resilience and healthy adaptation even amidst the challenges that trauma may bring (Anda et al., 2006; Shonkoff et al., 2012).

It is important for theatre educators to remember that, regardless of how mature students may look or sound, they are still children. When they do "act their age," it can be unexpected or even unsettling, but these moments call for educators to respond with patience and understanding. While educators cannot control student actions, they can control their own reactions, making it essential to model the calmness and understanding they hope to cultivate in their students. By consistently acting as the steady, supportive presence in the room, educators foster an environment where students feel valued and encouraged to grow. This approach not only guides students toward positive behavior but also strengthens resilience and emotional safety, both of which are foundational to trauma-informed teaching.

Power Dynamics

In any theatre classroom or rehearsal setting, power dynamics are inherently present, shaped by elements such as race, gender, education, and authority. Acknowledging this dynamic openly with students is essential, as it affects how they engage, express themselves, and set their boundaries. By addressing these power imbalances from the outset, we create space for candid discussions on privilege and authority, encouraging students to feel more empowered within the room. This transparency fosters a learning environment where students feel comfortable advocating for themselves, with the

understanding that the power structures at play are part of broader societal patterns that we aim to address and dismantle within our classrooms. Through this acknowledgment, we build trust and model the importance of self-awareness in creating inclusive and equitable spaces.

Secondary school theatre educators occupy a unique role, often forming meaningful connections with their students due to the extended time spent together and the emotional depth involved in theatrical exploration (Chrismon & Carter, 2019). For these educators, fostering ethical relationships founded on respect and care is paramount (Shawyer & Shively, 2019). Theatre students, driven by a desire to fully engage in the process, are frequently willing to go to great lengths to be involved (Vorbeck, 2019). However, this eagerness can be problematic when traditional theatre practices, like the "show must go on" mentality, encourage students to disregard their physical and emotional needs, reinforcing a culture where they feel they lack control over their well-being (Horn, 2020; Shawyer & Shively, 2019).

Theatre educators have a unique opportunity to reshape these traditional power dynamics. Rather than serving as the sole authority figure, educators can foster an environment where students feel empowered to voice their concerns and advocate for their own needs and safety (Chrismon & Marlin-Hess, 2023). This shift can be supported by implementing practices like self-care cues (e.g., "button," "pause," or "stop") during class or rehearsals. When a student uses a cue, the educator responds with "What do you need?" without requiring the student to justify their boundary. This gives students the chance to suggest alternative approaches that feel more comfortable, with the educator accommodating or negotiating a solution that respects both parties' needs (Pace, 2020). Such practices provide students with agency, reinforcing the importance of consent and promoting a more balanced and respectful classroom dynamic.

Within the larger theatre landscape, power and privilege can lead to abuses when the educator or director is perceived as the ultimate authority (Shawyer & Shively, 2019). This hierarchical dynamic is deeply embedded in both the theatre industry and secondary education, where students are expected to be willing, vulnerable, and disciplined, while educators provide guidance and approval (Seton, 2010). By incorporating consent-based practices, theatre educators can move away from these traditional, authoritarian models. This shift enables an environment where students advocate for their bodily autonomy, engage more deeply with the material, and reflect on their experiences with greater clarity (Daugherty, Hertzberg, & Wagner, 2020; Shively, 2022).

Planning

Intentional planning is vital in trauma-informed theatre teaching, particularly when crafting lessons, units, and curricula. By focusing on student well-being, trauma-informed planning recognizes the significant impact trauma can have on students' lives and how it shapes their learning processes (Cless & Goff, 2017; Minahan, 2019; Morton & Berardi, 2018; National Child Traumatic Stress Network, Schools Committee, 2017). Understanding that each student carries unique experiences that affect behavior and learning, educators can strengthen their practice by embedding trauma-informed principles into every phase of planning. Acknowledging trauma's effects on students' behavior and learning forms the foundation of this approach, which emphasizes flexibility and adaptability in lesson design.

The pre-production planning strategies discussed in Chapter 5 provides a foundational approach that parallels trauma-informed planning. Just as pre-production requires attention to the entire production process, developing a theatre curriculum requires careful consideration of students' needs, multiple engagement pathways, and clear expectations. Building on these pre-production strategies, the following trauma-informed practices add layers of support focused on student well-being. Thoughtful planning anticipates diverse student needs, provides varied participation options, and designs adaptable lessons to support students' comfort and engagement. Whether choosing plays, crafting assignments, or structuring activities, each decision should embody a commitment to a trauma-sensitive and inclusive learning environment, fostering safety, trust, and empowerment.

Flexible Curriculum Structure

Theatre educators frequently have the flexibility to shape our curriculum, which provides a valuable opportunity to create a supportive and inclusive learning environment tailored to students' diverse needs. This flexibility allows educators to design a curriculum that not only meets educational goals but also addresses students' emotional and psychological well-being. For instance, in a lesson involving physical exercises, a student who may feel uncomfortable with this type of activity could be given an alternative assignment. Rather than participating directly, the student could observe their peers, analyze the dynamics of the exercise, and complete a reflective writing task that captures their observations and insights. This option respects the student's boundaries while still

allowing them to engage intellectually and creatively with the content. Such an approach accommodates different comfort levels, ensuring students feel safe and valued, regardless of their personal preferences or past experiences.

Flexible curriculum planning also means offering various pathways for participation throughout the course. For instance, while some students may thrive in group improvisation exercises, others may benefit from solo work or activities that emphasize non-verbal expression. By designing assignments that allow for individual expression alongside group collaboration, educators can provide choices that honor students' unique learning styles and comfort zones. This approach not only respects students' autonomy but also reinforces the importance of consent and agency in the learning process.

Thoughtful Material Selection

Theatre courses, unlike other subjects tied to high stakes testing, allow for creative and flexible content choices, such as plays, monologues, videos, guest artists, and theatre games. With this flexibility comes the responsibility to consider community values and involve administrators when selecting potentially sensitive material. For instance, if a scene addresses mental health issues, discussing its purpose and educational goals with administrators can build support and address any concerns proactively. This proactive approach ensures that students can engage with challenging material in a supportive environment, backed by understanding and care from both educators and administrators.

Addressing Potential Triggers

Planning to mitigate potentially triggering material is essential in a trauma-informed theatre classroom. When selecting scenes or topics, educators should anticipate themes that may evoke strong emotions and provide content disclosures early. For instance, informing students, caregivers, and administrators in advance about sensitive content such as scenes involving loss or abuse enables students to opt for alternative assignments if necessary. This preparation prevents retraumatization and ensures a supportive network ready to help students navigate challenging material.

Cross-Curricular Collaboration

Collaborating with other educators for interdisciplinary units enriches students' learning by connecting theatre with subjects like history, language arts, or social studies. Partnering with school counselors and administration to integrate emotional, academic, and social supports throughout the course

further ensures students have the resources they need. This team approach reinforces a trauma-informed environment across the school, fostering a cohesive support system where students feel safe in all aspects of their education.

Incorporating Students' Identities
Recognizing the diversity of students' cultural, racial, gender, and personal experiences is a key aspect of trauma-informed planning. Selecting diverse plays, monologues, or projects empowers students by reflecting their backgrounds in the curriculum. educators should also strive to understand the cultural and social contexts of their students, facilitating discussions around these identities and allowing students to share perspectives. Additionally, inviting students to bring in or suggest materials in which they see themselves further personalizes the curriculum and validates their identities. This inclusivity builds empathy among peers and helps students feel seen and valued in their theatre work.

Caregiver Communication
Establishing early contact with caregivers is essential for building trust and creating a collaborative support system that benefits students throughout the year. Start with a welcoming introduction at the beginning of the semester through a letter, email, or brief video to introduce yourself, share an overview of your program, and outline curriculum goals. Consider hosting a virtual or in-person "Meet the Teacher" night to answer questions and provide caregivers with insight into the theatre class structure. Regular updates, such as a monthly newsletter or email highlighting class activities and upcoming projects, help caregivers stay engaged and informed. This consistent communication fosters a supportive network, making it easier to address challenges or celebrate student successes.

Structure and Routine
Establishing a consistent structure and routine in the theatre classroom creates a sense of safety and predictability, which is particularly important for students with trauma histories. Clear procedures for common needs, such as breaks, water, and restroom access, provide a foundation of security, allowing students to focus on learning without anxiety. Collaboratively creating community agreements further enhances this sense of structure, empowering students to have a voice in shaping the rules they follow and fostering a shared sense of responsibility. Thoughtful classroom organization, including seating arrangements and accessible placement of materials, contributes to a well-ordered and reliable environment that supports both learning and emotional well-being.

Enrolling and Deroling for Classroom Structure

Both enrolling and deroling are essential components of effective theatre teaching, but they require intentional planning. Without incorporating these rituals into the lesson design, they are easily overlooked in the flow of class activities. Planning for these moments ensures that the transition into and out of theatre class is purposeful, setting students up for success and supporting their emotional well-being. By making time for enrolling and deroling, educators create a structured environment that values both the artistic process and the holistic needs of their students.

In the theatre classroom, enrolling students into the space is essential for setting a tone of focus, creativity, and community. Utilizing consistent rituals like warm-ups, clear expectations, and familiar routines helps students shift from their previous activities into the mindset of theatre class. Rituals such as breathing exercises, vocal warm-ups, or a short circle check-in allow students to center themselves and prepare for the work ahead. This intentional transition signals to students: "This is my theatre class. This is what is expected of me in this space. This is how I interact with this group of peers and this teacher." By establishing these routines, students know they are entering a space where they can safely explore, collaborate, and express themselves. These rituals foster a sense of belonging and create a consistent framework that guides students into the roles of engaged, creative participants ready for the unique challenges of theatre work.

Just as enrolling helps students step into the theatre space, deroling is an important process to help them step out of it and re-enter the rest of their school day. Closure rituals, like a cool-down activity, reflection prompts, or a collective deep breath, allow students to transition away from the heightened emotions and creative focus of theatre class. Taking time for this intentional deroling helps students leave behind any intensity or vulnerability they may have experienced, grounding them before they move on to their next class or activity. It signals to students: "Our time in theatre is ending, and it's time to shift back into the rhythm of the rest of the school day." These closure practices are crucial for emotional regulation and mental clarity, helping students carry the lessons of theatre with them while letting go of any residual stress or tension.

Physical Environment

The physical layout of the theatre classroom, whether in a traditional room or an auditorium, plays a vital role in creating a supportive and inclusive environment. Thoughtfully designed seating arrangements, such as whether

it is assigned or flexible, allow students to select spots where they feel most comfortable and secure. In an auditorium setting, designating specific work areas and establishing clear boundaries promote physical safety, while creating quiet zones for emotional regulation provides students with spaces to manage stress. Additionally, being mindful of disabilities and mobility differences is essential to fostering an inclusive space. Ensure that seating, entrances, exits, and any performance or rehearsal areas are accessible to all students and, consider seating options that support various physical needs. Incorporating elements such as fidget toys, adjustable lighting, and accessible seating options further enhances inclusivity by catering to a diverse range of needs. Room decor that reflects students' varied backgrounds and identities reinforces the message that the theatre space is welcoming and embraces diversity, making it a space where all students feel valued and at ease.

Trauma Anniversaries

Planning for trauma anniversaries is an important part of trauma-informed teaching, as significant dates tied to personal, or community events can have a profound impact on students' well-being and engagement. We acknowledge that educators may not always be aware of these dates, and it is not the responsibility of the student to disclose such personal information. However, when educators are informed, either through collaboration with school counselors or other supportive channels, they can provide thoughtful accommodations. For example, if a student is approaching the anniversary of a traumatic event, offering flexibility in assignments or providing alternative activities can help them manage their emotions during this challenging time. This approach reinforces the classroom's role as a safe, supportive space where students' emotional and academic needs are respected and nurtured.

By incorporating these trauma-informed strategies into curriculum planning, theatre educators create a compassionate, adaptable environment. This intentional planning allows students to explore theatre confidently, knowing that their well-being is valued and that the space respects their individual needs and experiences.

Teaching

In a trauma-informed theatre classroom, teaching mirrors the dynamic nature of rehearsals, requiring theatre educators to demonstrate flexibility, empathy, and a commitment to student well-being. Like directors adapting

to performers' needs, theatre educators must remain attentive to the emotional and physical dynamics in the room, adjusting activities, pacing, and support to sustain a safe, supportive environment. This approach creates a space where students feel empowered to take risks, express themselves, and explore without fear of judgment. By honoring each student's boundaries, educators encourage artistic growth within a compassionate, adaptable framework. The following principles and practices provide a foundation for building this inclusive, nurturing atmosphere.

Clear Communication and Consistency

Clear communication of expectations, directions, and routines is essential in a trauma-informed theatre classroom, as it fosters a stable, predictable environment that supports emotional safety. Transparent and consistent guidelines allow students to feel secure and confident in their participation, especially in a setting that often calls for vulnerability and collaboration. Establishing a routine such as a structured warm-up, a focused lesson, and closure helps students transition smoothly between activities, reducing anxiety. While consistency is key, allowing for flexibility within this structure enables educators to adapt to students' changing needs without sacrificing stability. This approach does not remove spontaneity from the theatre classroom; rather, it ensures that spontaneity exists within a framework of trust. By clearly communicating what will happen and following through, educators reinforce trust and respect, creating a classroom where students feel empowered to engage fully and creatively.

Community Agreements

Community agreements are a cornerstone in establishing consent-forward, trauma-informed environments, especially in theatre classrooms, where emotional depth and personal experiences are integral to the work. These agreements, collaboratively developed by students and educators, set guidelines for respectful communication, boundary-setting, and mutual support, all which are key elements in fostering a safe, inclusive, and empowering space (Himelstein, 2016). By inviting students to actively contribute to the creation of these agreements, theatre educators ensure that classroom norms reflect the collective needs and values of the community. This approach not only promotes a sense of ownership but also encourages students to engage in maintaining a respectful environment as they explore emotionally charged material.

The co-creation of community agreements also plays a critical role in balancing power dynamics within the classroom. When students have a say in defining expectations for behavior and interaction, it shifts the dynamic from an educator-led authority to a shared responsibility, empowering students to advocate for themselves and each other (Bradd, 2020). This collaborative framework supports trauma-informed classroom management and reinforces consent-based practices that help students set boundaries and express their needs openly. Community agreements function as living documents, enabling the group to revisit and adjust them as needed (Anti-Oppression Network, 2024). This adaptability ensures that the agreements remain relevant and responsive to the evolving needs of the class, fostering a culture of dialogue, accountability, and mutual respect.

Integrating community agreements into theatre classrooms helps reduce the risk of retraumatization, establishing a foundation of trust and respect that enhances student engagement. As these agreements articulate the shared values of the group, they provide a clear framework for navigating challenging material and sensitive discussions. Regular reflection and revision of the agreements empower students to hold themselves and one another accountable, creating a trauma-informed environment where emotional safety and creative exploration coexist.

Creating a community agreement with theatre students requires a thoughtful, collaborative process that allows everyone in the room to contribute their perspectives and values. This co-creation process sets the tone for how the group will work together throughout the course or production (St. John, 2022). To start, educators can facilitate discussions with guiding questions such as, "How do we work best together?" or "What does respect look like in this space?" (CAEA, 2024). These prompts encourage students to reflect on what makes them feel safe and respected in a classroom or rehearsal environment. It is essential to give students time to consider their answers, either through open discussion or individual reflection, and to compile their ideas into a collective list that everyone supports (Bradd, 2020).

The language of the agreement should be clear, positive, and action-oriented, focusing on behaviors that promote respect and inclusion. Using "we will" statements, such as "We will listen to each other without interrupting" or "We will take care of ourselves and others," helps establish a collaborative tone (Roberts, 2023). Once the agreement is finalized, it is crucial to revisit it regularly, allowing it to remain a living document that can be updated as the group evolves (Anti-Oppression Network, 2024). Engaging students in this process not only fosters a culture of accountability, but also empowers them to play an active role in shaping a safe, inclusive environment.

School Theatre Program Community Agreement for Theatre Class or [Play Name] Cast and Crew

Purpose: The School Theatre Program is dedicated to fostering a safe, inclusive, and respectful environment for all participants involved in our productions. This community agreement outlines the principles and expectations that guide our interactions and behaviors during rehearsals, performances, and all program-related events. This is a living document created by the students, director, and any other stakeholders in the production process.

Our Community Agreements
1. **Respect and Inclusivity**
 - We treat all participants, including performers, crew, staff, and volunteers, with respect and kindness, regardless of age, gender, race, ethnicity, ability, sexual orientation, or religious beliefs.
 - We create a welcoming space where everyone feels valued, heard, and included.
2. **Celebration and Encouragement**
 - We celebrate the talents and efforts of our fellow cast and crew members, offering encouragement and support.
 - We honor vulnerability and authenticity, allowing for emotional expression and growth.
3. **Rejection of Discrimination and Harassment**
 - We reject all forms of discrimination, bullying, and harassment within our community, including but not limited to sexism, racism, homophobia, ableism, and religious intolerance.
 - We stand up against unfair treatment or hurtful behavior and support those who may experience discrimination or mistreatment.

What We Don't Do in Our School Theatre
- We do not tolerate disrespectful language or behavior, including teasing, name-calling, or exclusion.
- We do not engage in any form of bullying, cyberbullying, or intimidation toward others.
- We do not make jokes or comments that are hurtful or offensive to others' identities or backgrounds.

Reporting Violations
- If you witness or experience harassment or any violation of this community agreement, please report it immediately to the [School Name] Theatre Program Director or a trusted adult.
- Reports can also be submitted anonymously through the school's reporting system, ensuring confidentiality and prompt resolution.

Consequences of Violations
- Participants who engage in disrespectful or harmful behavior may face consequences, such as loss of participation privileges or disciplinary action, as determined by program leadership.
- We prioritize the safety and well-being of all participants and take appropriate measures to address reported violations.

Taking Care of Ourselves and Each Other
- We encourage participants to prioritize their mental and emotional well-being, seeking support from trusted adults or school counselors as needed.
- We commit to fostering a culture of empathy, kindness, and understanding, where everyone feels valued and supported in their artistic endeavors.

Student Signature
By signing below, I acknowledge that I have read and agree to abide by the terms of this community agreement.

_____ _____ _____
Signature Printed Name Date

Teacher Signature
By signing below, I acknowledge that I have read and agree to abide by the terms of this community agreement.

_____ _____ _____
Signature Printed Name Date

This community agreement reflects our shared commitment to creating a positive and inclusive environment within the School Theatre Program, where every participant can thrive and express themselves creatively with confidence and respect.

The Importance of Transparency

Transparency in teaching is essential, especially for students who have experienced trauma. Explaining the "why" behind assignments and activities helps build trust, allowing students to see the purpose and goals of their work more clearly. This openness not only fosters trustworthiness but also demonstrates that the tasks assigned are meaningful and directly connected to their learning journey. By sharing your decision-making process, you are also modeling

how to make thoughtful, intentional choices, teaching students a valuable skill they can apply in their own lives. Transparency reduces ambiguity, which can help alleviate anxiety and create a greater sense of security in the classroom. By consistently sharing your reasoning, you create an environment where students feel respected and included in the educational process which is a particularly grounding approach for students with trauma histories.

Honoring Consent and Boundaries

Enforcing and honoring consent and boundaries in the theatre classroom is essential to creating a safe, supportive environment where all students feel respected and empowered. As an educator, modeling these behaviors establishes a standard for how students should interact with one another and respect their own personal boundaries. Avoid physical touch unless it is absolutely necessary and has been explicitly consented to, recognizing that students may have diverse comfort levels, particularly those with trauma histories.

Provide students with alternatives for participation that respect their boundaries, allowing them to engage in ways that feel safe and comfortable. For example, if an exercise involves close physical proximity or heightened emotional expression, offer students the option to observe, take on a different role, or engage in a way that aligns with their comfort level. This flexibility supports students' autonomy and helps build trust, as they understand their boundaries will be respected.

Honoring consent goes beyond individual interactions; it also means creating an environment where students feel empowered to voice their needs and where their boundaries are consistently upheld. Encourage open communication by inviting students to express when they feel uncomfortable and validating those feelings without judgment. This approach not only empowers students to take ownership of their comfort and participation but also reinforces the importance of consent as a foundation for all interactions within the classroom. Over time, this creates a culture of mutual respect and trust, where students feel safe to explore, create, and connect without fear of boundary violations.

Caregiver Communication During Active Learning

When students are actively engaged in the classroom, maintaining consistent caregiver communication can be challenging, yet it remains essential for providing ongoing support, particularly as students navigate challenging

material or emotional responses. Building on the communication plans developed in the planning phase, theatre educators should implement strategies that are both efficient and informative. One effective approach is to schedule regular, brief updates such as weekly or bi-weekly emails to highlight key class activities, upcoming projects, and general student progress. These updates do not need to be lengthy; a concise summary with bullet points or highlights can effectively keep caregivers informed and engaged without requiring extensive time from the educator. Using a simple template can streamline these updates, ensuring consistency and efficiency.

In addition to scheduled communications, educators should aim for timely follow-ups when specific concerns or achievements arise. For example, if a student demonstrates notable progress or faces a challenging moment, a quick, individualized message to the caregiver can help keep them informed and create a positive context for addressing any future issues. Utilizing a school-approved messaging app or group email for real-time updates is also beneficial, particularly when sudden changes or important reminders need to be communicated promptly. Open lines of communication allow theatre educators and caregivers to proactively address potential issues, ensuring that caregivers are not caught off guard by concerns at a later stage. This consistent connection reinforces the importance of collaboration in supporting students' emotional and academic growth, especially within a trauma-informed framework, where caregiver involvement is vital in maintaining a united support system.

Building Ensemble Without Trauma Disclosure

In a trauma-informed theatre classroom, it is crucial to handle emotionally charged activities with care, being mindful of the potential risks of emotional activation or trauma dumping, as these can lead to unintended and harmful consequences. Trauma dumping is the act of sharing personal trauma or distressing experiences in a way that may overwhelm or emotionally burden others, especially in settings without the appropriate support structures to manage such disclosures. Activities like "The Baggage Activity," where students anonymously share their emotional burdens with the group, can unintentionally turn into a space where trauma is publicly unpacked without adequate support in place. This can overwhelm both students and educators, as students may experience heightened emotional responses that require professional mental health support, which educators may not be equipped to provide. Although the intention behind such activities is often to foster empathy and connection, they can inadvertently

retraumatize students who may not be prepared to disclose their trauma in a group setting.

Instead of using emotionally raw activities that may overwhelm participants, theatre educators should prioritize building ensemble and fostering connection through structured, consent-based practices. Rather than encouraging students to disclose personal traumas, educators can implement exercises that promote trust, empathy, and collaboration without requiring vulnerability that crosses personal boundaries. Ensemble-building activities should focus on creating shared experiences that cultivate a sense of community while respecting each student's comfort level. By emphasizing creative problem-solving, teamwork, and imaginative exploration, educators can foster empathy and understanding without centering students' potential trauma as a foundation for community building. This approach creates a safe, supportive environment where students can engage meaningfully and comfortably, adhering to trauma-informed practices that protect emotional boundaries for both students and educators.

Reconsidering Traditional Methods for Emotional Safety

In a trauma-informed theatre classroom, it is essential to examine "the way we have always done it" and thoughtfully reconsider traditional methods to better support all students. Acting methods, the canon of theatrical literature, and writing practices should be reviewed to ensure they align with students' emotional safety. For example, while method acting or deeply personal journaling exercises may have been common in the past, these approaches can unintentionally push students to relive trauma or disclose sensitive information. Theatre educators should instead be intentional about what they ask students to write or perform, connecting exercises directly to the lesson and focusing on skill development rather than personal histories. This approach not only protects students but also acknowledges the educator's role as a mandated reporter, helping to prevent classroom practices from inadvertently leading to harmful or distressing disclosures. By reevaluating these traditional methods, theatre educators can foster a learning environment that prioritizes both creative expression and emotional well-being.

Furthermore, it is crucial for theatre educators to avoid games, projects, and ensemble-building exercises that could lead to trauma dumping or emotional dysregulation. Although theatre often requires vulnerability, educators must differentiate between healthy emotional exploration and activities that might inadvertently push students to disclose deeply personal or traumatic experiences. For instance, games that encourage intense emotional recall or

improvisation exercises focused on personal hardships can overwhelm students emotionally, potentially triggering them without offering the necessary support structures. Instead, educators should select exercises that build ensemble and foster collaboration in ways that emphasize safety and connection, without venturing into potentially harmful territory. Techniques centered on creative problem-solving, skill-building, and imaginative storytelling allow students to engage deeply without risking emotional activation. By carefully choosing activities that consider their emotional impact, theatre educators can create a supportive classroom environment that encourages creativity while safeguarding emotional safety.

Embracing Play and Exploration

In the theatre classroom, emphasizing the importance of play and exploration is essential for creating a creative and supportive environment where students feel free to take risks, think outside the box, and collaborate openly. Play allows students to experiment with ideas, characters, and narratives without fear of judgment, building their confidence and unleashing their creativity. By fostering a mindset where failure is not only accepted but valued as part of the learning journey, students learn to see mistakes as opportunities for growth and discovery. This approach fosters resilience, adaptability, and problem-solving skills, all of which are valuable not only on stage but also in everyday life. When exploration is celebrated and failure is normalized, students develop the courage to stretch their boundaries and dive deeper into creative expression. By creating a space that values curiosity, theatre educators empower students to engage fully, connect with others meaningfully, and unlock their full creative potential.

Restorative Practices

Restorative practices have emerged as an effective tool for classroom management, particularly in trauma-informed settings such as theatre classes, where emotions and personal experiences play a significant role. Unlike traditional punitive approaches that focus on punishment and compliance, restorative practices emphasize repairing relationships and building trust through respectful dialogue and mutual understanding (Drewery & Kecskemeti, 2010). This approach is especially vital in theatre classes, where students are

often encouraged to express vulnerable aspects of themselves through performance. By fostering a space where students feel safe and respected, theatre educators create an environment that supports creative exploration and models healthy, non-adversarial ways to manage conflict and differences.

Restorative conversations are central to this practice and can be used to address conflicts in the classroom, honoring both the individuals involved and the overall classroom dynamic. A simple model for a restorative conversation includes four steps: 1) identifying the harm, 2) acknowledging responsibility, 3) discussing the impact, and 4) creating a path forward. Similar to the process for addressing crossed boundaries (Pace, 2020), this model emphasizes respect, accountability, and collaboration. It empowers students to take responsibility for their actions, reflect on the impact of their behavior, and engage in solutions that support both individual and collective well-being. The goal is to preserve relationship integrity and create a culture of trust where students feel comfortable voicing their needs and boundaries.

Restorative practices also emphasize the importance of maintaining strong relationships and recognizing that behavior often stems from underlying emotional needs or conflicts. In a trauma-informed classroom, theatre educators shift away from behavior management strategies that rely on control and discipline, adopting practices that engage students in conversations, mediation, and community-building activities (Pareja Conto et al., 2023). For example, when conflicts arise in a theatre class, rather than immediately assigning blame or punishment, educators can hold restorative "chats" or use circle discussions to encourage open dialogue. These methods resolve the immediate issue and teach students critical skills such as empathy, conflict resolution, and mutual respect, which are essential in both theatre and life.

Additionally, restorative practices align with trauma-informed approaches by recognizing that behavior is often a response to trauma, and punitive measures can intensify emotional and behavioral issues (Crosby et al., 2018). In theatre classes, where emotional expression is integral to the work, trauma can manifest as heightened emotional responses, impulsivity, or withdrawal. Educators using restorative practices can de-escalate these situations by addressing the root causes of the behavior rather than punishing the symptoms. This might involve taking time to understand the student's perspective, acknowledging their feelings, and collaborating to find solutions that restore trust and maintain the student's dignity (Drewery & Kecskemeti, 2010).

Finally, the use of restorative practices fosters a more inclusive and equitable classroom environment. Traditional discipline systems often disproportionately affect marginalized students, leading to harsher consequences and further alienation (Fronius et al., 2019). In contrast, restorative practices offer

a framework rooted in dialogue and equity, allowing all students to participate in creating a positive, supportive classroom culture. For theatre students, this approach not only helps sustain a healthy learning environment but also reinforces the values of collaboration, empathy, and self-expression that are central to the art form. By integrating restorative practices into theatre classes, educators build stronger, more trusting relationships with their students, ultimately creating a space where both artistic and personal growth can flourish.

Power of an Apology

Apologizing when mistakes are made is a vital yet often underestimated aspect of building trust and respect in the theatre classroom. Research highlights that apologies serve as a means of restoring social harmony and acknowledging responsibility (Limberg, 2016). By offering a genuine apology, theatre educators can address any unintended breaches in conduct or expectations, allowing them to correct missteps and maintain positive relationships with students. This act of taking responsibility is impactful because it signals not only regret but also a commitment to improved behavior, making it an essential tool for restoring balance after an error (Cheng, 2022). In the classroom, such apologies go beyond words, they create a supportive and empathetic atmosphere where students feel heard, respected, and valued (Ash, 2020).

Apologizing also humanizes educators, demonstrating vulnerability and strengthening the teacher-student relationship. When educators admit their mistakes and offer sincere apologies, they model accountability and integrity, aligning their actions with the high standards they set for students (Ash, 2020). This process reinforces the relational dynamic in the classroom, showing students that even authority figures can make mistakes and are open to learning from them. In turn, students feel more comfortable expressing their own vulnerabilities and seeking resolution when conflicts arise. Furthermore, a well-delivered apology, especially one accompanied by an explanation and a commitment to do better, can help mitigate the negative effects of educator missteps, ensuring that trust and learning are preserved (Vallade, 2020).

Assessment and Evaluation

Integrating trauma-informed principles into assessment and evaluation in the theatre classroom mirrors the post-production phase in a theatrical process,

where feedback and reflection are crucial for growth. Just as post-production feedback helps a cast and crew understand successes and areas for improvement, classroom assessments should focus on constructive feedback that celebrates individual progress. Intentional planning of assessment methods allows students to reflect on their learning and showcase their strengths, much like actors reflect on their performances. This reflection emphasizes growth rather than pointing out failures and encourages both students and educators to identify areas for improvement. For educators, this phase is also a time for self-reflection, evaluating which methods were effective and considering adjustments to better support students' artistic and emotional development. By fostering a space that prioritizes reflection and thoughtful feedback, educators empower students to develop their skills while also refining their own teaching practices.

Trauma-Informed Language

Using trauma-informed language in assessments is crucial in 9–12 grade theatre classrooms, where students often engage in sensitive and creative processes. This approach fosters a supportive environment by focusing on growth, effort, and progress, rather than simply highlighting areas for improvement. By choosing words that emphasize development and strengths, educators can help students feel empowered and motivated rather than discouraged. For example, instead of saying, "You didn't convey enough emotion," an educator might reframe feedback as, "I noticed how dedicated you were to the character's physicality. Let's explore some techniques to bring more emotional depth into your performance." This shift not only recognizes the student's strengths but also involves them actively in the learning process, creating a collaborative and positive experience. Trauma-informed language also avoids expressions that could reinforce negative self-perceptions, which is especially vital for students with trauma histories. Ultimately, this approach supports students in building confidence, self-awareness, and resilience through constructive feedback that is inclusive and affirming.

Flexible Assessment Methods

In a trauma-informed theatre classroom, flexible assessment methods, including accommodations, student choice, and alternative assessments, are essential to creating a supportive and inclusive environment. Regular, low-stakes

evaluations, such as peer feedback sessions, short performance exercises, technical design work, or personal reflections, provide students with opportunities to engage with the material without the pressure of high-stakes assessments. Allowing students to choose how they participate in these evaluations, whether by performing a scene, presenting a costume design, or sharing personal reflections on their process, fosters a sense of empowerment and ownership. This ongoing process allows for real-time feedback and offers space for adjustments to meet students' unique needs, such as extended deadlines or alternative workspaces. Focusing on gradual improvement and reducing anxiety, these assessments help create a sense of safety, particularly for students affected by trauma.

For more formal evaluations, trauma-informed practices recommend offering a range of assessment options, allowing students to demonstrate understanding in ways that align with their strengths and preferences. For example, when assessing costume design, students could present a sketchbook of their designs, create a partial or full costume, or develop a mood board with fabric samples, color schemes, and historical research. Alternatively, students might present a digital portfolio or explain their design choices through a verbal presentation. This emphasis on choice extends to alternative assessments like portfolios, where students can select specific design elements or personal reflections to showcase their growth. By offering a variety of assessment options, theatre educators promote student agency, ensuring that each individual feels supported, confident, and engaged throughout the process.

Constructive Feedback

Constructive feedback is crucial in trauma-informed theatre classrooms, shaping both ongoing and final assessments to support student growth with a focus on the learning process over the final product. In daily activities, such as scene work, technical projects, or improvisation exercises, providing immediate and constructive feedback helps students improve while reinforcing a safe and supportive environment. Educators should emphasize the learning journey, highlighting students' strengths such as vocal projection, emotional expression, or thoughtful lighting choices and offering actionable suggestions for further growth. This approach helps students see feedback as a continuous tool for growth rather than a judgment of their final product. By focusing on progress and providing clear steps for improvement, educators encourage students to take creative risks without fear of failure, reinforcing that the journey of learning is just as important as the outcome.

In final assessments, whether for performances, technical portfolios, or comprehensive design projects, feedback should build on progress observed throughout the course. While the quality of the final product remains important, the demonstration of growth is paramount. Educators can uphold high standards while supporting students throughout the creative process. For example, if a student shows significant improvement in vocal projection or costume design execution, recognizing this progress alongside areas for further refinement builds the student's confidence. Written feedback on technical projects, such as costume designs or set models, should reflect this process-driven approach, acknowledging how the student's work has evolved over time. By valuing growth and effort alongside the final product, theatre educators empower students to take ownership of their artistic journey, fostering pride in their development and setting goals for continued improvement.

Grading Practices

Equitable grading practices in a trauma-informed theatre classroom should reflect each student's unique learning journey, mastery of content and standards, and personal growth. Rather than focusing solely on final outcomes, assessments should consider the cumulative progress students make over time, recognizing that each individual learns and develops at their own pace. Grading should be flexible and adaptive, allowing students to demonstrate mastery in different ways. For example, a student who struggles with performing a monologue might excel in a written character analysis or a design project that demonstrates their understanding of the material.

To promote fairness, formative assessments, such as scene work or design drafts, offer students regular feedback and opportunities for growth, reducing the pressure associated with high-stakes, one-time evaluations. This process emphasizes improvement and mastery of standards over time rather than perfection in a single moment. Additionally, providing options for revisions or alternative assessments ensures that students have multiple avenues to demonstrate their learning, reinforcing the idea that effort and progress are just as important as final performance.

By focusing on individual progress, mastery of theatre standards, and overall growth, trauma-informed grading practices foster a supportive environment where all students feel empowered to succeed, no matter their starting point. This approach promotes equity and nurtures a culture of continuous development and achievement on a personal level.

Reflection and debriefing are essential components of assessment in a trauma-informed theatre classroom, mirroring the post-production phase in rehearsals. Encouraging students to engage in self-reflection helps them process their learning, understand their growth, and identify areas for improvement. This reflective practice reinforces both personal and artistic development, much like theatre professionals who assess their work after a performance run. By providing structured reflection opportunities, students can connect their creative choices to learning objectives, deepening their understanding of the material. This reflective process supports self-awareness, resilience, and a sense of ownership over the learning journey, reinforcing that learning is ongoing and evolves with each project.

Facilitating meaningful discussions through quality questioning techniques is essential for effectively assessing students' progress. Thoughtful, open-ended questions allow educators to gauge students' understanding of objectives while encouraging creativity and critical thinking. For example, questions like, "How did your character's motivation influence your performance choices?" or "What strategies did you use to collaborate with your scene partner?" invite students to reflect on their artistic process and technique. Such questions go beyond simple recall, allowing educators to assess deeper levels of comprehension, creativity, and skill development. By consistently using quality questions in discussions, theatre educators create a dynamic environment that fosters artistic growth, critical self-awareness, and a thoughtful approach to learning. These quality questions are the foundation of meaningful evaluation in a theatre classroom, ensuring students are engaged and their learning is assessed with depth and insight.

Ongoing Support

After assessments are completed, the learning process in a theatre classroom continues. Ongoing support is essential in helping students connect previous learning to new concepts introduced within the scaffolded curriculum. For example, a student who has developed an understanding of body language in a monologue might be guided on how to apply those skills to group scene work. By linking past achievements to upcoming challenges, educators create a more cohesive learning experience. This approach is especially beneficial in trauma-informed classrooms, where students thrive with consistent reinforcement that both acknowledges their progress and introduces new concepts at a comfortable pace. Such ongoing support encourages students to build on what they have already mastered, fostering a sense of safety and accomplishment as they advance in their learning journey.

Celebrations

Celebrating student achievement within the context of classwork is essential in trauma-informed theatre classrooms, as it not only motivates students but also reinforces their sense of self-worth and ownership of their learning. Acknowledging progress in activities like improvisational exercises, group discussions, or individual scene work helps instill pride and allows students to recognize their growth. Simple, low-pressure celebrations, such as verbal praise, peer acknowledgment of effort, or showcasing student work in class, validate students' efforts without creating added stress. Asking students how they prefer to be celebrated also respects individual comfort levels and personal boundaries, ensuring that recognition feels meaningful and supportive. These forms of recognition are particularly valuable in trauma-informed environments, where some students may be hesitant to share or express themselves fully. Celebrating their achievements in ways that resonate with them creates a safe space where students feel seen and valued, encouraging them to take creative risks and continue challenging themselves both academically and artistically.

Self-Reflection for Educators

Regular self-reflection is essential for theatre educators aiming to maintain a trauma-informed classroom. After each class or assessment, educators might ask themselves questions like, "Did I foster a safe environment for all students to participate?" or "Was my feedback constructive and focused on growth?" These reflections help educators identify areas for improvement, such as adjusting discussion formats to support hesitant students or rephrasing feedback to emphasize strengths. Educators can also consider whether activities respected students' emotional boundaries, allowing flexibility for those needing alternative engagement options. Evaluating language for inclusivity and ensuring the class pacing allows all students to process comfortably are equally important. If students seemed disengaged or uncomfortable, educators might focus on building stronger individual relationships. This ongoing self-reflection enables educators to adapt their practices, ensuring that their approach aligns with the goals of trauma-informed education, fostering a classroom that prioritizes safety, inclusivity, and student empowerment.

Thermometers and Thermostats

While thermometers merely react to changes in their environment, thermostats actively set and maintain the desired atmosphere and in the theatre

classroom, educators should strive to be thermostats rather than thermometers (Landreth, 2006). A thermometer reflects the fluctuations around it, responding passively to shifts in mood, behavior, and energy. In contrast, a thermostat controls and stabilizes the environment, regulating the "temperature" of the room by setting a tone of calm, support, and structure. By embracing trauma-informed teaching principles, theatre educators can take on this thermostat role, creating a space that feels safe, predictable, and nurturing for all students.

Acting as a thermostat means that educators consciously manage our own responses to challenging situations rather than simply mirroring the emotions or behaviors of our students. While we cannot control how students might react to certain stimuli, we can maintain our own calm and respond thoughtfully, helping to de-escalate potentially stressful situations. For example, if students arrive agitated or unfocused, a thermometer would reflect that energy, becoming equally flustered or frustrated. A thermostat, however, would assess the mood and respond grounded and with clarity, adjusting the class plan if needed to meet students where they are while maintaining a steady, supportive presence. This approach creates a balanced environment where students feel safe to express themselves and engage, knowing their educator is setting a tone of stability and understanding.

In trauma-informed classrooms, being a thermostat allows educators to model emotional regulation, resilience, and empathy. When educators maintain control of their own responses, they prevent negative energy from amplifying and demonstrate healthy coping mechanisms. Instead of allowing reactive behavior to escalate, they respond with patience and intention, fostering a learning space where students are encouraged to bring their full selves without fear of judgment or chaos. By actively creating this environment, educators embody a nurturing and resilient classroom culture, enabling students to focus on growth, connection, and creativity.

Essential Practices for Theatre Educators' Wellness and Self-Care: Enrolling and Deroling

Enrolling: Stepping into the Role of Teacher

The concepts of enrolling and deroling, essential practices for actors to step into and out of their characters, also hold valuable lessons for theatre educators, offering strategies to maintain healthy boundaries and protect personal well-being. When we step into our classrooms each day, we are, in a sense,

enrolling into the role of teacher. This involves adopting the mindset, energy, and presence needed to guide, support, and educate our students. It may look like reviewing lesson plans, mentally preparing for student interactions, or engaging in self-talk that affirms our teaching intentions for the day. This moment of transition helps us step into our role with purpose and clarity, similar to how an actor prepares for a scene. However, enrolling does not mean losing ourselves entirely to the identity of "teacher." It is about putting on the "teacher hat" consciously, while recognizing it is one of many roles we play in our lives. By intentionally stepping into this role, we bring focus, energy, and intention to our teaching practice, but we must also remember that it is not our only identity.

Questions for Enrolling:
- What mindset do I want to bring to my teaching today?
- How can I prepare myself to be present and engaged with my students?
- What personal boundaries do I need to set as I enter this role today?

Taking Breaks Throughout the Day

Just as actors may take breaks to step out of character momentarily, theatre educators need to pause throughout the day to check in with themselves. Teaching is a profession filled with empathy, compassion, and constant decision-making. Without moments of reprieve, we risk compassion fatigue—becoming overwhelmed by the emotional demands of the role. Taking intentional breaks, even brief ones, helps us reconnect with our own needs, allowing us to breathe, reflect, and reset before stepping back into the teaching role. These pauses can be small acts of self-care, like taking a walk, engaging in deep breathing, or stepping outside for fresh air. These moments help us regulate our emotions, recharge, and approach the next part of our day with renewed focus and energy.

Ideas for Mid-Day Breaks:
- A few minutes of mindfulness or meditation between classes.
- A walk outside to clear your head and reconnect with your body.
- A brief journaling session to process any strong emotions that came up during the morning.

Deroling: Leaving the Role of Teacher Behind

When the school day ends, it is vital for our mental health and well-being to intentionally derole from the identity of "teacher." This means consciously

shedding the responsibilities and mindset of our professional role so we can transition into our personal lives. Without this intentional practice, it can be easy to carry the weight of our teaching role home with us, blurring the lines between our professional and personal selves. Deroling might involve a ritual or activity that signals the end of the workday, such as changing clothes, going for a walk, or setting aside time to decompress before heading home. It is a way of telling our minds and bodies, "The workday is over. It's time to focus on myself and my personal life now." By deroling, we create a clear boundary between our professional and personal identities, allowing us to be fully present in our lives outside of work.

Questions for Deroling:
- How can I mark the end of my workday and step out of the teacher role?
- What rituals or activities help me transition from work mode to personal mode?
- How can I leave work-related stress at work and not carry it into my home life?

The Importance of Boundaries: Protecting Against Compassion Fatigue

Teaching is a role that demands high levels of empathy, compassion, and emotional investment. We listen to our students, support their needs, make constant decisions, and often take on their emotional burdens. While this can be fulfilling, it also puts us at risk of compassion fatigue—a state of physical, emotional, and mental exhaustion caused by prolonged exposure to the stress of caring for others. Enrolling and deroling practices help us set healthy boundaries, ensuring that our role as a teacher does not consume our entire identity. By intentionally stepping into and out of the teacher role, we protect our own emotional reserves and create space for self-care, personal relationships, and activities that fulfill us outside of our work.

Centering Ourselves: Reclaiming Our Identity Outside of Teaching

To maintain a sustainable career in education, we must remember that we are more than just our jobs. Centering our personal identity outside of teaching involves carving out time for hobbies, relationships, and self-reflection. It means allowing ourselves to be fully present in our personal lives without the constant mental pull of work-related concerns. When we enroll into our teaching role, we do so with intention and care. When we derole, we give ourselves permission to rest, recharge, and embrace the other parts of our

lives that bring us joy and fulfillment. This balance is crucial for long-term health and wellness, allowing us to show up fully for our students while also honoring our own needs.

Tips for Centering Yourself:
- Schedule time for activities you enjoy that have nothing to do with teaching.
- Practice mindfulness or meditation to help release work-related thoughts and stress.
- Create a clear end-of-day ritual that signals the shift from work life to home life.

In prioritizing our own needs, we model healthy boundaries and self-care for our students, teaching them the importance of balancing work and personal life. Ultimately, by caring for ourselves, we are better equipped to care for those we teach, ensuring a compassionate and effective educational experience for everyone involved.

Intentionality

Intentionality is the cornerstone of trauma-informed practices, shaping every choice we make in the theatre classroom. Every aspect of teaching, from lesson planning to the language we use, should be approached with thoughtfulness and purpose. This intentional approach creates an environment where students feel safe, respected, and empowered, allowing them the freedom to explore, take risks, and experience growth on both personal and artistic levels. Our words, actions, and even our silent cues hold power, and it is essential that we use them deliberately to build trust and support among students.

Being intentional in every interaction signals to students that their well-being is prioritized. This approach goes beyond simply managing behavior; it involves setting up a classroom culture that honors each student's unique journey, reinforcing that they are seen, valued, and respected. By consciously creating this environment, we model care and empathy, showing students how to engage with the world thoughtfully and compassionately. Every decision—whether it is how we approach difficult material, facilitate group dynamics, or offer feedback—should be purposeful, guided by an understanding of the potential impact on each student's growth and well-being. When we act with intention, we do not leave anything to chance; we make purposeful choices knowing they have the power to make a meaningful difference in our students' lives.

References

Anda, R. F. et al. (2006). The enduring effects of abuse and related adverse experiences in childhood. *European Archives of Psychiatry and Clinical Neuroscience, 256*(3), 174–186.

Anti-Oppression Network. (2017). *Safer space policy/community agreements.* The Anti-Oppression Network. https://theantioppressionnetwork.com/resources/saferspacepolicy/

Ash, R. (2020). *Teacher vulnerability and the power of apology in the Latin classroom.* Cambridge: Brighter Thinking Blog. https://www.cambridge.org/us/education/blog/2020/12/08/teacher-vulnerability-and-the-power-of-apology-in-the-latin-classroom/

Birch, S. H., & Ladd, G. W. (1997). The teacher-child relationship and early school adjustment. *Journal of School Psychology, 55*(1), 61–79.

Bradd, S. (2020). *Co-creating community agreements in meetings – Drawing Change.* Drawing Change. https://drawingchange.com/co-creating-community-agremeents-in-meetings/

Brunzell, T., Stokes, H., & Waters, L. (2016). Trauma-informed flexible learning: Classrooms that strengthen regulatory abilities. *International Journal of Child, Youth & Family Studies IJCYFS, 7*(2), 218. https://doi.org/10.18357/ijcyfs72201615719

CAEA. (2024). *The member guide to creating a community agreement.* Canadian Actors Equity Association. https://www.caea.com/Portals/0/Documents/HealthSafety/Member%20Guide%20to%20Creating%20a%20Community%20Agreement.pdf

Cheng, D. (2022). Communication is a two-way street: Instructors' perceptions of student apologies. *Pragmatics: Quarterly Publication of the International Pragmatics Association, 27*(1), 1–32. https://doi.org/10.1075/prag.27.1.01che

Chrismon, J., & Carter, A. (2019). Teacher and administrator perceptions of traits, characteristics, and instructional practices of effective theater teachers. *Journal of Educational Leadership in Action, 6*(1). https://digitalcommons.lindenwood.edu/ela/vol6/iss1/8

Chrismon, J., & Marlin-Hess, M. (2023). Intimacy direction best practices for school theatre. *Drama Research, 14*(1).

Cless, J. D., & Goff, B. S. N. (2017). Teaching trauma: A model for introducing traumatic materials in the classroom. *Advances in Social Work, 18*(1), 25–38. https://doi.org/10.18060/21177

Crosby, S. D., Howell, P., & Thomas, S. (2018). Social justice education through trauma-informed teaching. *Middle School Journal, 49*(4), 15–23. https://doi.org/10.1080/00940771.2018.1488470

Curby, T. W., Rimm-Kaufman, S. E., & Ponitz, C. C. (2009). Teacher-child interactions and children's achievement trajectories across kindergarten and first grade. *Journal of Educational Psychology, 101*(4), 912–925.

Daugherty, E. D., Hertzberg, D., & Wagner, D. (2020). Offstage intimacy: Best practices for navigating the intimacy of costuming, *Theatre Topics, 30*(3), 211–216. https://doi.org/10.1353/tt.2020.0039

Drewery, W., & Kecskemeti, M. (2010). Restorative practice and behaviour management in schools: Discipline meets care. *Waikato Journal of Education, 15*(3), 101–113. https://doi.org/10.15663/wje.v15i3.85

Fronius, T., Darling-Hammond, S., Persson, H., Guckenburg, S., Hurley, N., Petrosino, A., & WestEd. (2019). *Restorative justice in U.S. Schools: An updated research review*. https://www.wested.org/wp-content/uploads/2019/04/resource-restorative-justice-in-u-s-schools-an-updated-research-review.pdf

Hamre, B. K., & Pianta, R. C. (2001). Early teacher-child relationships and the trajectory of children's school outcomes through eighth grade. *Child Development, 72*, 625–638.

Himelstein, S. (2016). *4 simple tips to creating safety with group agreements*. Center for Adolescent Studies. https://centerforadolescentstudies.com/4-simple-tips-creating-safety-group-agreements/

Horn, E. B. (2020). And so she plays her part: An autoethnographic exploration of body image, consent, and the young actor, *Youth Theatre Journal, 34*(1), 55–65. https://doi.org/10.1080/08929092.2019.1633720

Landreth, G. L., & Bratton, S. C. (2006). *Child-parent relationship therapy (CPRT): A 10-session filial therapy model*. Routledge.

Limberg, H. (2016). Teaching how to apologize: EFL textbooks and pragmatic input. *Language Teaching Research: LTR, 20*(6), 700–718. https://doi.org/10.1177/1362168815590695

McCrory, E., Gerin, M. I., & Viding, E. (2017). Annual research review: Childhood maltreatment, latent vulnerability, and the shift to preventative psychiatry–The contribution of functional brain imaging. *Journal of Child Psychology and Psychiatry, 58*(4), 338–357.

Minahan, J. (2019). Trauma-informed teaching strategies. *Educational Leadership, 77*(2), 30.

Morton, B. M., & Berardi, A. A. (2018). Trauma-informed school programing: Applications for mental health professionals and educator partnerships. *Journal of Child & Adolescent Trauma, 11*(4), 487–493. https://doi.org/10.1007/s40653-017-0160-1

National Child Traumatic Stress Network, Schools Committee. (2017). *Creating, supporting, and sustaining trauma-informed schools: A system framework*. National Center for Child Traumatic Stress. https://www.nctsn.org/

sites/default/files/resources/creating_supporting_sustaining_trauma_informed_schools_a_systems_framework.pdf

NIMH. (2024). *The teen brain: 7 things to know*. National Institute of Mental Health (NIMH). https://www.nimh.nih.gov/health/publications/the-teen-brain-7-things-to-know#part_6528

Pace, C. (2020). *Staging sex: Best practices, tools, and techniques for theatrical intimacy* (1st ed.). Routledge.

Pareja Conto, L., Restrepo, A., Recchia, H., Velez, G., & Wainryb, C. (2023). Adolescents' retributive and restorative orientations in response to intergroup harms in schools. *Journal of Research on Adolescence, 33*(1), 92–107. https://doi.org/10.1111/jora.12785

Perry, B. D. (2006). Applying principles of neurodevelopment to clinical work with maltreated and traumatized children. In N. Boyd Webb (Ed.), *Working with traumatized youth in child welfare* (pp. 27–52). The Guilford Press.

Rimm-Kaufman, S. (2015, March 9). *Improving students' relationships with teachers*. American Psychological Association. https://www.apa.org/education-career/k12/relationships

Roberts, L. (2023). *Working with actors: Creating a community contract*. Pioneer Drama Service. https://www.pioneerdrama.com/Newsletter/Articles/Community_Contract.asp

Seton, M. C. (2010). The ethics of embodiment: Actor training and habitual vulnerability. *Performing Ethos: International Journal of Ethics in Theatre and Performance, 1*(1), 5–20. Available at: https://doi.org/10.1386/peet.1.1.5_1

Shawyer, S., & Shively, K. (2019). Education in theatrical intimacy as ethical practice for university theatre, *Journal of Dramatic Theory and Criticism, 34*(1), 87–104. https://doi.org/10.1353/dtc.2019.0025

Shively, K. (2022). Using principles of theatrical intimacy to shape consent-based spaces for minors, *Journal of Consent Based Practice*, (Spring), 74–80.

Shonkoff, J. P. et al. (2012). The lifelong effects of early childhood adversity and toxic stress. *Pediatrics, 129*(1), e232–e246.

St. John, A. (2022). Thought bubble theatre festival: Applying and developing consent-based practices with pre-professional actors. *Journal of Consent-Based Performance, 1*(2), 111–136. https://doi.org/10.46787/jcbp.v1i2.2872

Teicher, M. H. et al. (2016). The impact of childhood maltreatment on brain structure, function, and connectivity. *Nature Reviews Neuroscience, 17*(10), 652–666.

Vallade, J. I. (2021). Instructor accounts and sincere amends following integrity- and competence-based misbehavior. *Communication Education*, 70(1), 71–91. https://doi.org/10.1080/03634523.2020.1788105

Vorbeck, C. (2019). *New directions in teaching theatre arts. Theatre Research International*, 44(2), 221–222. https://doi.org/10.1017/S0307883319000208

9

Conclusion

Throughout this book, we have explored the intersection of trauma-informed practices and traditional theatre education, emphasizing the significant shift this approach represents from conventional teaching methods. Most theatre educator training programs have not historically included trauma-informed practices in their curricula, meaning many educators, both experienced and new to the field, may not have encountered these tools and insights (Anderson et al., 2022; Chrismon & Carter, 2023; Chrismon, 2022; L'Estrange & Howard, 2022; McIntyre et al., 2019; Miller et al., 2023; Reddig & VanLone, 2022). This gap in knowledge does not reflect on your abilities as an educator. Instead, it presents an opportunity to grow and adapt, fostering a new way of engaging with students, materials, and audiences. Trauma-informed education is not a collection of strategies to use intermittently; it is a cultural shift that changes how we teach, view students, and commit to their emotional and psychological well-being (St. John, 2022).

We have underscored that trauma-informed practices do not equate to censorship. On the contrary, they empower us to tackle challenging, meaningful work that resonates with our students and communities, providing them with a space to engage with this art safely. What distinguishes trauma-informed educators is their ability to engage with this material thoughtfully, telling stories more effectively and safely while fostering care and support for one another throughout the creative process (St. John, 2022; Venet, 2019).

Icebergs and Ice Cubes

Addressing complex challenges and overwhelming tasks can be likened to confronting a massive iceberg. When faced with such an enormous problem, it is easy to feel overwhelmed by its size and scope. However, breaking the issue into smaller, manageable pieces is like chipping away at the iceberg to create ice cubes. Tackling one small portion at a time transforms the daunting obstacle into something more approachable. Just as a single ice cube feels far less intimidating than a towering iceberg, breaking down a complex task into smaller steps allows for steady progress, a sense of accomplishment, and, ultimately, the resolution of even the most significant challenges. This incremental approach empowers individuals to navigate complexity with confidence and efficiency, showing that with patience and persistence, even the largest obstacles can be overcome one "ice cube" at a time.

Implementing trauma-informed practices in theatre education is not a sprint but a deliberate and gradual journey. It is important to recognize that change does not happen overnight, and it is perfectly acceptable to take things one step at a time. The idea of transforming an entire pedagogical approach can feel overwhelming, but small, intentional steps can lead to meaningful progress. Begin by selecting one or two trauma-informed strategies or techniques that align with your teaching style. Focus on integrating these practices into your theatre program thoughtfully and effectively. Whether it involves incorporating content disclosures, fostering open communication, or prioritizing student well-being during rehearsals, each step you take contributes to building a safer and more supportive educational environment.

Remember, better is better, even if the improvement is modest (Pace, 2020). As you begin to notice the positive impact of these initial changes, you will feel encouraged to incorporate more trauma-informed practices over time. By taking intentional steps and gradually building your expertise, you become part of a movement advancing theatre education toward greater awareness, empathy, and support for both students and the broader community (Rikard & Villarreal, 2023).

In the pursuit of trauma-informed practices, it is essential to maintain a realistic perspective. The goal is not perfection but continuous improvement. While it is impossible to eliminate every potential harm, we can make a concerted effort to minimize it. It is important not to be overly critical of ourselves when we fall short of our aspirations. Instead, we should celebrate the small victories along the way. Recognizing and appreciating each successful application of trauma-informed strategies, no matter how minor, provides

valuable momentum. These small wins serve as steppingstones toward creating a safer and more supportive learning environment.

Challenges and setbacks are inevitable in any journey toward improvement. When things do not go as planned, these moments provide an opportunity to reflect on what worked and what did not. As with lesson planning and teaching, we adapt and adjust our approach based on these insights. It is through this process of reflection and adjustment that we grow and refine our trauma-informed practices.

As we have explored throughout this book, the early stages of pre-production are where intentionality in trauma-informed strategies is most naturally embraced and effectively implemented. However, as the production process progresses, maintaining this intentionality becomes increasingly challenging. Our research reveals the difficulties that emerge during rehearsals, technical rehearsals, and post-production phases, where the initial enthusiasm for trauma-informed practices can begin to wane.

It is important to remind every dedicated theatre educator that it is perfectly okay not to get everything right all the time. Do not dwell on perceived shortcomings; instead, keep moving forward. Granting ourselves grace is essential. Progress may not always be linear, and setbacks are a natural part of growth. Navigating these challenges with resilience and compassion means recognizing our efforts, regardless of the outcomes, and accepting that it is okay to take breaks, seek support, and adjust our approach when needed.

The commitment to incorporating trauma-informed practices already sets you on the path to making a meaningful difference in the lives of your students. So, do not give up. Continue striving to create a safer, more supportive theatrical environment. Your persistence and dedication will make a lasting impact—one ice cube at a time.

One of the most powerful actions an educator can take is to apologize when mistakes are made. Mistakes are inevitable, and the ability to apologize, repair relationships, and commit to personal growth is essential to trauma-informed work. Maintaining perspective means recognizing that the journey toward trauma-informed education is an ongoing process of learning, adapting, and evolving. It is a path filled with both successes and challenges. By celebrating our achievements, learning from our mistakes, and remaining resilient, we can continue moving forward with a compassionate and effective approach to supporting our students and the theatre community.

While we take great pride in the progress made in trauma-informed theatre education, we acknowledge that this work is not ours alone. We honor and uplift the many individuals and organizations contributing to this field,

generating new knowledge, and continually teaching us more effective methods. Together, we are reshaping the landscape of theatre education, fostering ethical, empathetic, and safer storytelling. This collective effort reflects our shared commitment to learning, growth, and positive change within our community.

As we draw the curtain on our exploration of trauma-informed practices in 9–12 grade theatre, it is essential to highlight the importance of continuous professional development and a commitment to lifelong learning. While the insights shared in this book provide a solid foundation, the journey toward becoming the best educators we can be does not end here. If the professional development opportunities offered by your administration or district fall short, seek out resources elsewhere. Articles, books, virtual training, weekend intensives, summer residencies, podcasts, and online learning communities offer a wealth of knowledge waiting to be explored.

The journey of learning and growth is ongoing. By embracing a proactive approach to professional development, we can continue to evolve as educators and advocates for the well-being of everyone within our theatrical community. Consider forming your own professional learning community to exchange insights and experiences with like-minded peers. Additionally, investing in training such as Mental Health First Aid, Mental Health Coordination, or further trauma education can provide essential tools to support both your students and yourself.

Final Thoughts

We want to express our deepest gratitude to you for your dedication and passion. Your willingness to explore these ideas and implement trauma-informed practices in your theatre programs reflects your care and conscientious approach to teaching.

Remember, this journey is not the end but merely the beginning. Your ongoing growth and success are vital to the continued evolution of trauma-informed theatre education. As you return to your classrooms, stages, and communities, know that you have the power to create safer, more nurturing environments for your students. By embracing these practices and committing to continuous growth, you are actively shaping the future of theatre education, one intentional step at a time.

Thank you for your commitment. Together, let us strive toward a brighter, more compassionate future in theatre education.

References

Anderson, K. M., Haynes, J. D., Ilesanmi, I., & Conner, N. E. (2022). Teacher professional development on trauma-informed care: Tapping into students' inner emotional worlds. *Journal of Education for Students Placed at Risk (JESPAR), 27*(1), 59–79. https://doi.org/10.1080/10824669.2021.1977132

Chrismon, J. D. (2022). Trauma-informed practices in theatre education. *Pathways to Research in Education*, EDU087, 1–20.

Chrismon, J. D., & Carter, A. W. (2023). The absence of trauma-informed practices in the high school production process: A qualitative study. *Youth Theatre Journal*, 1–16. https://doi.org/10.1080/08929092.2023.2218719

L'Estrange, L., & Howard, J. (2022). Trauma-informed initial teacher education training: A necessary step in a system-wide response to addressing childhood trauma. *Frontiers in Education, 7*, 929582. https://doi.org/10.3389/feduc.2022.929582

McIntyre, E. M., Baker, C. N., Overstreet, S., & The New Orleans Trauma-Informed Schools Learning Collaborative. (2019). Evaluating foundational professional development training for trauma-informed approaches in schools. *Psychological Services, 16*(1), 95–102. https://doi.org/10.1037/ser0000312

Miller, K., Miller, K., & Wellman, E. (2023). New repetitions: Questions and suggestions for a more trauma-informed production process. *Journal of Consent-Based Performance, 2*(1), 17–48. https://doi.org/10.46787/jcbp.v2i1.3496

Pace, C. (2020). *Staging Sex: Best practices, tools, and techniques for theatrical intimacy* (1st ed.). Routledge.

Reddig, N., & VanLone, J. (2022). Pre-service teacher preparation in trauma-informed pedagogy: A review of state competencies. *Leadership and Policy in Schools*, 1–12. https://doi.org/10.1080/15700763.2022.2066547

Rikard, L., & Villarreal, A. R. (2023). Focus on impact, not intention: moving from "safe" spaces to spaces of acceptable risk. *Journal of Consent-Based Performance, 2*(1), 1–16. https://doi.org/10.46787/jcbp.v2i1.3646

St. John, A. (2022). Thought bubble theatre festival: Applying and developing consent-based practices with pre-professional actors. *Journal of Consent-Based Performance, 1*(2), 111–136. https://doi.org/10.46787/jcbp.v1i2.2872

Venet, A. S. (2019). Role-clarity and boundaries for trauma-informed teachers. *Educational Considerations, 44*(2). https://doi.org/10.4148/0146-9282.2175

Glossary

Acute Trauma: A type of trauma resulting from a single distressing event.

Agile Retrospectives Model: A structured format for post-mortem discussions, involving questions about what went well, what didn't, and how the process can be improved moving forward.

Boundaries: Limits set by individuals regarding physical, emotional, and psychological comfort, particularly in the context of intimate scenes.

Boundary Blurring: The phenomenon where the line between an actor's personal identity and the character they portray becomes unclear, affecting well-being.

Burnout: Physical, mental, and emotional exhaustion caused by prolonged stress and overwork.

Chronic Stress: Long-term stress that can lead to physical, mental, and emotional health issues.

Chronic Trauma: Trauma caused by repeated and prolonged exposure to distressing events.

Collective Trauma: Psychological and social impact shared by a group experiencing a significant, devastating event together.

Community Agreements: Collaborative guidelines created with students to establish expectations for respectful communication, boundary-setting, and mutual support.

Compassion Fatigue: Emotional strain resulting from intense empathy and caring for others, common in caregiving professions.

Complex Trauma: Exposure to multiple, varied traumatic events over time.

Consent: An ongoing, enthusiastic, informed agreement to participate, which can be withdrawn at any time without consequence.

Consent-Based Practices: Approaches that prioritize obtaining and respecting students' permission, particularly in scenes involving physical or emotional vulnerability.

Content Disclosure/Note: A transparent summary of potentially triggering themes or scenes in a production, designed to prepare students, caregivers, and audiences.

Cultural Competence: The ability to interact effectively with people of diverse cultural backgrounds, recognizing and valuing their differences.

Cultural Humility: A practice of continuous self-reflection and learning about diverse cultures, recognizing one's own biases and limitations.

Cultural Sensitivity: Awareness and respect for the cultural backgrounds, traditions, and values of others.

Debriefing: Structured conversations held after significant events, such as a production or strike, to discuss immediate experiences, challenges, and achievements, fostering open communication and closure.

Deroling: A process that helps actors mentally and emotionally separate from their characters, supporting emotional balance after rehearsals or performances.

Desexualized/Depersonalized/Deloaded Language: Neutral, technical terminology used in rehearsals to describe intimate scenes, reducing discomfort and maintaining professionalism.

Director's Statement: A document outlining the purpose, goals, and educational significance of a production, emphasizing the intentional choices made in alignment with trauma-informed practices.

Documentation: Detailed records kept by educators of consent agreements, rehearsal logs, and incidents, ensuring accountability and transparency.

Embodied Acting Methods: Techniques that focus on physical exploration and movement to develop characters, reducing the need for emotional recall.

Emotional Check-In: A system for students to share their emotional state at the start of rehearsals, helping educators understand and address individual needs.

Emotional Labor: The mental and emotional effort required to manage and support the well-being of participants, particularly significant for theatre educators in trauma-informed spaces.

Emotional Processing: The act of exploring and making sense of one's emotions, which should be approached cautiously in educational settings to avoid crossing into therapeutic territory.

Emotional Regulation: The ability to manage and respond to emotional experiences in a healthy and controlled manner.

Equity-Centered Trauma-Informed Care: A model that places cultural, historical, and gender issues at the core of trauma-informed practices.

Ethno-Racial Trauma: Trauma experienced by individuals as a result of systemic racism, discrimination, and historical injustices.

Grounding Techniques: Strategies that help students manage intense emotions by focusing on physical sensations, such as deep breathing or sensory changes.

Growth Mindset: An approach that emphasizes learning from challenges, focusing on personal growth and continuous improvement rather than fixed abilities.

Informed Consent: Consent given with a full understanding of what participation entails, particularly important when working with minors, requiring caregiver approval.

Instructional Touch: Physical contact initiated by an educator to guide or correct a student's movement, now discouraged in favor of verbal or visual feedback.

Intentionality: The deliberate focus on aligning every aspect of the theatrical process with trauma-informed principles, from pre-production to post-production.

Intersectionality: A framework highlighting how overlapping social identities (e.g., race, gender, class) intersect to create unique experiences of privilege and oppression.

Intimacy Choreographer: A professional who designs physical actions for intimate scenes, often with a focus on movement and choreography expertise.

Intimacy Coordination: The management of intimate scenes in recorded media such as film and television, focusing on safety and clear consent.

Intimacy Direction: The practice of choreographing and overseeing intimate scenes in live performances, prioritizing actor safety and well-being.

Intimacy Professional: An umbrella term for specialists in intimacy direction and coordination, addressing staging, consent, and actor advocacy.

Karoshi Syndrome: A term describing "death by overwork," linked to chronic stress and excessive working hours.

Marginalization: The process by which certain groups are pushed to the edges of society, limiting their access to resources and opportunities.

Mediation: A conflict-resolution process facilitated by an educator to address unresolved issues or emotional challenges that may arise during or after a production.

Mental Health Coordination (MHC): An interdisciplinary role that supports the accurate and sensitive portrayal of mental health and traumatic themes in creative projects. This includes providing individualized guidance, dramaturgy, crisis management, and therapeutic insight to ensure respectful storytelling and foster a deeper understanding of mental health issues.

Mindfulness: A practice of focusing on the present moment, often used to reduce stress and improve mental health.

Pathogenic Approach: A deficit-based approach that focuses on diagnosing and addressing problems caused by trauma.

Post-Mortem: A comprehensive review conducted after a production ends, focusing on analyzing successes, identifying challenges, and generating actionable insights for future improvements.

Post-Production Blues: Feelings of sadness, emptiness, or disconnection that often arise after a production ends, due to the intense bonds formed and the abrupt shift away from the collaborative environment.

Power Dynamics: The ways in which power is distributed and exercised within social relationships, often affecting interactions and opportunities.

Pre-Blocking: The process of planning movement and choreography before rehearsals begin, allowing for flexibility and addressing potential emotional challenges.

Privilege: Unearned advantages afforded to individuals based on aspects of their identity within a specific social context.

Progressive Muscle Relaxation (PMR): A technique that involves tensing and relaxing specific muscle groups to reduce physical and emotional tension.

PTSD (Post-Traumatic Stress Disorder): A mental health condition triggered by experiencing or witnessing a traumatic event.

Reflection: A personal process where students or educators explore their experiences, emotions, and growth throughout a production, often through journaling, creative activities, or guided questions.

Representation: The inclusion of diverse identities and experiences in media, literature, and the arts, reflecting a wide range of perspectives.

Resilience: The ability to adapt and recover from stress, adversity, or challenging circumstances.

Restorative Practices: Approaches focused on repairing relationships and resolving conflicts through dialogue and mutual understanding, rather than punitive measures.

Rituals: Consistent practices integrated into rehearsals or performances to create a sense of predictability, safety, and emotional closure.

Salutogenic Approach: A focus on health and well-being, emphasizing strengths and resilience rather than deficits.

Secondary Traumatic Stress: Emotional distress experienced by individuals who are exposed to others' trauma, often seen in frontline workers.

Self-Care: Deliberate actions to nurture one's well-being across physical, mental, emotional, and other dimensions of health.

Self-Care Cues: Predetermined signals used by students to indicate the need to pause or stop a scene for their safety or comfort (e.g., "button," "hold," "pause," "stop").

Show Captain: A student leader responsible for guiding warm-ups, deroling, and other trauma-informed practices during the run of the show.

Showmance: A romantic relationship that develops between cast or crew members during a production, which may complicate professional dynamics.

Systemic Inequalities: Structural and institutional factors that create unequal access to resources and opportunities based on identity markers.

Tiered Content Disclosures: A method of providing varying levels of information about a production's sensitive content, allowing participants to choose how much detail they want to know.

TIPPS Method: A grounding technique consisting of Time and space, Intense exercise, Paced breathing, Progressive muscle relaxation, and Sensation change.

Transgenerational Transmission of Trauma: The passing of trauma effects from one generation to the next through genetic, behavioral, or environmental factors.

Transparency: Clear, open communication about the production's goals, themes, and support mechanisms, fostering trust and understanding among all stakeholders.

Trauma: An event, series of events, or set of circumstances that an individual experiences as physically or emotionally harmful or life-threatening, leading to lasting adverse effects on their mental, physical, social, emotional, or spiritual well-being.

Trauma Dumping: The act of sharing personal trauma in a way that may overwhelm others or require emotional support beyond the capacity of the group setting.

Trauma-Informed Language: Language used by educators that emphasizes growth, effort, and strengths, avoiding negative self-perceptions and focusing on constructive feedback.

Trauma-Informed Practices: Approaches that recognize and respond to the effects of trauma, emphasizing safety, trust, and support.

Trigger: Anything including a sound, sight, smell, or situation that brings back memories of a past trauma, causing a strong emotional or physical reaction. It can make someone feel as if they are reliving the event, often triggering fight, flight, freeze, fawn, or flop responses.

Wellness: A holistic state of health, encompassing mental, emotional, social, spiritual, financial, and environmental well-being.

For Product Safety Concerns and Information please contact our EU representative GPSR@taylorandfrancis.com
Taylor & Francis Verlag GmbH, Kaufingerstraße 24, 80331 München, Germany

www.ingramcontent.com/pod-product-compliance
Lightning Source LLC
Chambersburg PA
CBHW080938300426
44115CB00017B/2863